INTERNATIONAL GRAPHIC DESIGN, ART & ILLUSTRATION

Editor: YUSAKU KAMEKURA

Publisher: RECRUIT CO., LTD.
Production: RECRUIT CREATIVE CENTER

Printing: TOPPAN PRINTING CO., LTD.
Distributors: RIKUYO–SHA PUBLISHING, INC.
ZOKEISHA (USA) INC.

編集長 ——————————— 亀倉雄策

編集アシスタント ————— 菊池雅美

アートディレクター ———— 亀倉雄策

デザイナー ——————— 水上 寛

アシスタントデザイナー —— 加藤正巳
　　　　　　　　　　　　　廣田由紀子

プリンティングディレクター — 小嶋茂子

英訳 ——————————— ロバート・ミンツァー

発行 ——————————— 1991年3月1日

定価 ——————————— 3,200円（本体3,107円）

発行所 ——————————— 株式会社 リクルート
　　　　　　　　　　　　　〒104 東京都中央区銀座 8-4-17
　　　　　　　　　　　　　TEL.03-3575-7074（編集室）

発行人 ——————————— 位田尚隆

制作 ——————————— リクルートクリエイティブセンター

印刷 ——————————— 凸版印刷株式会社

用紙 ——————————— 特漉NKダルアート　日本加工製紙株式会社

発売 ——————————— 株式会社六耀社
　　　　　　　　　　　　　〒160 東京都新宿区新宿 2-19-12 静岡銀行ビル
　　　　　　　　　　　　　TEL.03-3354-4020 FAX.03-3352-3106

世界のグラフィックデザイン，アート＆イラストレーション

クリエイション

編集——亀倉雄策

発行——株式会社リクルート
制作——リクルートクリエイティブセンター

印刷——凸版印刷株式会社
発売——株式会社六耀社

Editor —————————— Yusaku Kamekura

Editorial assistant ——— Masami Kikuchi

Art director ————————— Yusaku Kamekura

Designer ———————————— Yutaka Mizukami
Assistant designers ——— Masami Kato
Yukiko Hirota
Printing director ————— Shigeko Kojima
Translator ————————— Robert A. Mintzer

CREATION No.8 1991
Publisher ————————— Recruit Co., Ltd.
8-4-17 Ginza, Chuo-ku, Tokyo 104, Japan
TEL. 03-3575-7074 FAX. 03-3575-7077 (Editor's Office)
Production ———————— Recruit Creative Center
Printing ——————————— Toppan Printing Co., Ltd.
Distributors ——————— Rikuyo-sha Publishing, Inc.
Shizuoka Bank Bldg., 2-19-12 Shinjuku, Shinjuku-ku, Tokyo 160, Japan
TEL. 03-3354-4020 FAX. 03-3352-3106

Zokeisha (USA) Inc.
51 East 42nd Street, New York, N.Y. 10017 USA
TEL. 212-986-3120 FAX. 212-986-3122

©1991 by Recruit Co., Ltd.

Printed in Japan

CONTENTS——目次

Cover: WALDEMAR SWIERZY
表紙：ヴァルデマル・シュヴィエジ

CULTURE: A HIGH-BROW DIVERSION? 高尚な道楽

Yusaku Kamekura 亀倉雄策

The first major corporation in the world to turn its attention to "culture" was probably Olivetti, followed soon thereafter by IBM and the Container Corporation of America. I first noted the commitment of these companies to cultural pursuits just after WWII, yet even now I remember vividly the deep respect and envy which I felt toward these noble patrons of the arts. My awe was reinforced all the more by the pathetically impoverished state of post-war Japan, where every day was a struggle for survival itself and the notion of businesses turning an eye to culture was altogether inconceivable.

My feelings of admiration toward Olivetti, IBM and CCA were directly linked to their stance on design. Graphic policies at each company were relegated to a world-class designer: Giovanni Pintori at Olivetti, Paul Rand at IBM and Herbert Bayer at CCA. Each of these men enjoyed the unqualified trust of his company's senior echelons. This last fact merits special notice: for without the full understanding of those at the top, a corporate design policy has no chance of succeeding.

In the foregoing cases, success came swiftly. Olivetti commissioned Italy's most dynamic architects to design its factories and office buildings, and provided financial assistance in restoring Renaissance frescoes. IBM too began entrusting its factory and office designs to leading architects, and supported artistic activities around the world. CCA became sponsor of the International Design Conference in Aspen, and lent a helping hand in the restoration of that city's historic center.

It was not long before the whole world began to sit up and take note of the cultural stances of these corporate giants. And as this occurred, their cultural deeds came not only to reflect favorably on themselves, but even to serve as symbols of the cultural levels of their respective countries. Deserving particular mention here, too, is the fact that these corporate stances and the voluntary actions which they engendered were completely free from all governmental connections.

I was discussing these corporate trends one day with the president of a well-known Japanese company. "Kamekura-san," he confided without reserve, "to people in charge of companies like myself, the activities you describe are, if you'll pardon the expression, nothing but 'high-brow' diversions." His remarks initially took me by surprise. But then on reflection I began to realize that this view—so typical of Japanese company presidents—is based on a common perception in Japan that culture, by producing no material benefit, is but a diversion of the affluent. This notion, moreover, is not confined to upper corporate ranks, but lingers like encrusted detritus in the minds of the nation's governmental leaders and politicians as well.

It is against this backdrop that an organization was finally (and belatedly—a similar body was established in the U.S. 30 years ago) formed in Japan known as the "Association for Corporate Support of the Arts." As less than a year has passed since its inception, the

企業が文化に目を向けた最初が、イタリアのオリベッティ。そして少し後れてアメリカのIBMやCCAだったと思う。私が、この企業の文化を意識したのは、もちろん戦後すぐのことであった。当時疲弊していた遠い日本の地から、それらの企業が打ち出す文化姿勢に強いあこがれと深い尊敬の念をいだいたことを、今でもはっきりと憶えている。それは、とうてい日本の企業が文化に目を向けるなどという状況でなく、その日、その日の暮しにあえいでいた時代への反動でもあった。私が前記の3社に尊敬とあこがれを持った直接の原因は、この3社のデザインポリシーだった。当時のオリベッティのグラフィックデザイナーは、ジョバンニ・ピントーリだったし、IBMはポール・ランド、CCAはハーバート・バイヤーだった。まさに、この3人が世界のデザイン界をリードしていたといっても過言ではない。しかもピントーリもランドもバイヤーも、その企業の最高責任者と信頼の絆に結ばれていたことは注目に値する。それは、企業の責任者がデザインに理解を示さない限り、デザインポリシーは成功しないからである。このデザインポリシーが次第に発展して、CCAは毎回のアスペンデザイン会議のスポンサーになり、旧市街の復元にも手を差しのべたりしていた。IBMも世界中の芸術活動を陰で支援していたし、工場、オフィスビルなどには世界の一流の建築家を動員していた。オリベッティも工場やオフィスビルをイタリア最先端の建築家に依頼し、またルネサンスの壁画の修復援助を行っていた。

このような文化的な企業姿勢は、やがて世界中から注目されるようになる。そして、その企業の行為が、単にその企業の評価だけにとどまらず、その国の文化にまで高められて評価されるという現象がおきてくる。しかもこの企業姿勢は、その国の政府とは何の関係もなく、企業自身の自発的行為というところに注意を向けなければならない。そして近年、デザインポリシーという思想が、さらに深く厚いものとなって文化に貢献するという強い意志が企業から表現されるようになった。企業が社会に利益還元するという行為で、その国の文化を支えるということだ。これこそ企業文化であり、企業表現である。

このような企業の新しい動向について、ある名の通った会社の社長に話したことがあった。すると社長が「先生、そういうことは私らにとっては、言葉は悪いが道楽というもんと違いますか。要するに高尚な道楽ですわなあ」といった。私は思いもよらぬ指摘に驚いたが、しかし考えてみるとこの社長の指摘は、普通日本人の心の底にしみついている、金持ち道楽という観念である。文化などという利益につながらないものは道楽という考え方だ。この考え方は、企業家だけのものではない。政府の役人も、政治家もこの観念がオリのように心のなかにしみついているのだ。このオリがきれいにふきとれない限り、政府も政治家も真剣に文化に向かって目を開くということはあり得ないだろう。

こういう日本人の体質のなかで「企業メセナ協議会」というものが発足した。発足してから、まだ1年もたっていないので、海のものとも山のものともはっきりしていないが、きっといい成果をあげるだろうと期待できそうだ。「メセナ」の目的は企業体が結集して文化の擁護活動を推進するというものである。欧米各国ではすでに「メセナ」と同じような活動団体が先行し、着実に成果をあげているの

Association's true role has yet to be defined. And yet, its creation does invite some hope. The Association's driving purpose is for the corporate community to unite in promoting patronage of cultural activities. Founding members make for an impressive roster: Seiji Tsutsumi, Keizo Saji, Koichi Tsukamoto and Yoshiharu Fukuhara, who serves as chairman. Indeed, one could not ask for a collection of greater corporate and cultural leaders in Japan. What remains to be seen—and what will ultimately determine the Association's success or failure—is the conceptual direction to be adopted by these prominent men. Still, given their individual influence and prestige, high expectations come naturally. For few governmental or corporate leaders, if approached for financial support by one of these men, would be likely to refuse.

Herein, however, lies a certain danger. Namely, suddenly accorded an opportunity to acquire financial support, every Tom, Dick and Harry—from cultural arts organizations to individual artists—might now be expected to rush forward looking for aid. And while these various elements all deserve our sympathy in view of the cold treatment that culture has long received from the Japanese government, the Association must exercise caution not to become an organization dedicated to philanthropy. Instead it should focus its activities on projects of greatness that will pass down Japan's deeply rooted and noble cultural traditions to future generations.

I well remember the shock and pleasure I received upon hearing of Andre Malraux's appointment as France's Minister of Cultural Affairs in 1959. What startled me was the wisdom of the French government in selecting this renowned author to serve in charge of the promotion of his nation's culture. By his word of command, the architectural gems of Paris, long buried under the black soot of the centuries, were washed dazzlingly clean. Furthermore, even after Malraux left his post one decade later, thanks to the unprecedented popular support which his policies enjoyed, his legacy has continued to be carried on in an array of new architectural masterpieces: the Pompidou Centre, the recently renovated Louvre, the stunning Bastille opera house and Tête Defense.

I am not suggesting that the Japanese government should imitate this French example; this would be ineffective owing to the inherently lower caliber of the average Japanese compared with his French counterpart. Also, culture cannot be elevated through government initiatives alone. What are needed as well are the understanding and cooperation of the people. Unfortunately, even if a man of Malraux's stature existed in Japan, it is unlikely that he would be granted the same degree of power and trust. So it is precisely for this reason that I hold high hopes of the Association for Corporate Support of the Arts. I hope that through a clear corporate policy on culture, the Association will apply its efforts toward the gradual elevation of the cultural awareness of the Japanese public. Where the Association can begin is by slowly chipping away at the all-too-common notion—the psychological "detritus"—that culture is but a high-brow diversion.

に、日本は30年も後れてやっと誕生したというわけである。そして設立メンバーは私たちの知っている堤清二、佐治敬三、塚本幸一の諸氏と福原義春氏の理事長ということで信頼できる心強い発足と思われる。問題は、この先どのようなコンセプトで運動を進めるかで、これに成功の鍵がかかっている。恐らく日本でこれ以上求めることのできない企業家であり、文化人であり、実力者である方々の結集だから、その成果を期待するのは当然である。人格的には申し分のない立派な方々のお声がかりだから政府も企業も心のなかでは「高尚な道楽」と思っても、恐らく資金の提供が潤沢になることは想像にかたくない。それだけに、また危険もつきまとうという気がする。

その危険というのは、金につきまとう亡者よろしく助成金をほしがる芸術文化の団体から個人に至るまでが、群がりよってくることである。政府が文化に冷淡だから同情すべき点は多々あっても、「メセナ」は慈善的な助成団体になっては困るのだ。それは、しっかりと根を下ろした高い文化を日本民族の将来のために残すという壮大なプロジェクトに取り組んでほしいからだ。私が今でも鮮明に思い出すのはアンドレ・マルロオが文化相に就任した時の、あの衝撃的な感動だった。『王道』、『人間の条件』の著者を抜擢して、文化推進の責任者にしたフランス政府の見識の高さに驚いたのである。マルロオの大号令で何世紀もの間に黒く汚れたパリの建築を洗い落して、見違える程美しくした。1人の文人にこれ程まで力を与え支持したフランス国民の良識がマルロオ亡きあともその精神の遺産を受け継ぎ、ポンピドーセンター、ルーブル改修、バスティーユの新オペラ座、テット・デファンスで世界を驚かせた。しかし私は、ただちにフランスの真似をしろとは政府にいわない。日本国民の質がフランス国民ほど高くないからだ。文化を高めるのは政府の力だけでは出来ない。国民の理解と協力がなければ出来ないのだ。たとえマルロオのような人が日本にいても、決してフランスのように力を与え信頼をしたりしないだろう。私は、だから「メセナ」に期待したいのだ。それは企業の文化姿勢を通して一歩、一歩国民の文化意識を高めることに力を注いでもらいたいからだ。そのためには「高尚な道楽」という心の底によどんでいるオリを洗い流すことから始めてもらいたい。

SHIGEO FUKUDA 福田繁雄

Mamoru Yonekura 米倉 守

Having already written about Shigeo Fukuda on numerous occasions, here I would like to approach my renowned subject from a slightly different perspective. As the items selected by the Editor for this volume reveal, Fukuda's works follow a certain pattern.

In a nutshell, it is a pattern of self-multiplication. For every theme he chooses—hands, feet, forks, whatever—Fukuda continually creates new works by gleaning from and combining his earlier works, then giving them a new name. In this sense he is not so much a "designer" in the conventional vein, but rather what we might call the first "design methodologist." The method he has devised is one whereby he forges new works by culling elements from his numerous existing works, giving them new names in new contexts.

In other words, Shigeo Fukuda borrows from Shigeo Fukuda. As Mr. Kamekura has discovered and informs us through his selections presented here, Fukuda appears always to be seeking to outdo himself—no mean task, I might add. Like a pioneer ever searching for new frontiers, Fukuda is an artist who continuously attempts to stay one creative pace ahead of himself and his times.

In this respect, Fukuda might perhaps be likened to Rodin. Just as Rodin created his *Gate of Hell*, Fukuda, we might hope, will create a *Door to Humor*—or perhaps a *Gateway to Laughter*. This is the "different perspective" I spoke of earlier.

Gate of Hell in effect represents an agglomeration of Rodin's complete sculptural output. It was both compiled from his enormous volume of earlier works, and also served as the source of material for his subsequent works. Rodin not only gave various titles to a single work, he was also a genius at bringing together multiple copies of a given work to comprise an all-new one. His *Three Shadows* poised at the top of *Gate of Hell*, for example, consists of three of his *Adam* statues set in a line. His *Three Nymphs* was created by placing three identical dancing figures in a circular formation. His *Spring Run Dry* is a twin set of his *Beautiful Helmet-maker's Wife* counterpoised face-to-face.

Remarkably, too, the results of Rodin's reliance on this method were always rhythmical and structured yet without being monotonous—always evoking brilliantly and precisely the theme of the new work at hand. In his mind Rodin kept patterns of great variety which he retrieved and applied as he needed them, and in this process he succeeded in opening a new door in the realm of contemporary sculpture.

Where Fukuda differs from Rodin is in his fundamental orientation. While Rodin injects *The Thinker* into *Gate of Hell* in a depiction of horror, Fukuda opts for scores of Mona Lisa's smiles and sublimates them in a pinnacle of bliss, taking us through his imaginative world to the "Gateway to Laughter." The humor that we discover there, moreover, is by no means shallow. For as we see in his well-known *Victory*, within his humorous framework Fukuda also evokes a measure of disconcerting malaise. And it is here that he creates a unique niche for himself, and for us his admirers.

「笑いは福だ」と、これまで数多く福田繁雄について書いてきたので、今回は少し角度を変えてみたいと思う。というのは今回亀倉雄策が選んだ作品を眺めていると、あるパターンがあるのだ。

たとえば、「手」がでてくると「手」のいろいろな組み合わせが登場し、「足」がでてくると「足」、「フォーク」が図像化されると「フォーク」といった具合に作品が増殖されていく。「選択」と「名付け直し」と、「組み合わせ」で福田作品は次々と蘇生をくりかえしている。福田が創造したのは「図案」ではなく、新しい福田式図案方法なのだと思う。自分でつくった数多くの作品のなかからあるものを引用し、別の文脈で別の名を与えて新しい作品にすることを考案したのである。

福田繁雄は福田繁雄の引用なのである。これはぼう大な作品群から選びだした亀倉の発見でもあるが、福田はつねに超えなければならないのは福田繁雄自身である、という困難な主題を設定しているのだろう。真のパイオニアが、つねに自己を乗り越えてゆく存在であるように、福田もまた現代からもうひとつ先の新しいステージを用意し続けている作家なのだ。

そこで私はひそかに考えていることがある。福田繁雄論の角度を変えるとはこのことなのだが、ロダンが「地獄の門」をつくったように、福田は「ユーモアの門」か「笑いの扉」をつくらないだろうかという思いがするのだ。

ロダンの彫刻の集大成「地獄の門」は、従来のおびただしい数の作品の引用から成り立っているが、他の彫刻もまた「地獄の門」からの引用、独立から生れている。ロダンは同じ作品に様々なタイトルをつけているが、さらに、同じ作品を複数集め、組み替えて新作を生み出す達人でもあった。「地獄の門」でいえば、最頂部にある「3つの影」は「アダム」の男性像を3体並べたものだ。「3人の踊り子」は、踊っている同一の人体を円形に組み合わせたものであり、あの「美しかりしオーミエル」は、2つ向いあわせて「涸れた泉」に生れかわっている。ロダンはこの手法で、単調になることなく、リズミカルに、構築的に、それぞれの作品主題をより強く表現している。

近代彫刻の扉を開いたロダンは、戸棚に、あるいは頭の中にいろいろなパターンをしまっていて、次々と出しては組みあわせていった。

福田のアトリエにあるいろいろな玩具や回転の早いデザイナーの頭を思い浮かべ、「ロダンの言葉」ならず21世紀デザインの予告がはらまれている「福田繁雄の言葉」を私は改めて考えている。

「考える人」を軸心において、地獄に真っ逆さまにおちてゆく「地獄の門」とちがって、モナリザの百微笑ともども笑いの至福に上昇、浄化してゆく「笑いの門」はさぞ福田繁雄の想像空間をはっきりと浮上させることだろうと思うのである。

しかし、そのユーモアは単調な底の浅いものではなく、有名な作品「VICTORY」のように厳しく一抹の不安を含みこんだ福田繁雄畢生の作品になるはずである。と、私だけが思ってみてもせんないことだが、福田でなければできない仕事であり、それが福田作品の特徴だからである。

※参考「生誕150年ロダン展」図録(匠秀夫監修)

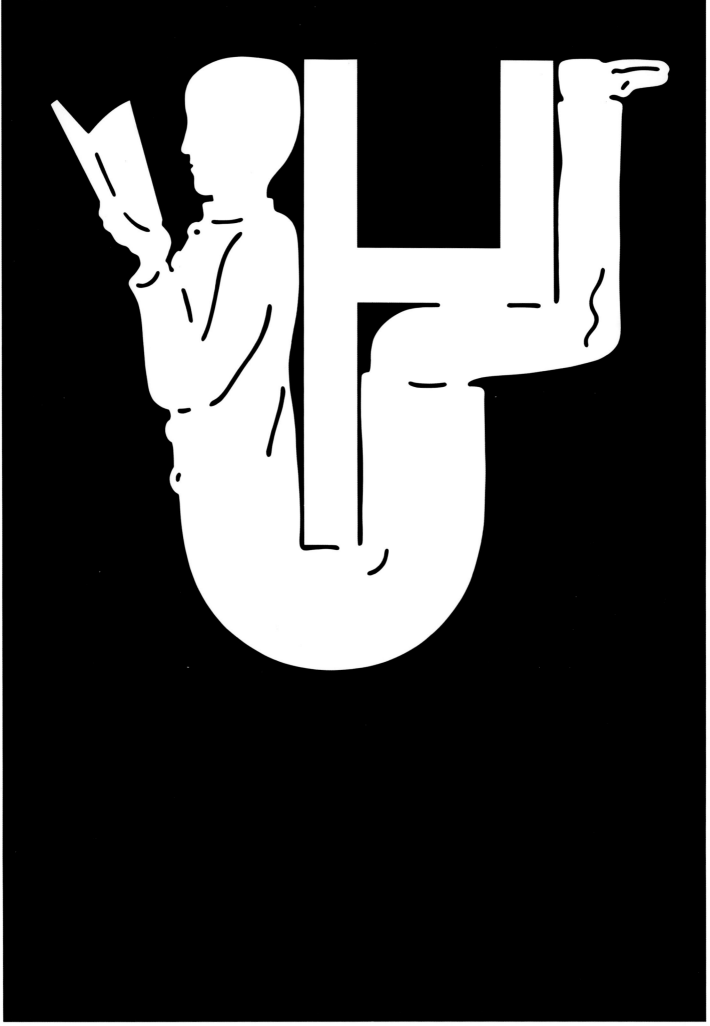

1 Illustration for educational seminar poster 教育セミナーのポスターのイラスト 1983

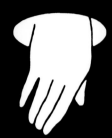

2 Illustration for design conference poster デザイン会議のポスターのイラスト 1976

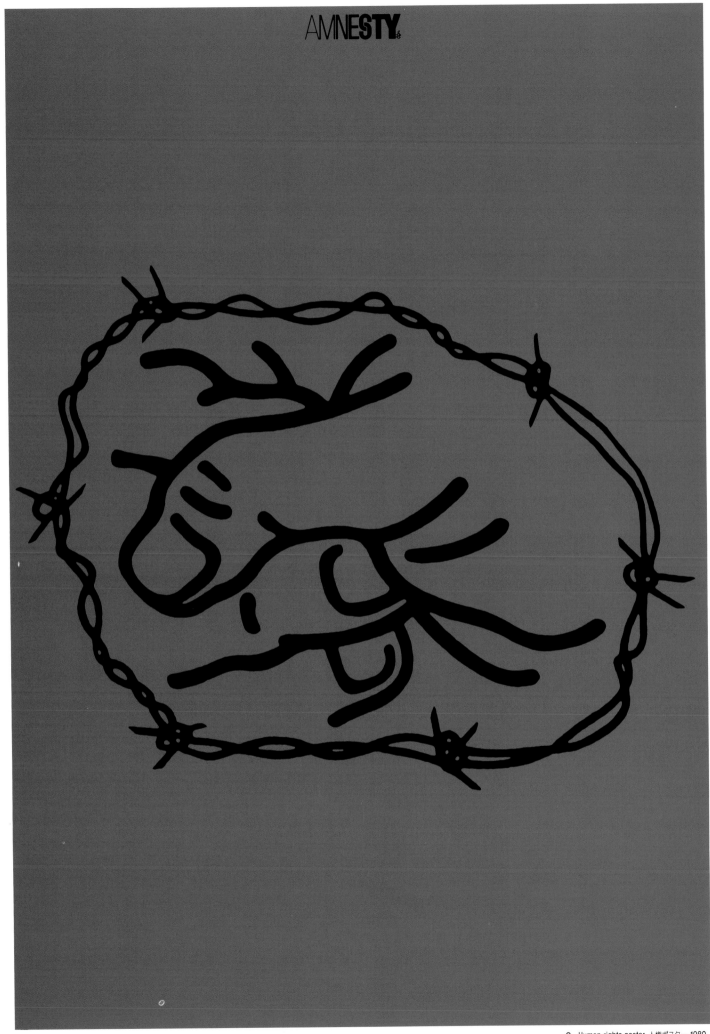

3 Human rights poster 人権ポスター 1980

4　Illustration for exhibition poster　展覧会ポスターのイラスト　1982

5　Illustration for exhibition poster　展覧会ポスターのイラスト　1986

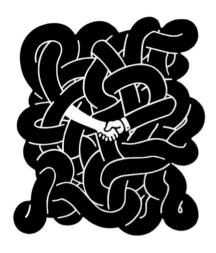

6　Illustration for poster promoting conference on Japanese culture and design
　　日本文化デザイン会議のポスターのイラスト　1981

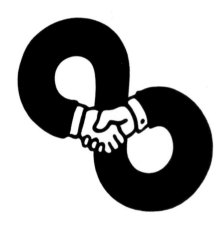

7　Illustration for book promotinal poster　本のポスターのイラスト　1983

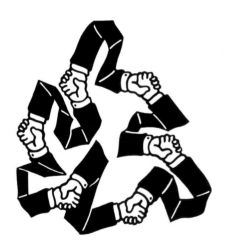

8　Cover illustration for educational journal　教育ジャーナル誌の表紙イラスト　1983

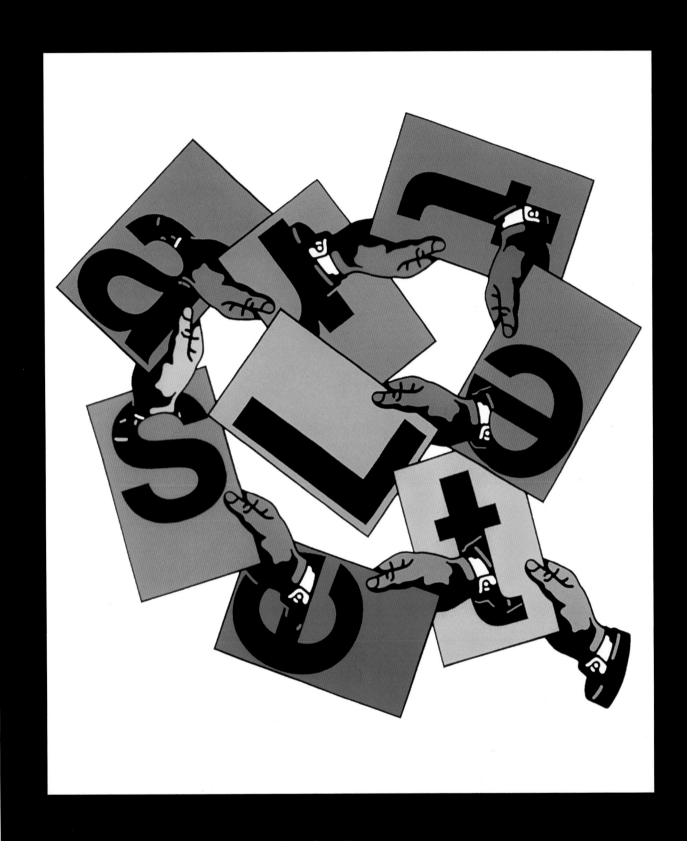

9　Illustration for poster promoting design contest　デザインコンテストのポスターのイラスト　1989

10 Illustration for poster for one-man show 個展ポスターのイラスト 1971　　　　12 Illustration for opera : poster "The Marriage of Figaro" オペラ「フィガロの結婚」ポスターのイラスト 198

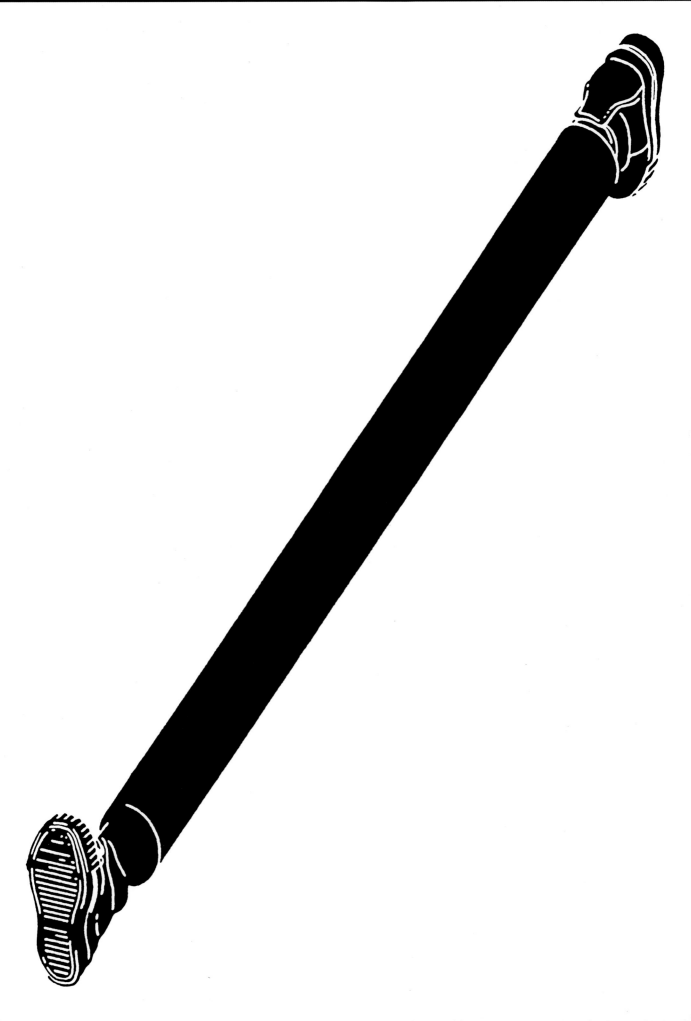

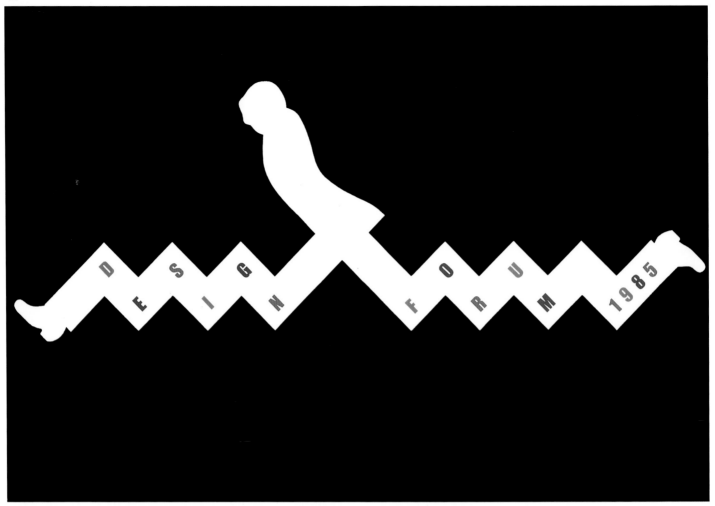

15 Illustraion for poster for open design exhibition デザイン公募展のポスターのイラスト 1985

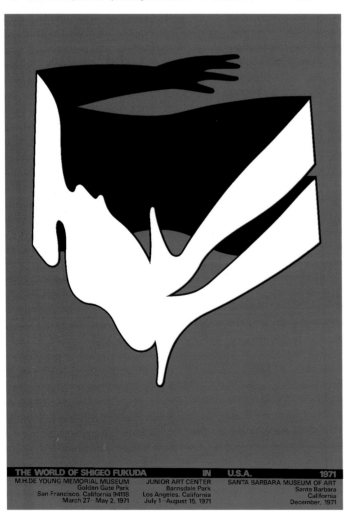

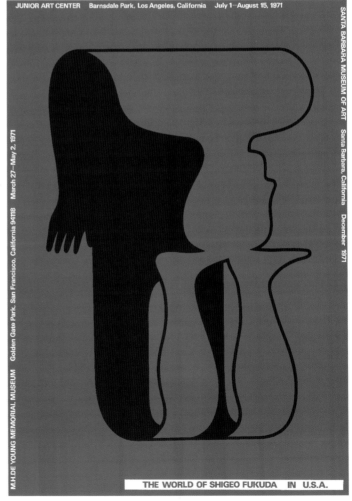

16-17 Posters for one-man show 個展ポスター 1971

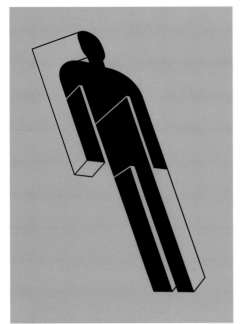

18

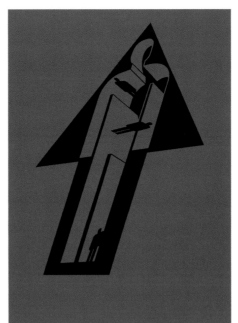

19

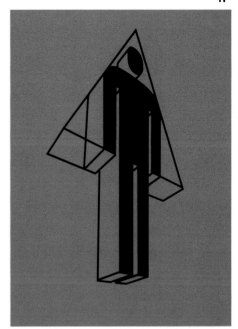

20

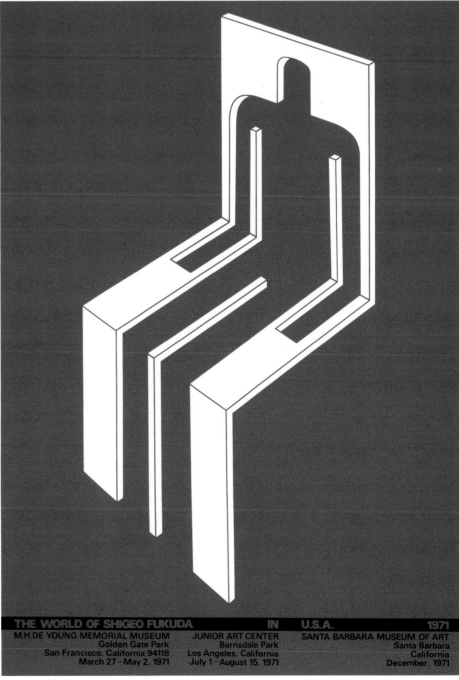

18-21 Illustrations for posters for one-man show 個展ポスターのイラスト 1971

22-24 Exhibition posters for "Japan Show" JAPAN展ポスターのイラスト 1987

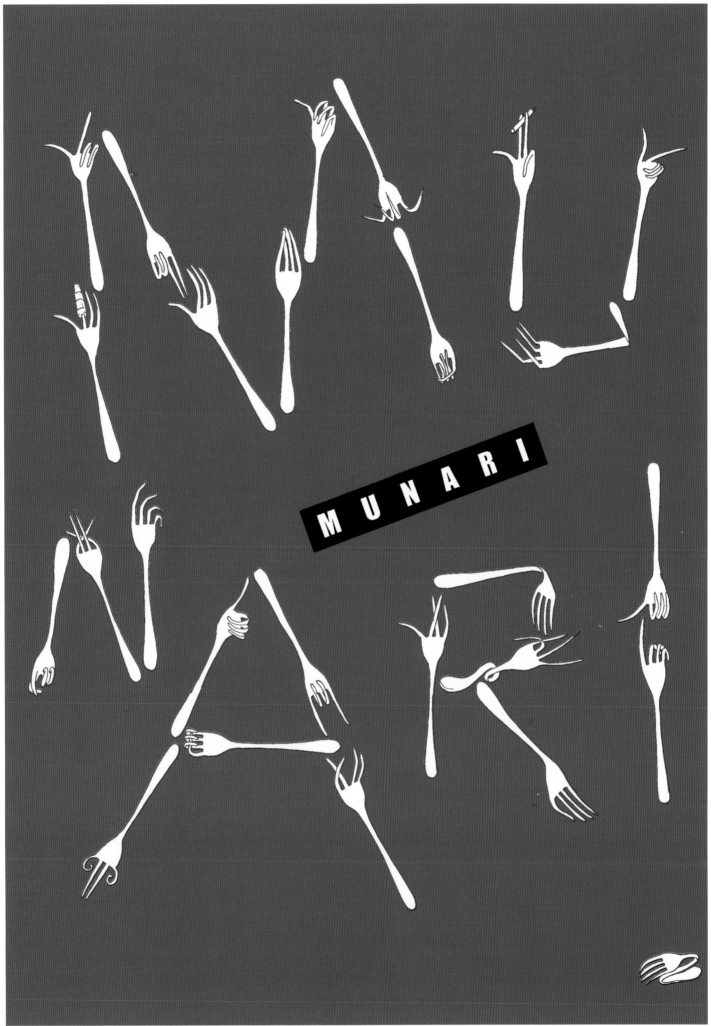

26 Poster for photocomposition firm 写植会社のポスター 1987

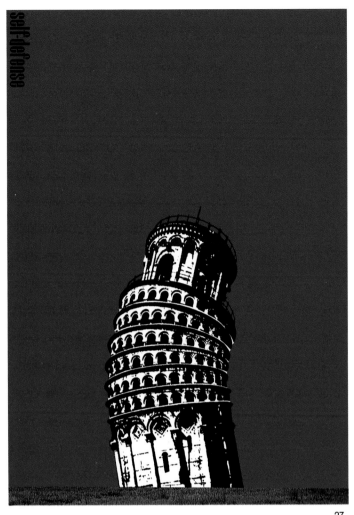

27

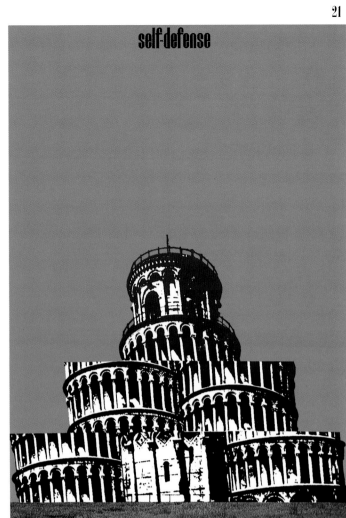

29

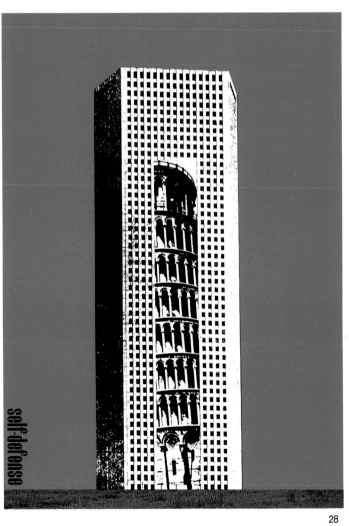

28

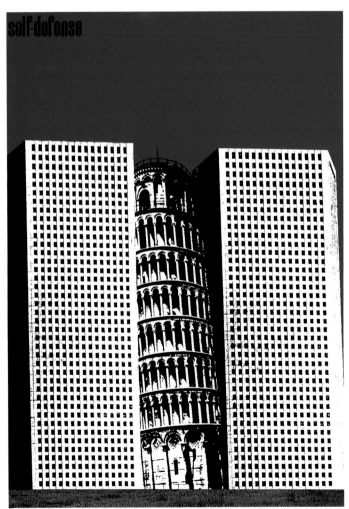

27-30 Posters for one-man show 個展ポスター 1974

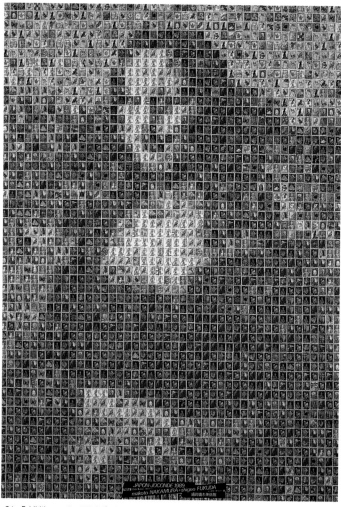

31 Exhibition poster 展覧会ポスター 1989

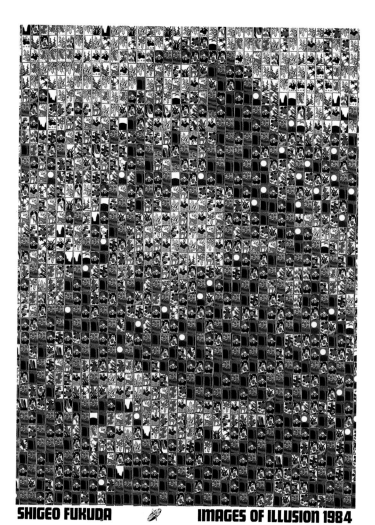

32 Poster for one-man show 個展ポスター 1984

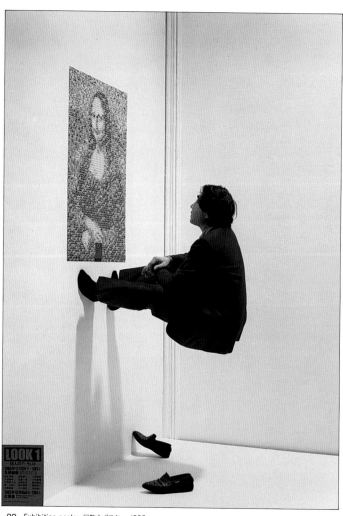

33 Exhibition poster 展覧会ポスター 1985

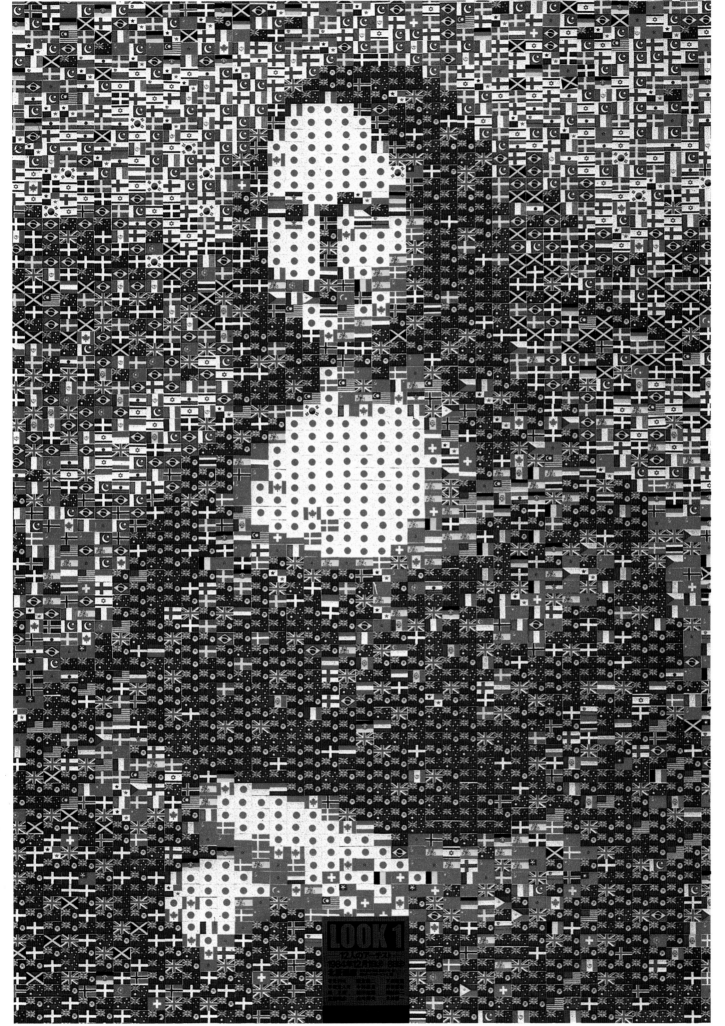

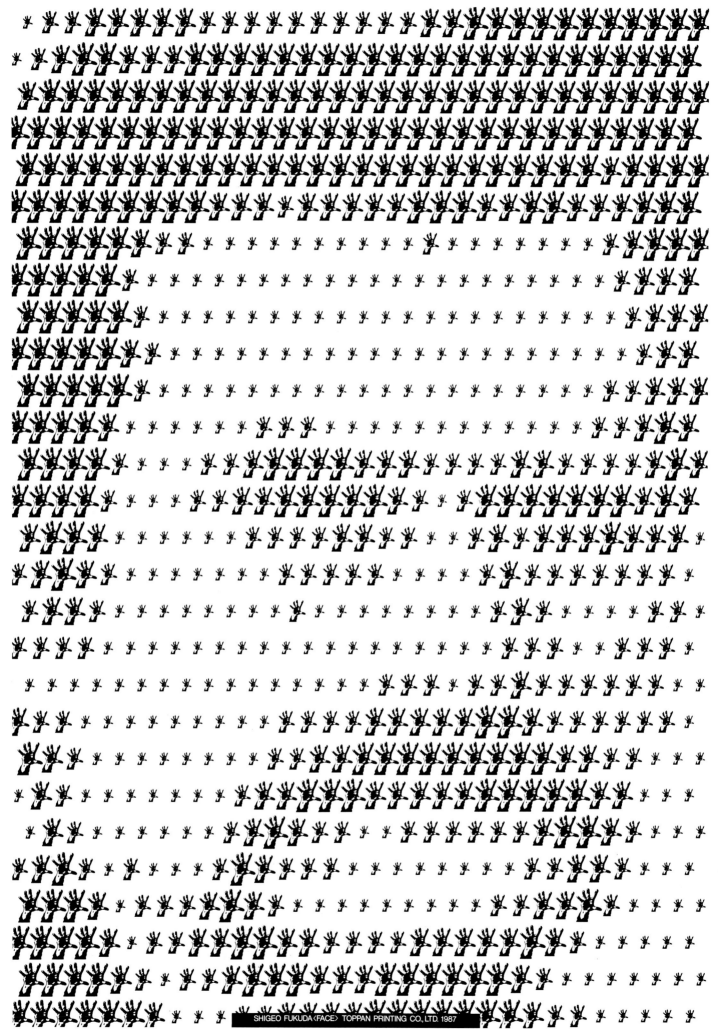

SHIGEO FUKUDA 〈FACE〉 TOPPAN PRINTING CO.,LTD. 1987

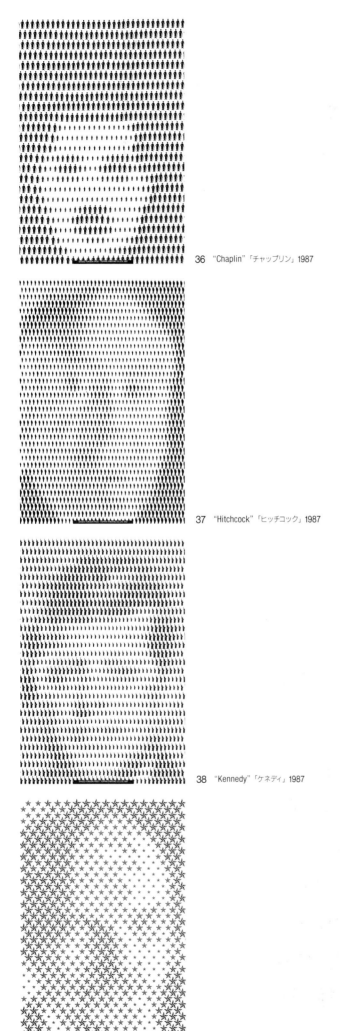

36 "Chaplin" 「チャップリン」 1987

37 "Hitchcock" 「ヒッチコック」 1987

38 "Kennedy" 「ケネディ」 1987

39 "Lenin" 「レーニン」 1987

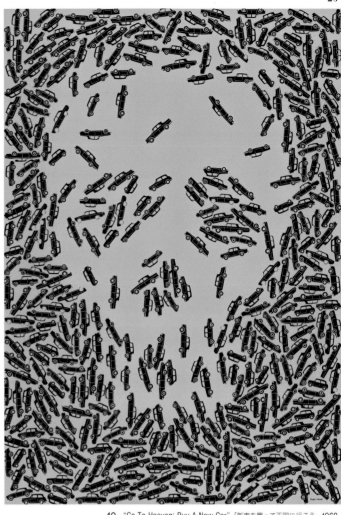

40 "Go To Heaven: Buy A New Car" 「新車を買って天国に行こう」 1968

41 Anti-war poster 反戦ポスター 1968

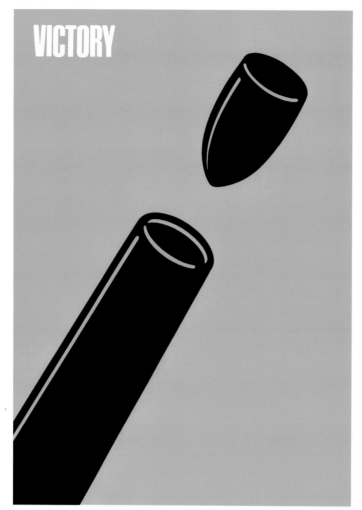

42

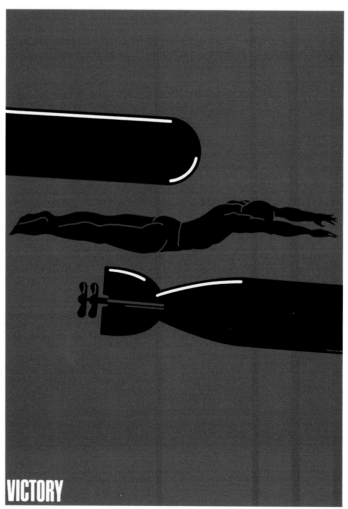

42-43 Anti-war posters 反戦ポスター 1976

44　Poster to prompte environmental greening 緑化運動のポスター 1982

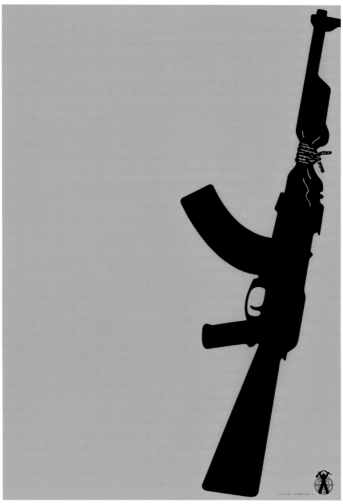

45　Anti-war poster 反戦ポスター 1982

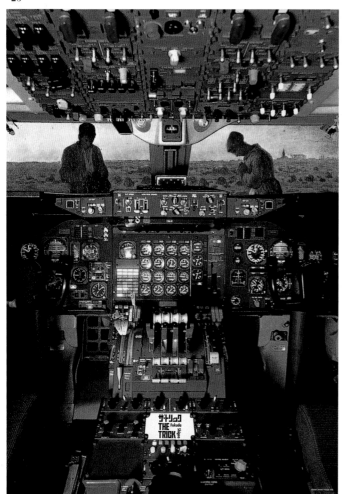

46

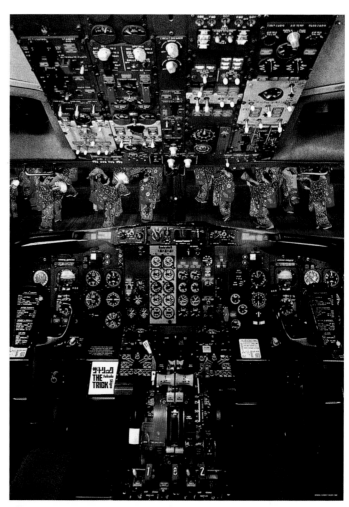

47

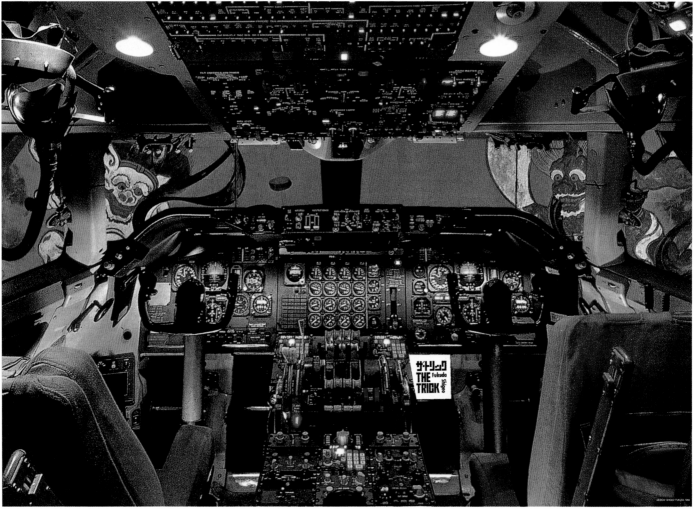

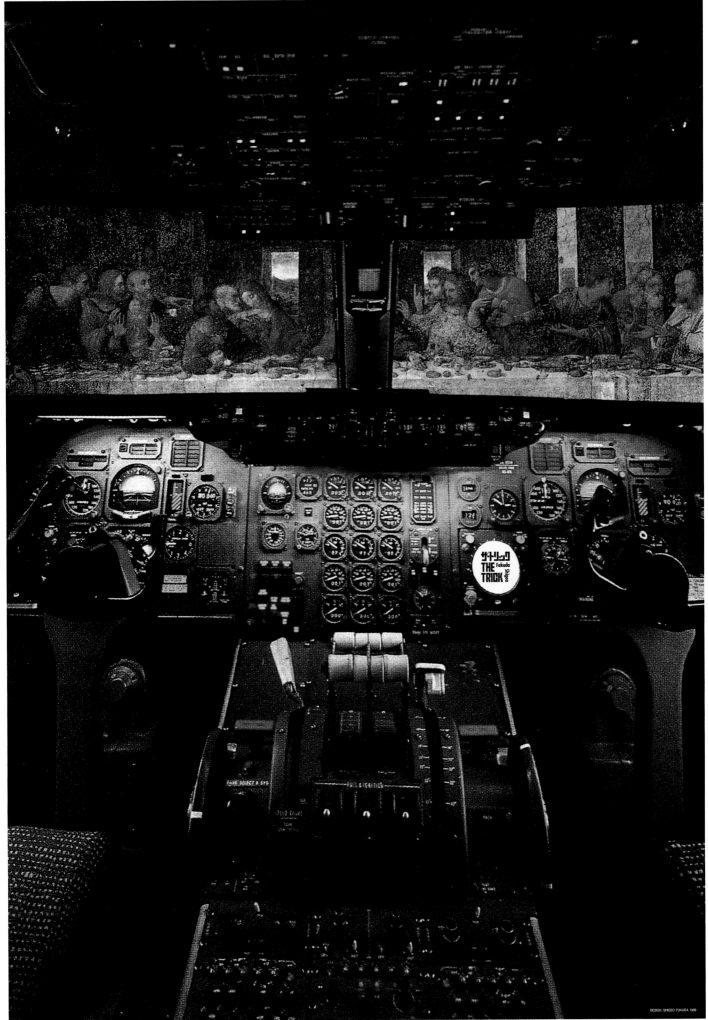

46-49　Posters promoting "Tricks" exhibition　トリック展のためのポスター　1989

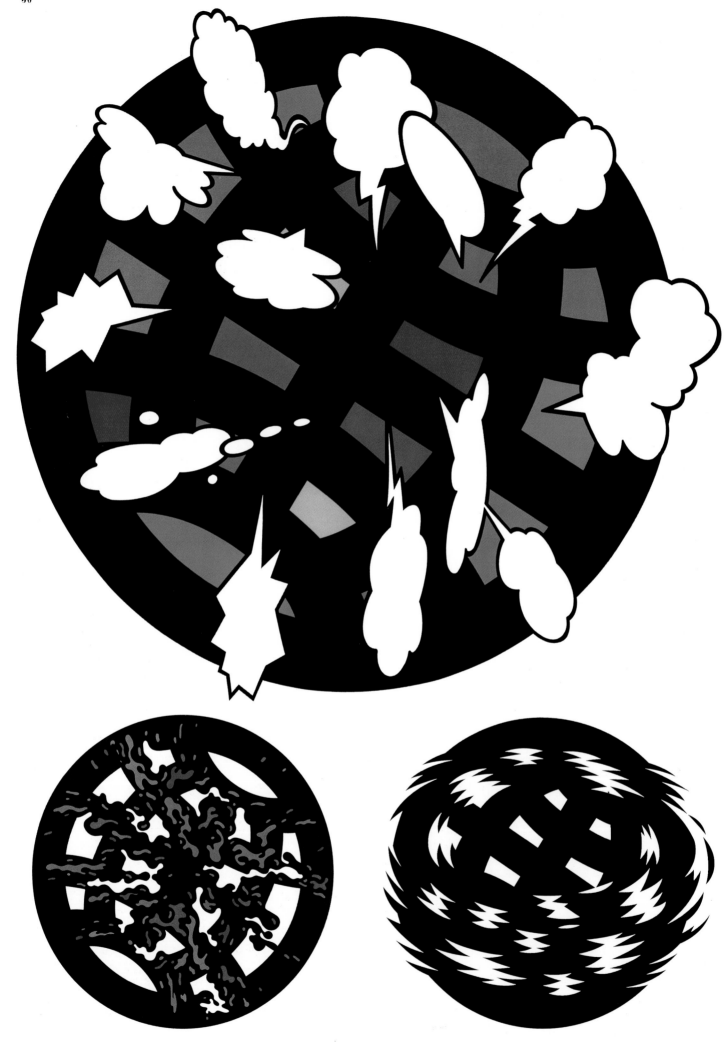

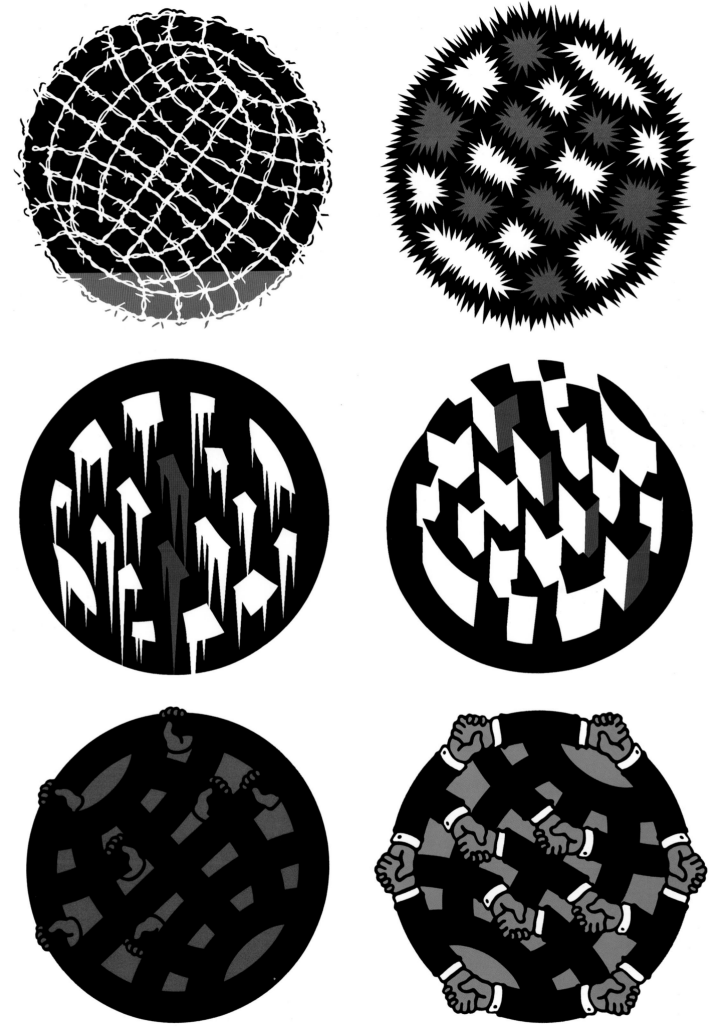

50-58 "Earth" series 地球シリーズ 1982-90

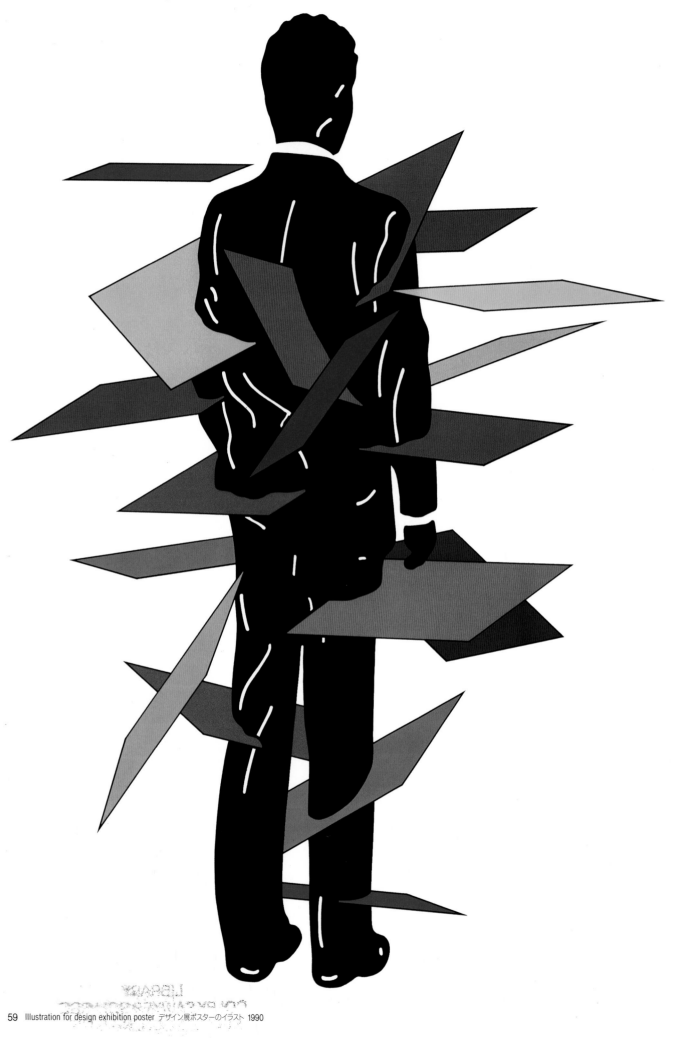

Illustration for design exhibition poster デザイン展ポスターのイラスト 1990

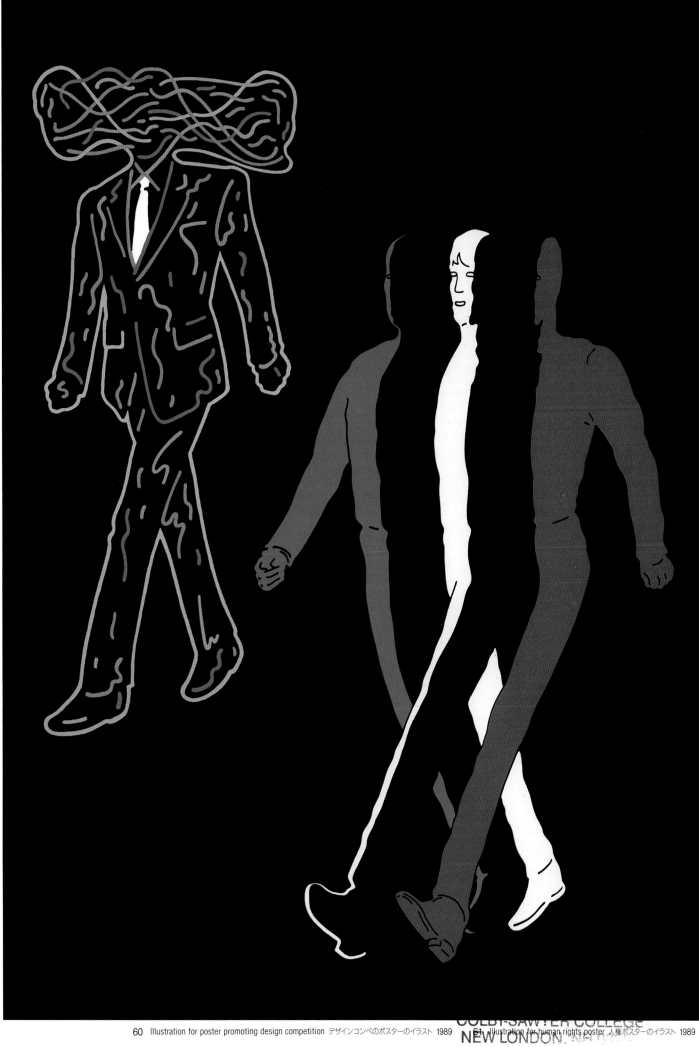

60 Illustration for poster promoting design competition デザインコンペのポスターのイラスト 1989 61 Illustration for human rights poster 人権ポスターのイラスト 1989

YOKO YAMAMOTO 山本容子

Yusuke Nakahara 中原佑介

As a student of English, I recall being mystified most by the grammatical forms known as the "perfect" tenses. My difficulty seemed to arise from the absence of correspondingly clear time references in Japanese. Naturally I had no problem with tenses such as past, present and future; yet it took considerable effort to get accustomed to tenses like the "past perfect," "present perfect" and "future perfect." On the other hand, once I did become used to them, I found them quite sensible. In fact, I came to realize that we Japanese actually have the same notions of time when we speak, and we know well the distinction between a past tense and a present perfect. It's just that we don't use grammatical labels such as "past perfect," "present perfect" and the like.

While the foregoing relates to questions of grammar in verbal expression, I believe the same ideas can be applied to imagistic expression as well. In other words, in my view there are "past" images, "present progressive" images, "future" images and so on. Naturally, in the latter case each specific time frame depends closely on the imagery itself, so it is extremely difficult to generalize in the same way one can with grammatical tenses. Nevertheless, when imagery and tense mesh well, together they produce a sublime effect that can perhaps best be described as "bewitching."

The illustrations of Yoko Yamamoto are a perfect example of this ideal harmony between tense and imagery. In Yamamoto's case, imagistic expression corresponds to the "present perfect" tense. This is because Yamamoto's images are neither completely of the past, nor do they unfold solely in the present. Instead they simultaneously belong partially to the past yet remain "living" in the present. Naturally, imagistic expression in the present perfect tense is not unique to Yoko Yamamoto alone. More accurately, it can be recognized as a manifestation of pop art, in the vein of Andy Warhol. By "pop art," of course, we refer not to "popular" culture as seen through the eyes of pop artists, but a movement that focused on cultural symbols already engraved in the memory of the masses.

Yoko Yamamoto debuted as a copperplate artist, and she continues to work in this genre even today. In recent years much of her work has involved illustrations for book covers, novels, posters and even calendars, and at all times she works from copper plates. She prefers this medium, one can assume, because of the infinite appeal of etching lines. What deserves special mention, however, is that in Yamamoto's case etching lines are used like a written text through which she creates images in a present perfect tense. It is her knowledge that etching lines are the most appropriate format for portraying images in this tense that, perhaps more than anything else, sets her works in a class by themselves.

Looking upon Yamamoto's illustrations, one senses both the shadow of what has gone past and the voice of the living present—what one might describe as the co-existence of memory and a sense of reality. This is what I mean by present perfect tense, and surely it is also what Yamamoto herself aims for in her imagery. And while the art world abounds with images of the past, images like hers in the present perfect tense are preciously rare.

英語を習ったとき、とまどったのは完了形という文法での時制だった。われわれ日本人にはそういう時制がはっきりしていないからである。過去、現在、未来という時制には違和感はない。しかし、過去完了、現在完了、未来完了という時制に慣れるには努力を要した。しかし、慣れてしまうとなるほどと思うようになった。過去完了とか現在完了などとはいわないけれど、われわれもそういうニュアンスの時制の表現をしているし、過去形と現在完了形でいわんとしている違いを知っているからである。

これは文法の問題というか、言葉による表現の問題に属することだが、私はイメージによる表現にも同種のことがあるように思う。たとえば、過去形のイメージ、現在進行形のイメージ、未来形のイメージなどというようにである。もっとも、それはまたイメージの内容とも密接に関係していて、文法のように時制として一般化するのはきわめて難しい。しかし、イメージと時制がうまく一致するとき、その作品は「魅力的」というようないい方しかできないようないわくいい難い雰囲気を醸しだす。

山本容子のイラストレーションは、私のいうイメージと時制のきわめてうまい一致の例であるように思う。それは、文法でいうところの現在完了形に相当するイメージ表現といっていいかと思う。彼女の描くイメージはまったく終わってしまった過去に属するのではなく、そうかといって現在のただ中で展開されているそれでもない。なかば過去に属しながら、今もなお息づいているといったイメージなのである。もっとも、こうした現在完了形のイメージ表現は、山本容子の独創というわけではない。アンディ・ウォーホルがそうであったように、ポップ・アートによって示されたことだった。というのも、ポップ・アーティストたちは眼前に繰りひろげられている大衆文化でなく、大衆の記憶に刻印されている文化の諸記号をとりあげたからである。

山本容子は銅版画家としてデビューし、現在も銅版画を続けている。近年は書籍の装丁のためのイラストレーション、あるいは小説の挿絵、さらにはポスターやカレンダーのイラストレーションといった仕事がきわめて多いが、そうしたイラストレーションもすべて銅版画を原画としている。エッチングの線に限りない魅力を感じているからであろう。しかし、そのエッチングの線が現在完了形としてのイメージをうみだすための文体として活かされている点こそ注目に値する。あるいは、エッチングの線は、イメージを現在完了形として描くのにもっともふさわしいということを自覚したところに、彼女の作品のかけがえのなさがある。

彼女のイラストレーションをみると、そこには過ぎ去ってしまったものの幻影のようなものと同時に、眼の前で息づいているものの肉声を同時に感じるだろうと思う。記憶と現実感覚の共存とでもいえばいいか。私が現在完了形といったのはそういうニュアンスのことだが、それはまた彼女自身がイメージとはそういうものだと考えていることによるだろう。過去形のイメージには事欠かない。しかし、現在完了形のイメージは希少に属するのである。

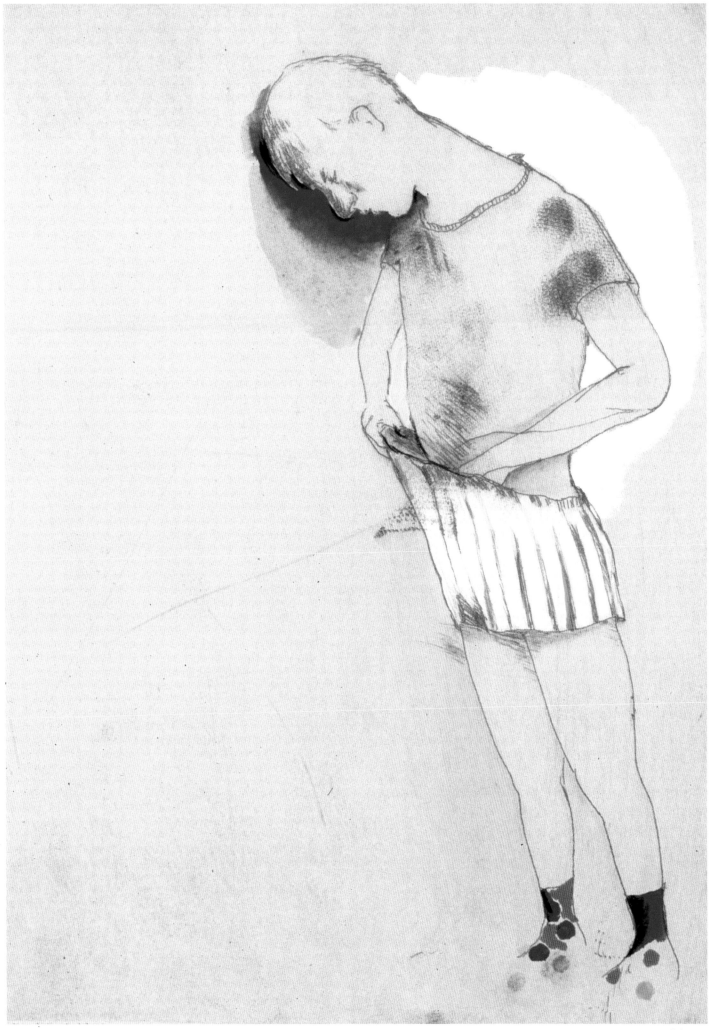

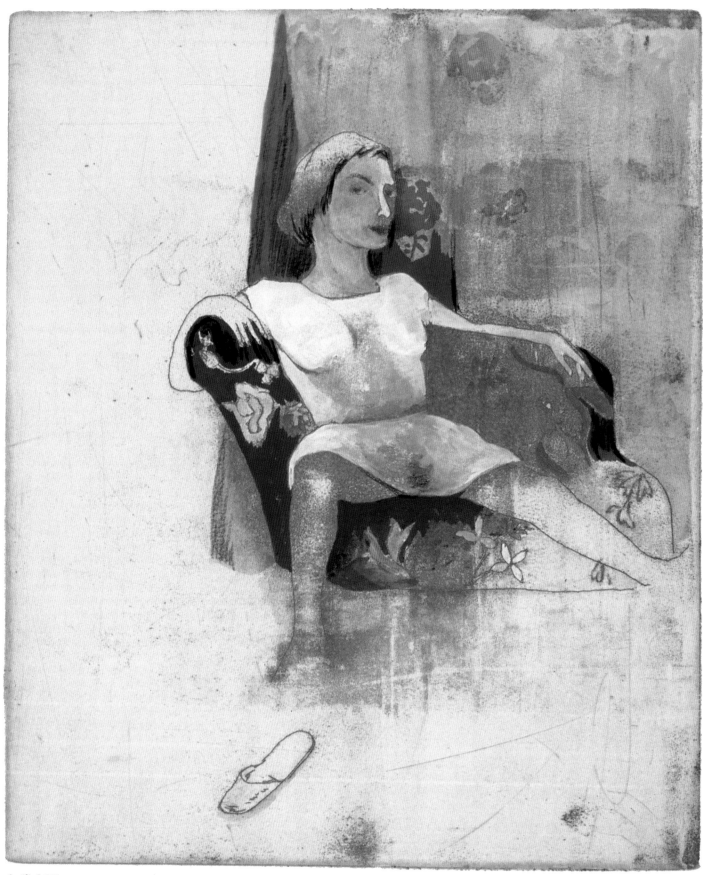

2 "She" 1990

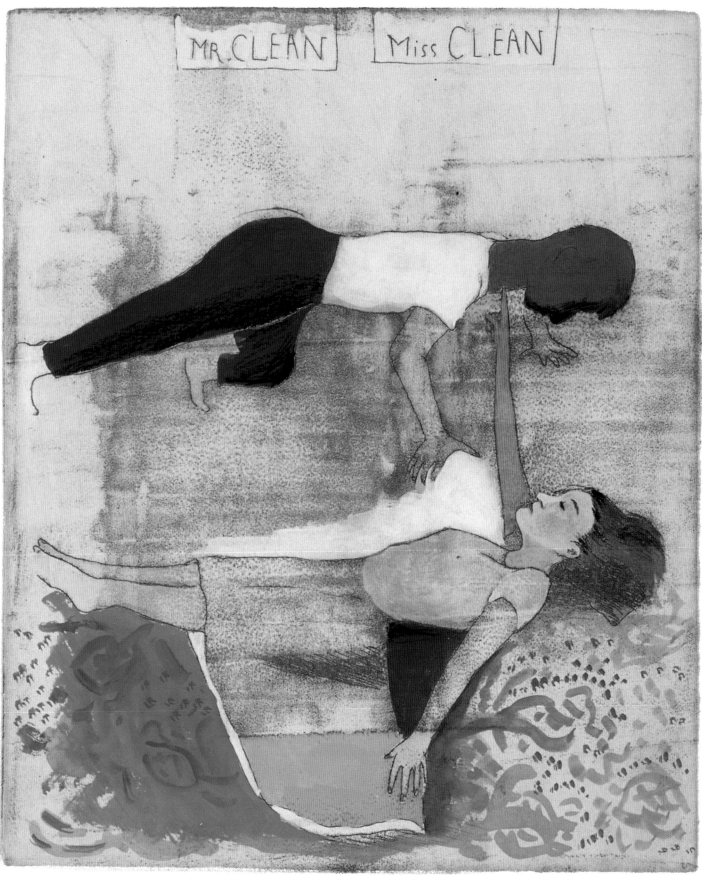

3 "Mr.and Miss Clean" 1990

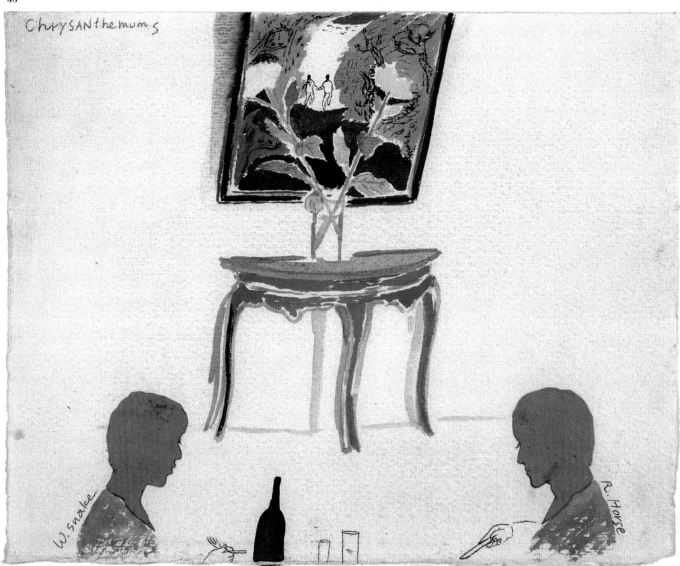

4 "Chrysanthemums" 1983

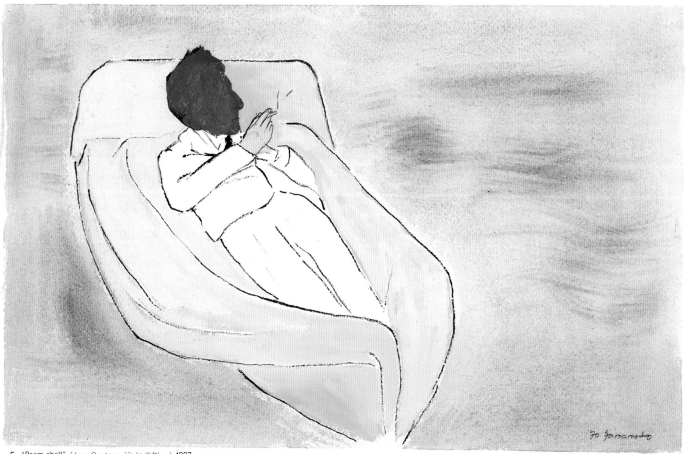

5 "Poem-shell" (Jean Cocteau ジャン・コクトー) 1987

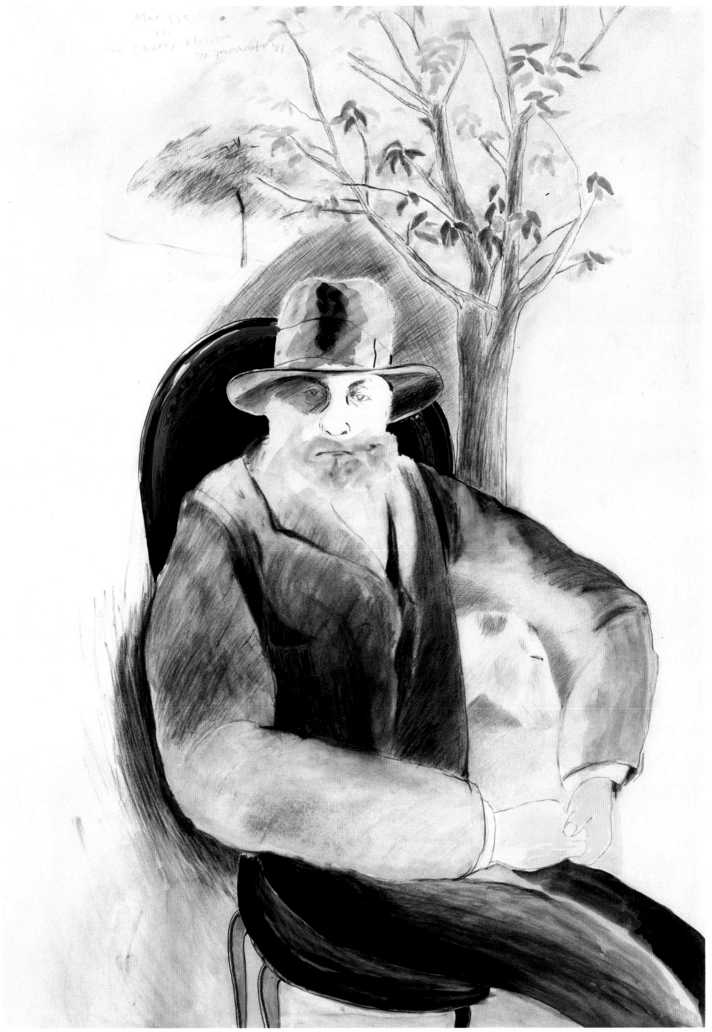

6 "Matisse in Cherry Blossoms"「マチス・イン・チェリー・ブロサムズ」1983

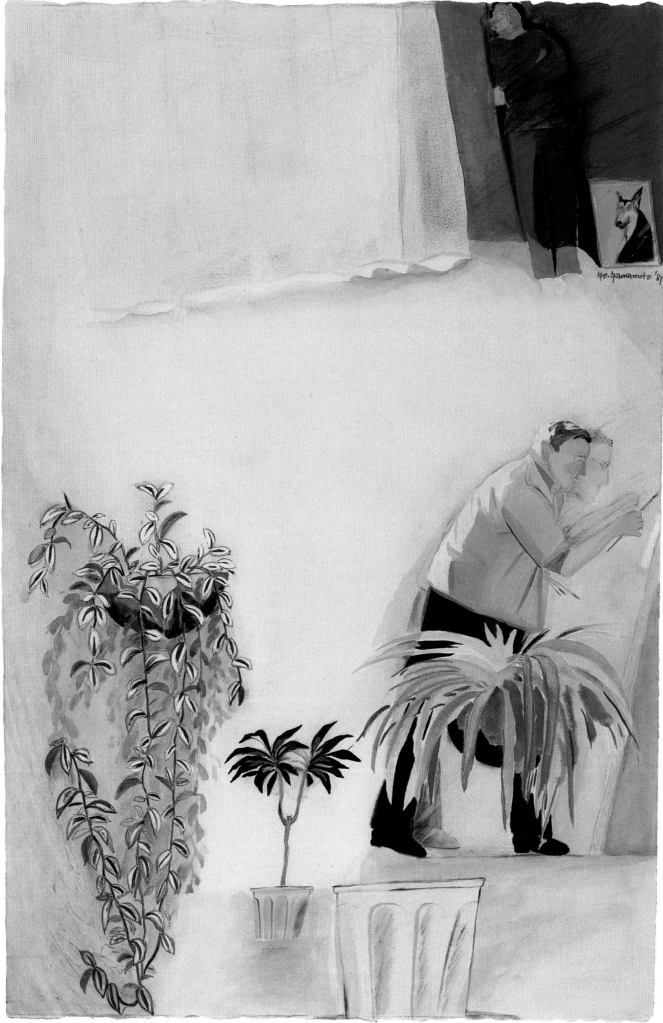

7 "Day" 1981

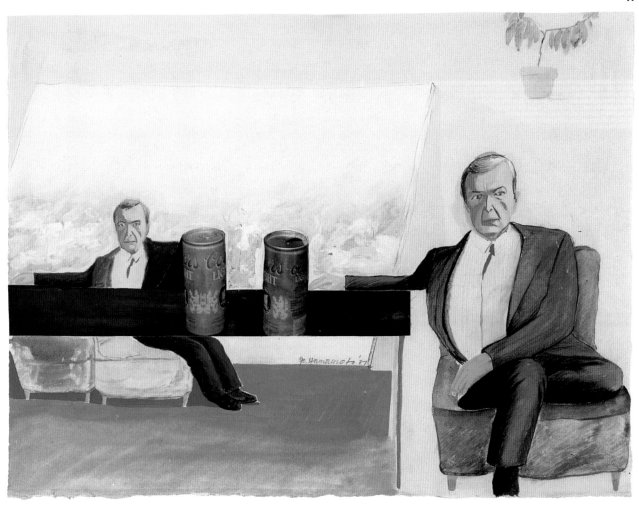

8 "Two Coors" (Jasper Johns ジャスパー・ジョーンズ) 1981

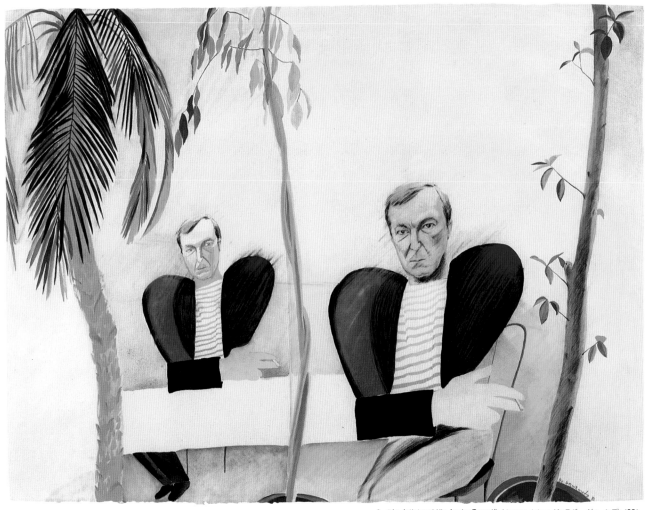

9 "An Artist and His Apple : Target" (Jasper Johns ジャスパー・ジョーンズ) 1981

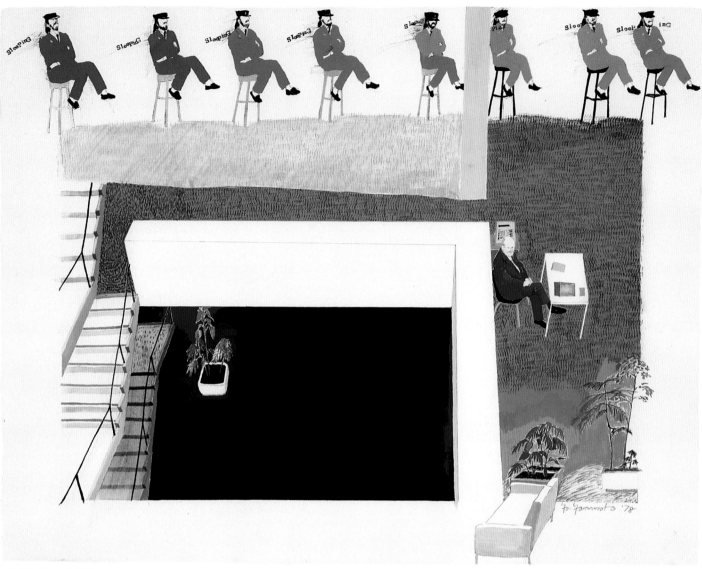

10 "The Museum" 1978

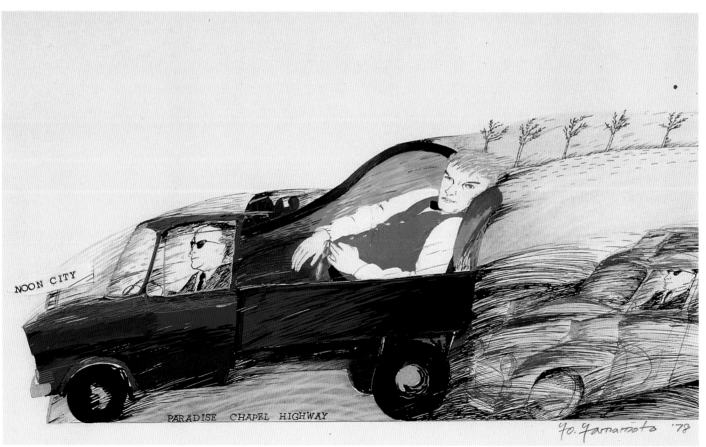

11 "Paradise Chapel Highway" 1978

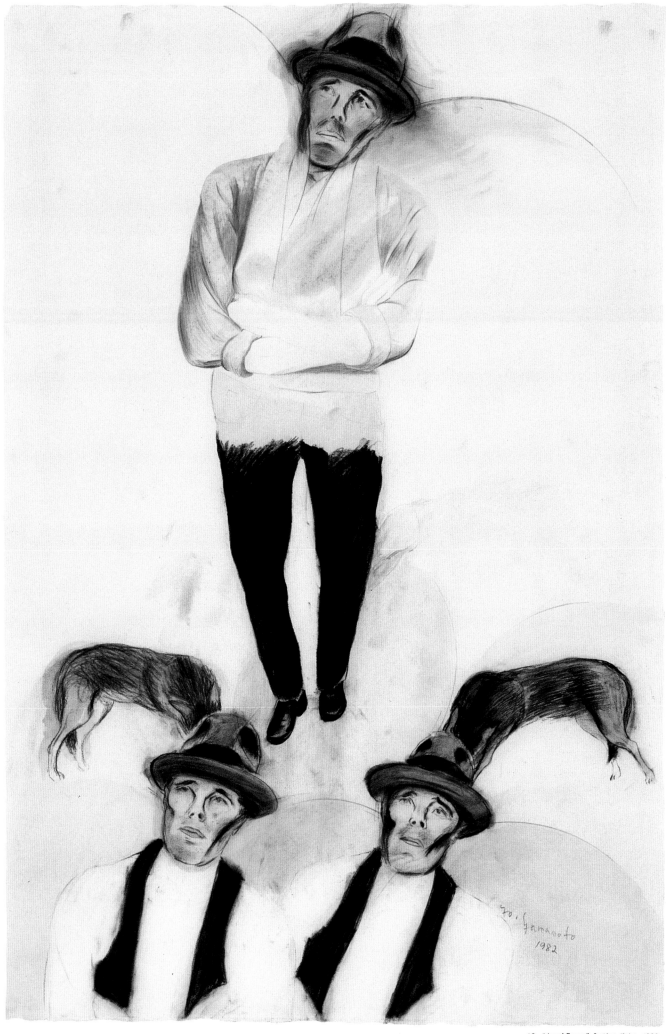

12 "Josef Beuys"「ヨゼフ・ボイス」1982

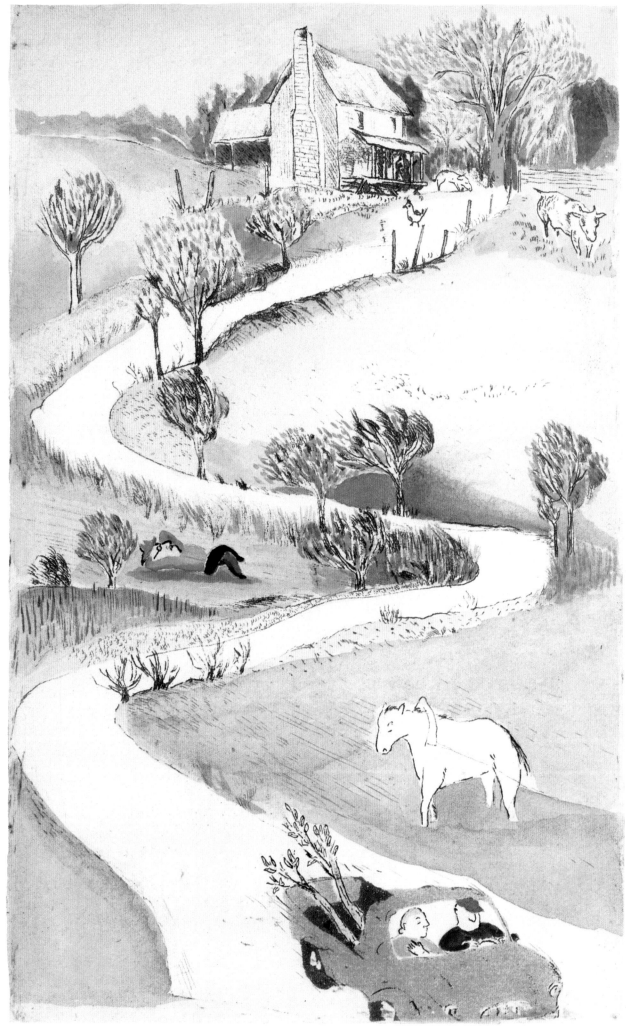

13 "I Remember Grandpa" 「おじいさんの思い出」 1988

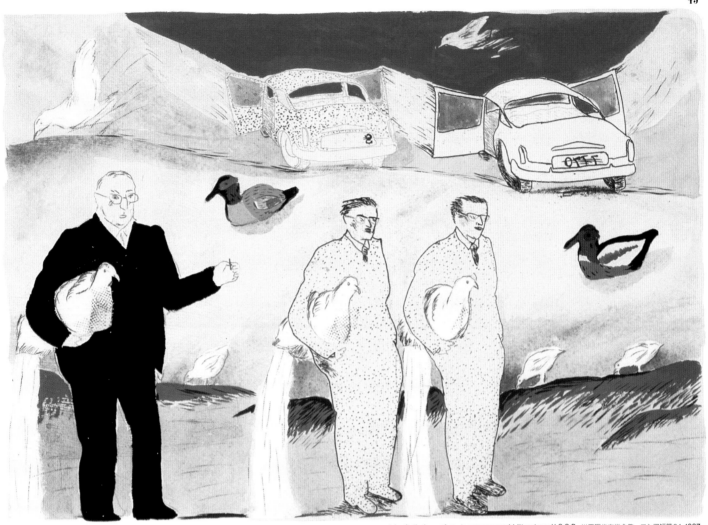

14 Anthology of contemporary world literature：U.S.S.R. 世界現代文学全集　ロシア短篇24 1987

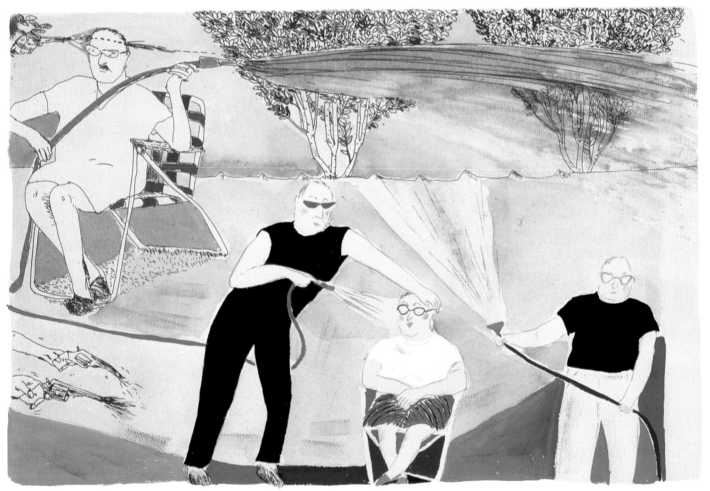

15 Anthology of contemporary world literature：U.S.A. 世界現代文学全集　アメリカ短篇24 1987

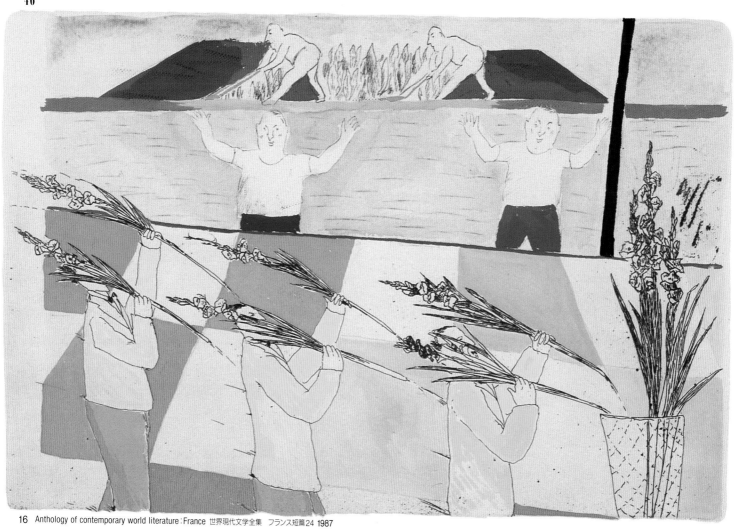

16 Anthology of contemporary world literature：France 世界現代文学全集　フランス短篇24 1987

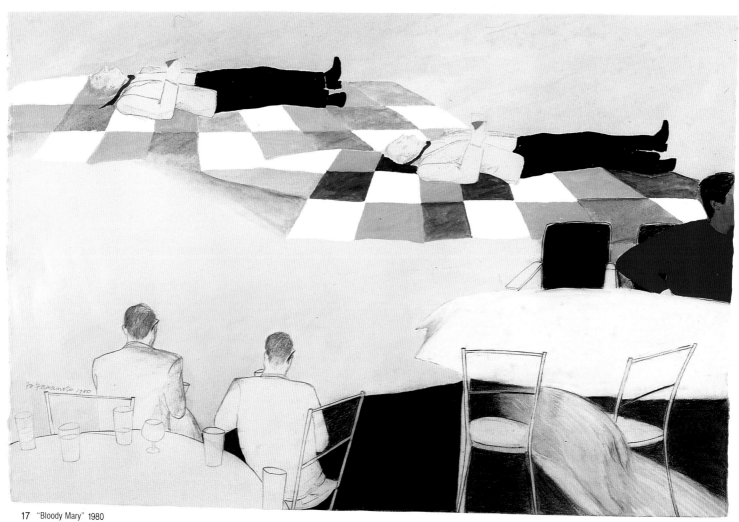

17 "Bloody Mary" 1980

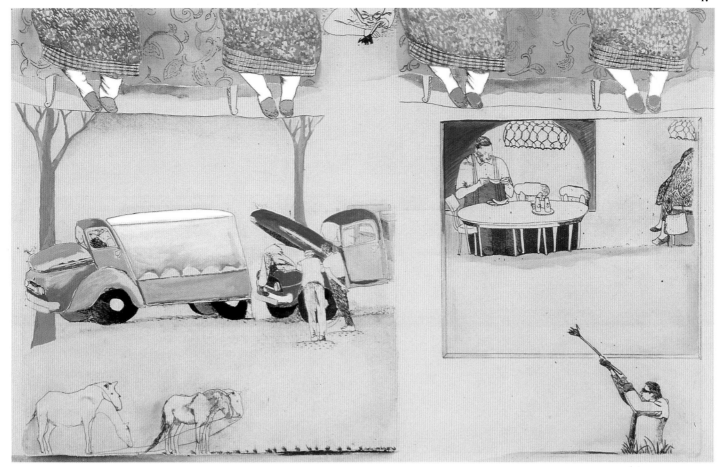

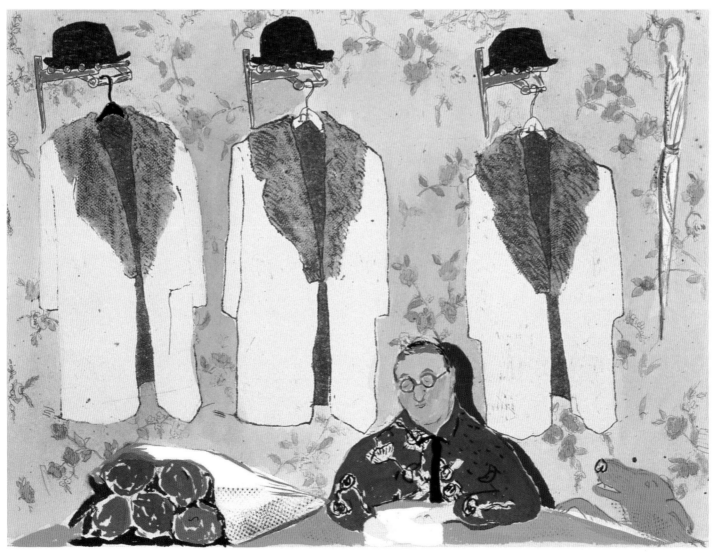

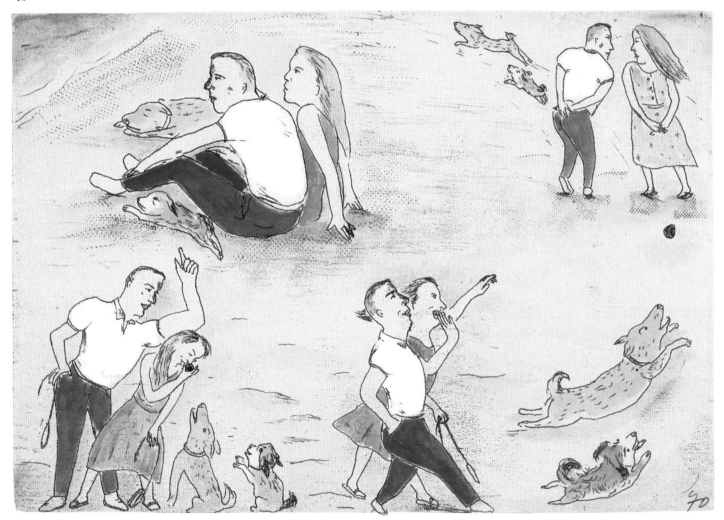

20 "Date" 1988

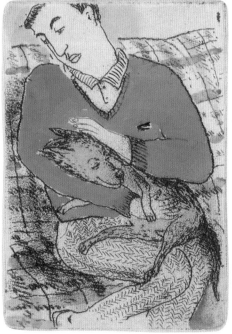

21 "June" 1988

22 "March" 1988

23 "October" 1988

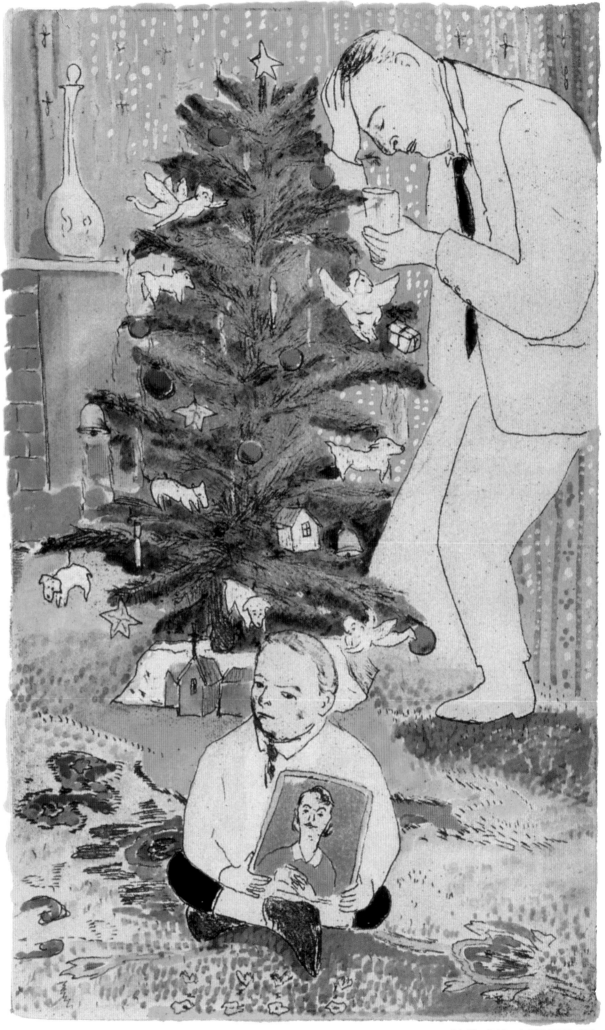

24 "One Christmas" 「あるクリスマス」 1989

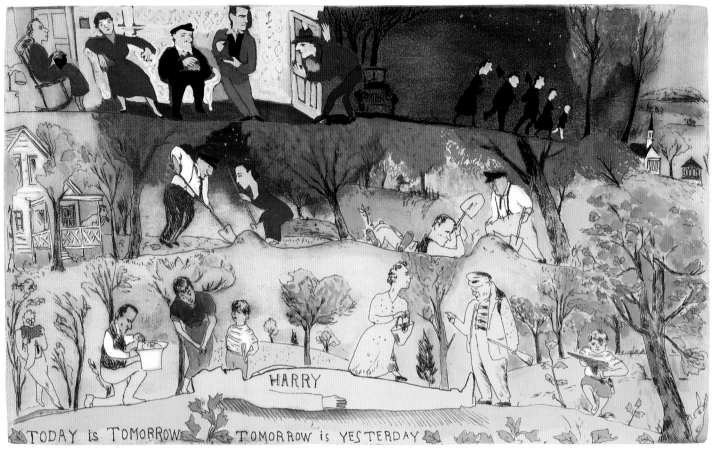

25 "The Trouble with Harry" 「ハリーの災難」 1990

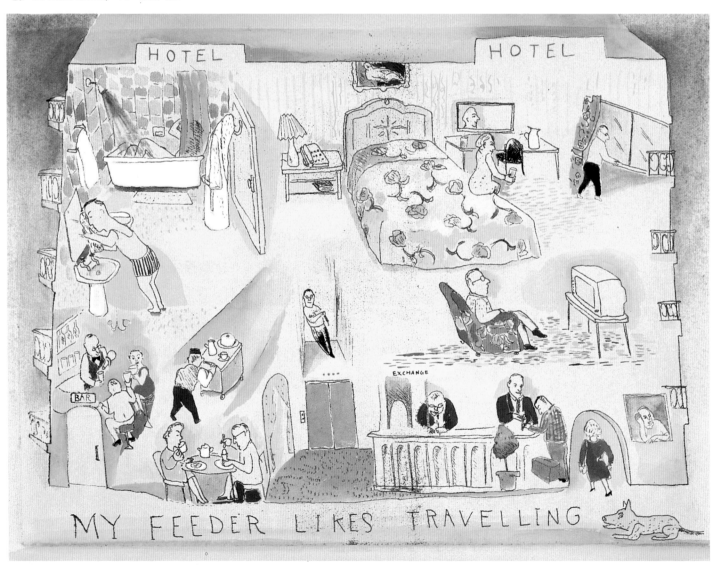

26 "My Feeder Likes Travelling" 「飼い主は旅行が好き」 1989

27 "Farm" 1988

28 "The Great Gatsby" 「偉大なギャツビー」 1989

29 "Lord of the Flies"「蠅の王」1990

30 "Transformation"「変身」1989

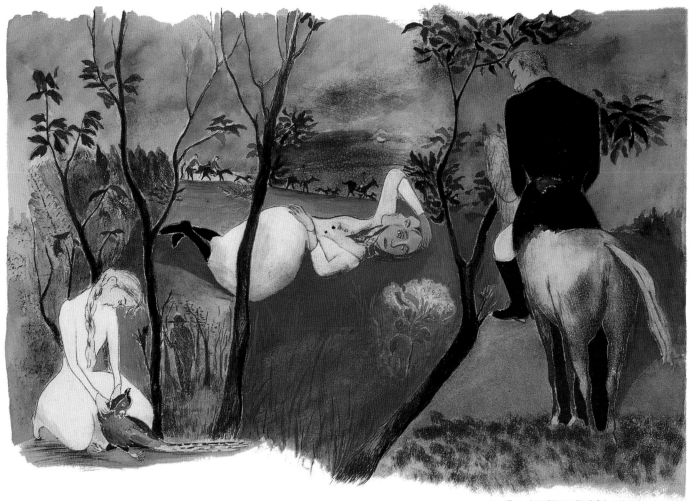

31 "Tess of the D'Urbervilles"「ダーバヴィル家のテス」1990

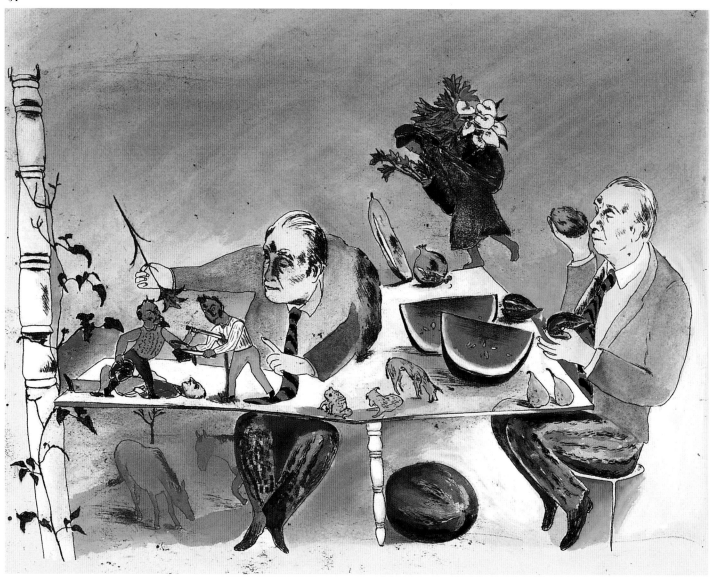

32 "The Book of Sand" 「砂の本」 1990

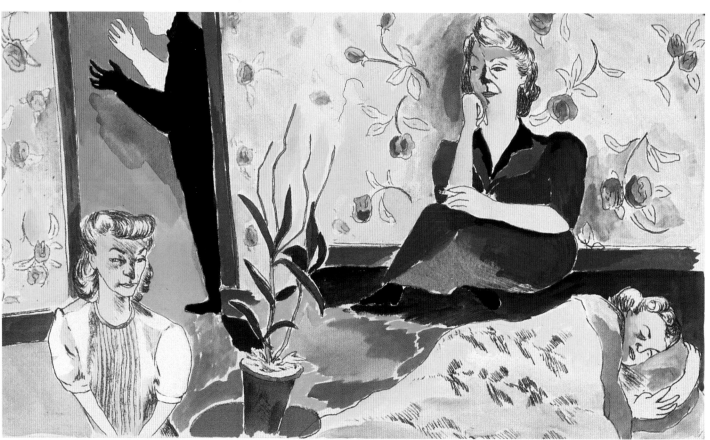

33 "Visitor" 1990

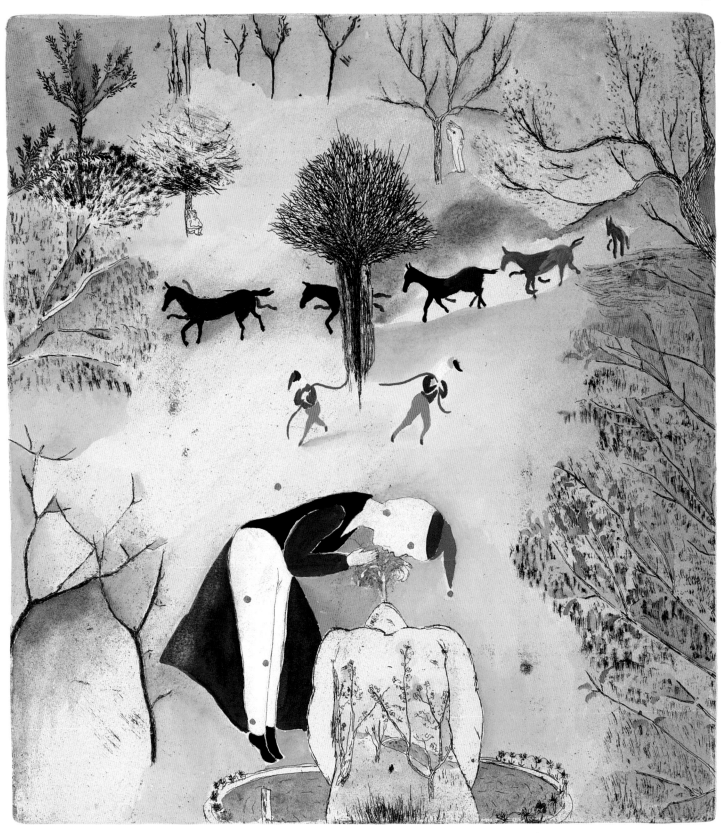

34 "The Dead Father" 「死父」 1990

MICHEL HENRICOT ミッシェル・アンリコ Painter

Shunsuke Kijima 木島俊介

Where do we come from?

Where are we going?

According to the Bible, God created man from dust and to dust he eventually returns. According to Greek mythology, humankind was created from earth and water by Prometheus.

The paintings of the French artist Michel Henricot immediately bring to mind the images of ancient lore and mythology that rest deep in the souls of contemporary Europeans. For just as the ancient Greeks deemed it natural to transmute the flesh and blood of human life or the physical images of their mythic gods to marble or silver or stone, Henricot, like a modern-day Hephaestus, transforms living flesh to metal. He does so, moreover, with chilling effect. Through his analogy, he paradoxically makes us uneasily aware of the ineffable fear lurking within us that emerges when confronted with a struggle between life and death.

Henricot says that he frequently enters deep into the recesses of a cave sequestered in darkness. There, closed off from the outside world, he sees stalactites resembling giants made of magma. He is referring, of course, to the graveyard that lies in the deepest recesses of his mind, a graveyard from which he plucks mummies and brings them back to life. His resuscitated beings are at once both dead and alive, infused simultaneously with the hard gloss of a stalactite and the colorful brilliance of human flesh. They fill us with the dreaded knowledge that metal can have life. They inspire us with the awe of seeing the first fetal movement of life in a primordial darkness. They send a disconcerting alarm to our ears like the trumpet of the Apocalypse that sounds at the moment when the dead return to the living.

Henricot's mummies are like Marsyas, half-man half-beast, before whom there appeared a deity who freed him from his shackles and breathed new life into him. In Henricot's case the task is not so simple, however. For unlike Marsyas, Henricot's mummies do not have the smooth and silky skin of Satyr but a dermis as hard and durable as marble or stalactite. And so Henricot's divine breath must be as powerful as a laserbeam, strong enough even to pierce through metal.

Yet just what are these mummies of his? Where do they come from? And where are they going?

The world of mythology offers us a glimpse into some truly strange wonders. In the days of ancient Greece, an especially glossy stone was widely believed to be a manifestation of life. The same notion was also embraced even farther back in history, in early India. Today, by contrast, life enclosed in an armor of metal is expanding our dreams to cosmic scale. Like men of those primeval times, we today can perhaps know who we ourselves are only if we know the metallic coldness of life and the human warmth of death.

Henricot's weirdly glistening mummies make us recognize the fleeting glint of happiness we have in life—a life that arises momentarily out of the inorganic deaths of ages past. Only with this knowledge in mind do we come to realize that murky darkness is the eternal resting place for which these bodies of ours are destined in *rigor mortis*.

何処より来たりて、何処へ。

『聖書』の創世記によれば、人間は神によって土のちりで創られ、命の息をその鼻に吹き入れられたのだという。そこで人間は、土を耕す者となり、死ぬとまた土にかえる。いっぽうギリシア神話においてもまた、人間はプロメーテウスによって土と水とから創られたとあるが、奸智にたけたこの神の仕業に怒った主神ゼウスが、禍のもととしてあらたに創られた人間は、鍛冶の神ヘパイストスの手になり、知の女神アテナによって白銅色の衣を着せられたとヘシオドスが記している。フランスの画家ミッシェル・アンリコの絵画を見るにつけ私は、ヨーロッパ人の心の奥に沈殿している古代神話のイメージを強く感じる。ギリシア人たちは、血肉にあつい人間や神の姿を大理石に転化させることに、いや、石や白銅から生きたものを生み出すことに違和感をもたなかったかに見えているのだが、現代のヘパイストスたるアンリコは、生身の肉体を金属に変容させるアナロジーによって、逆説的に、生の本能と死の衝動とが拮抗するところに立ちあわされる時、我々が襲われるえもいわれぬ潜在的恐怖を開示して見せているのである。

画家自身が語るところによれば、彼はしばしば、闇のうちに深い岩屋の奥に入り込み、その閉ざされた扉の奥にマグマに似た巨人のごとく鍾乳石が立っているのを見るという。奥とはもちろん心理の深層のことであろうが、そこを墓室ともみなしながら彼は、そこから一体のミイラを蘇らせてくれるのだ。

死したものでもあり、生きたものでもあるその一体はまた、鍾乳石の硬質な艶と血肉の色の輝きとをもっている。金属が血をもつことの恐ろしさ。原初の闇のなかに生きものの微かな胎動を見ることの畏怖。あるいは、死体の甦りの瞬間に鳴る黙示録のトランペット、アルファとオメガの神の顕現。

この神は半人半獣のマルシュアスのもとに現れて彼を就縛から解き、体軀に命の息を吹き込むのだが、その息吹は金属をも突きとおすレーザーの閃光でなくてはならない。なぜなら、神がかつて剝ぎ取ったこの敗者の皮は、サテュロスの柔らかな毛皮ではなく、鍾乳石か大理石の硬いからだったからだ。

さてこのミイラは何者なのだろう。彼は何処よりきたりて、何処へゆかんとしているのか？

神話世界は私たちにまことに不思議なものごとをかいま見させてくれる。ギリシアではしばしば、一つの艶やかな石が生の本能の顕現であったし、これはまた、もっと太古のインドにおいても同様であった。現代では逆に、生命を閉じ込めた金属の鎧が宇宙ひろしと我々の夢を浮遊させているのではないか。我々も原初の人に倣って、生の本能のわきに金属の冷たさを、また死の衝動のわきに血肉のぬくもりを接しておかなければ、おそらく、己が何者なのかを知ることができないのであろう。

無気味に輝きを発しているアンリコのミイラは、太古よりの無機質の死のなかに発生した我々の生命のほんの一瞬の僥倖を思わせるかとも見えれば、暖暖たる闇こそが、この硬直を強いられた肉体のゆきつく永劫の安息地であるかにも見せているのである。

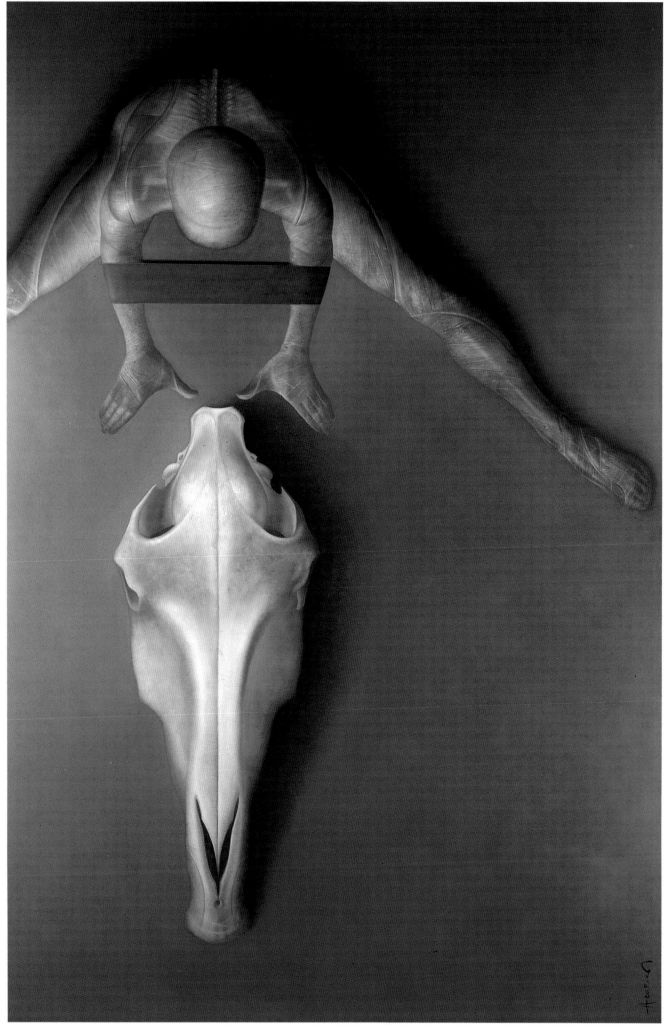

1 "The Annunciation"「受胎告知」1985

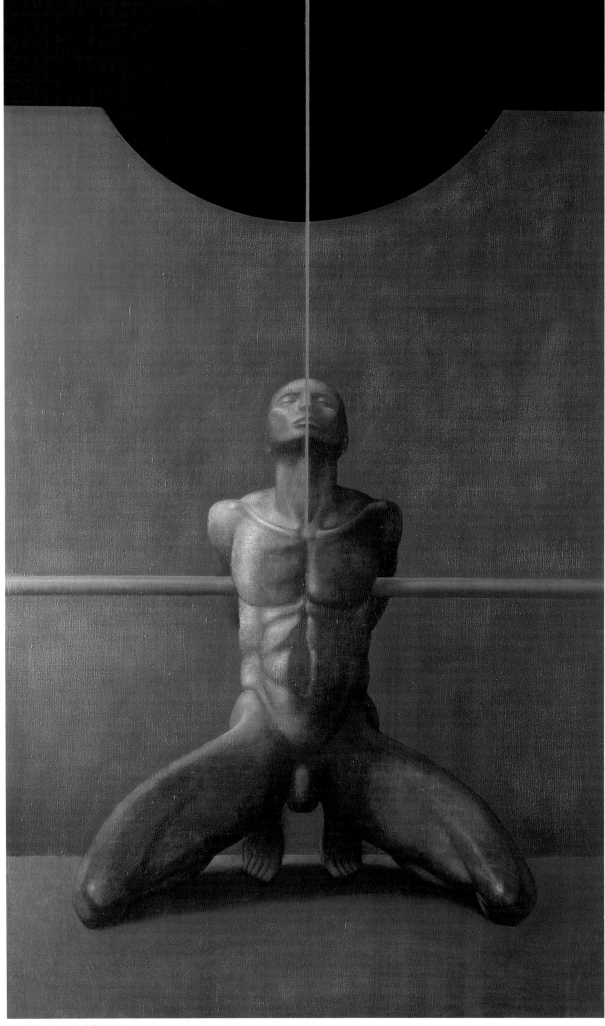

2 "Divine Revelation" 「天啓」 1986

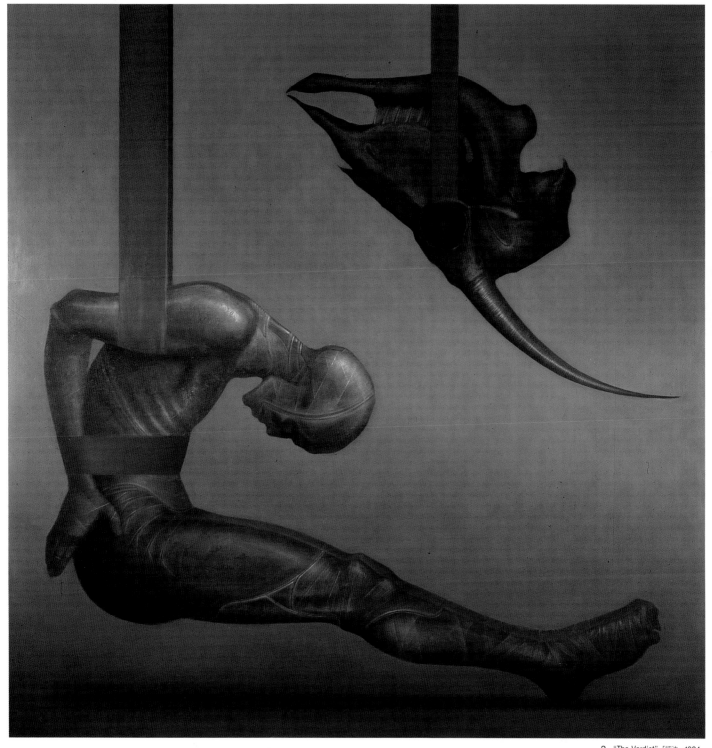

3 "The Verdict" 「評決」1984

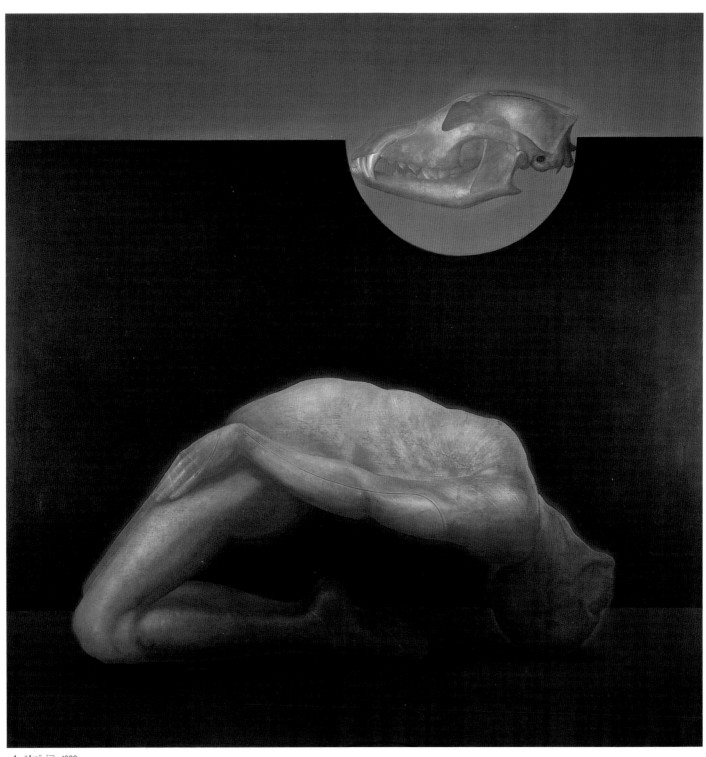

4 "Arc" 「弓」 1983

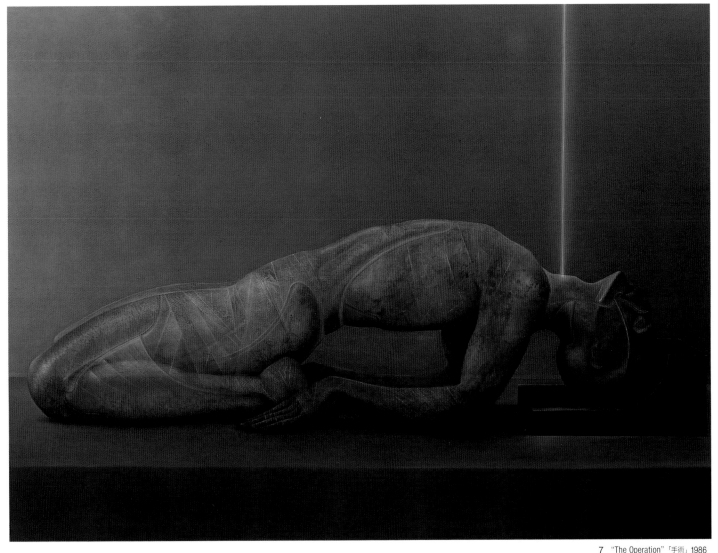

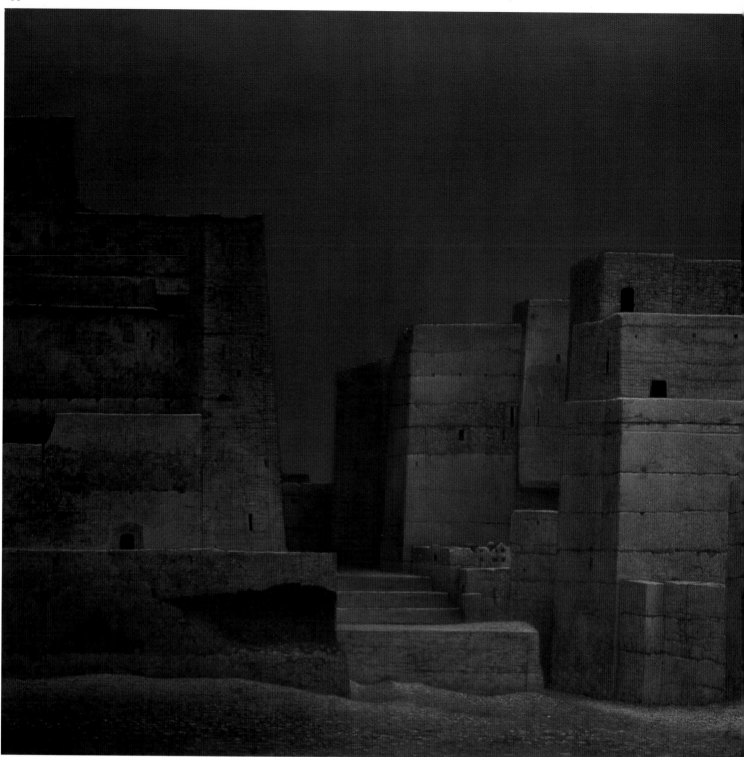

8 "The City" 「町」 1989

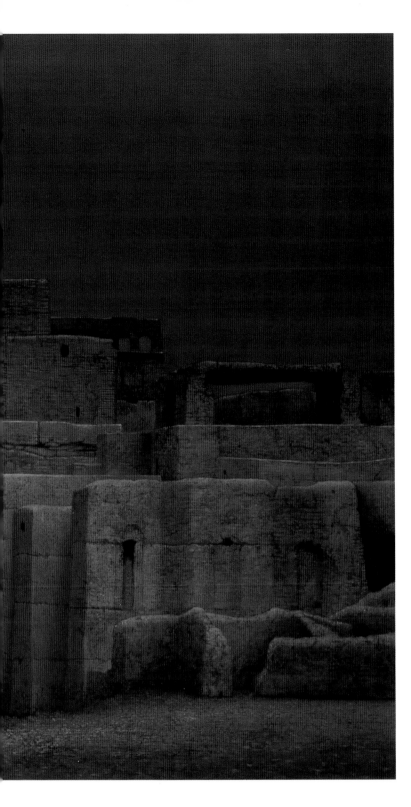

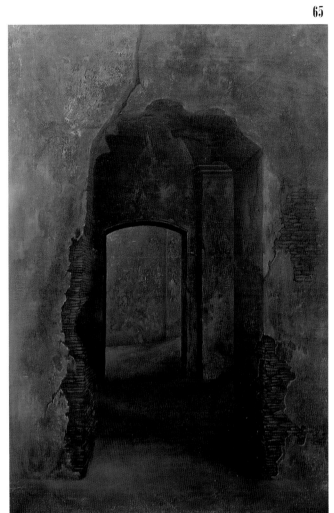

9 "Portal" 「門」 1987

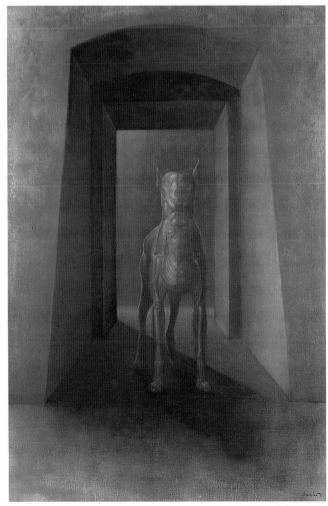

10 "On Guard" 「門番」 1987

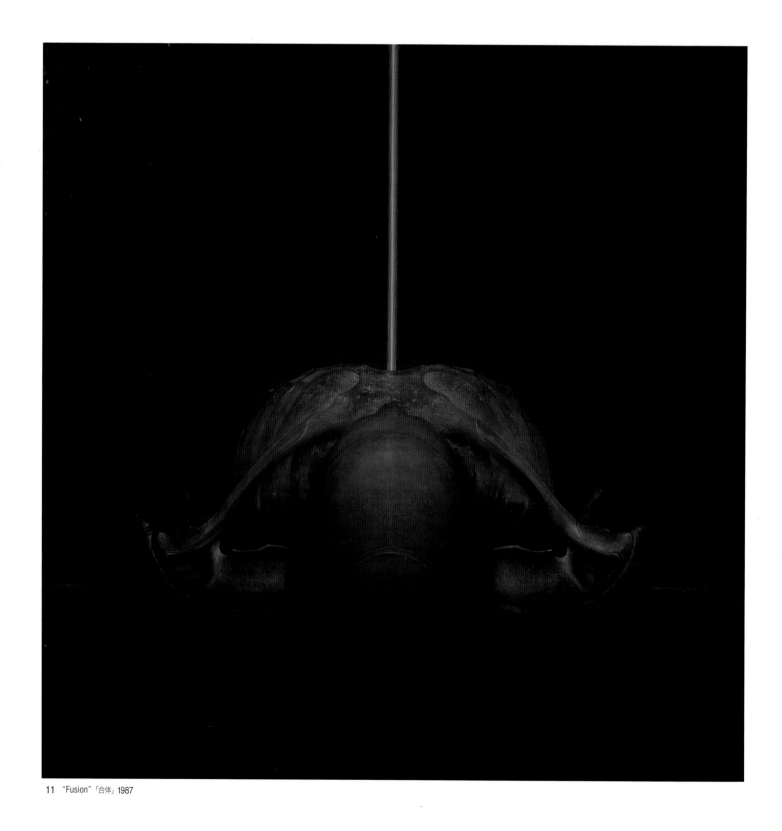

11 "Fusion"「合体」1987

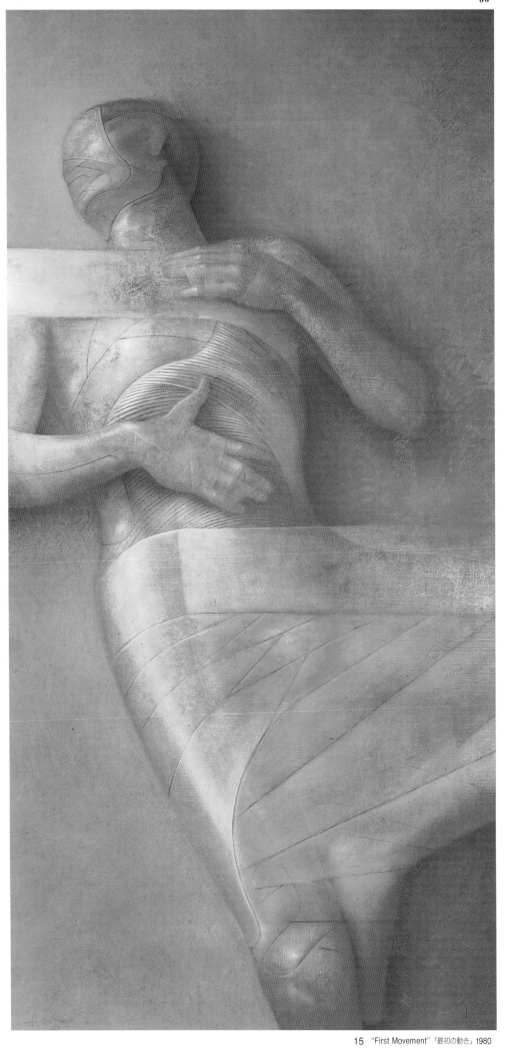

15 "First Movement"「最初の動き」1980

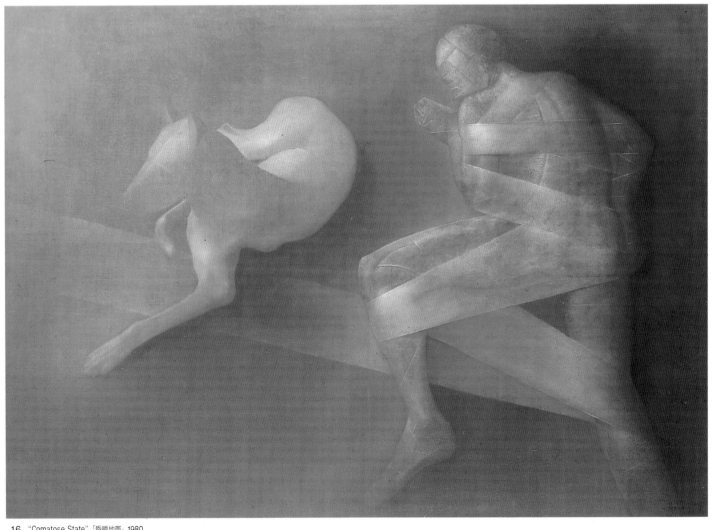

16 "Comatose State" 「昏睡地帯」 1980

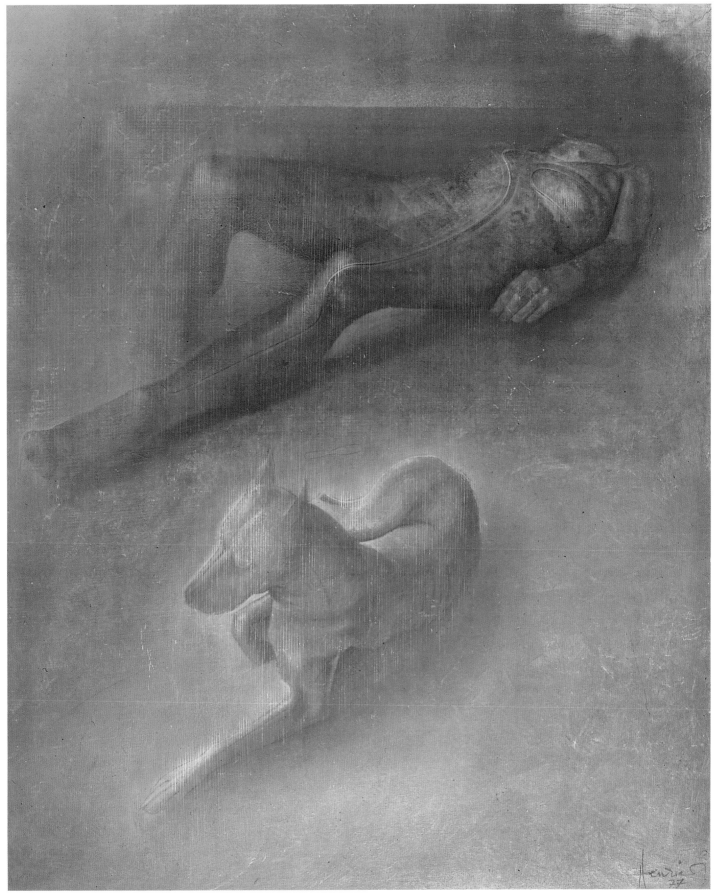

17 "Preliminary Sketch" 「習作」1980

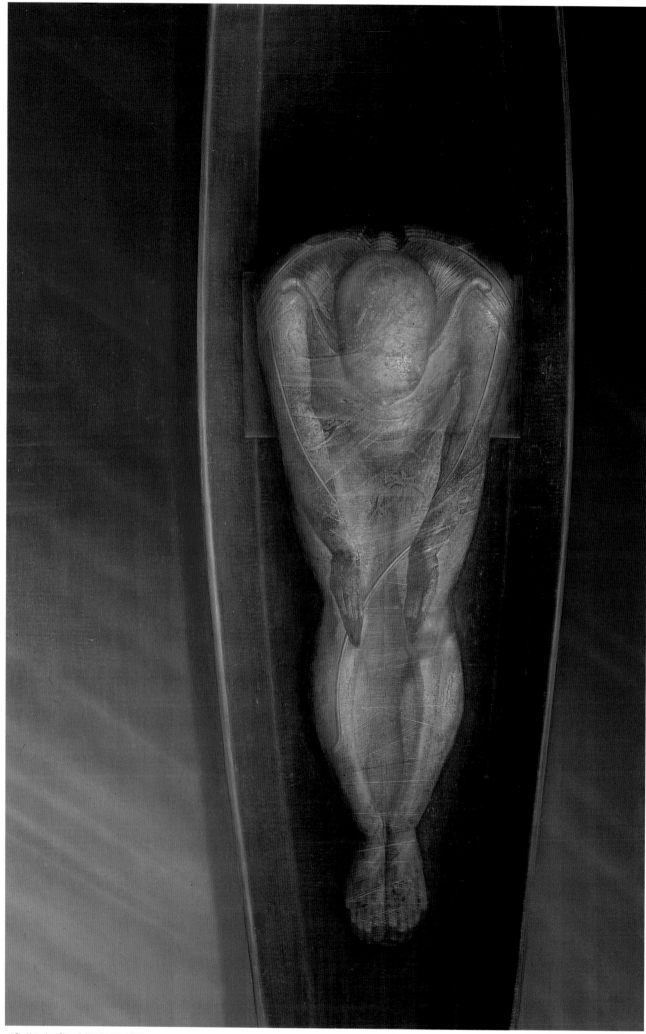

18 "Leaving Shore"「岸を離れて」1985

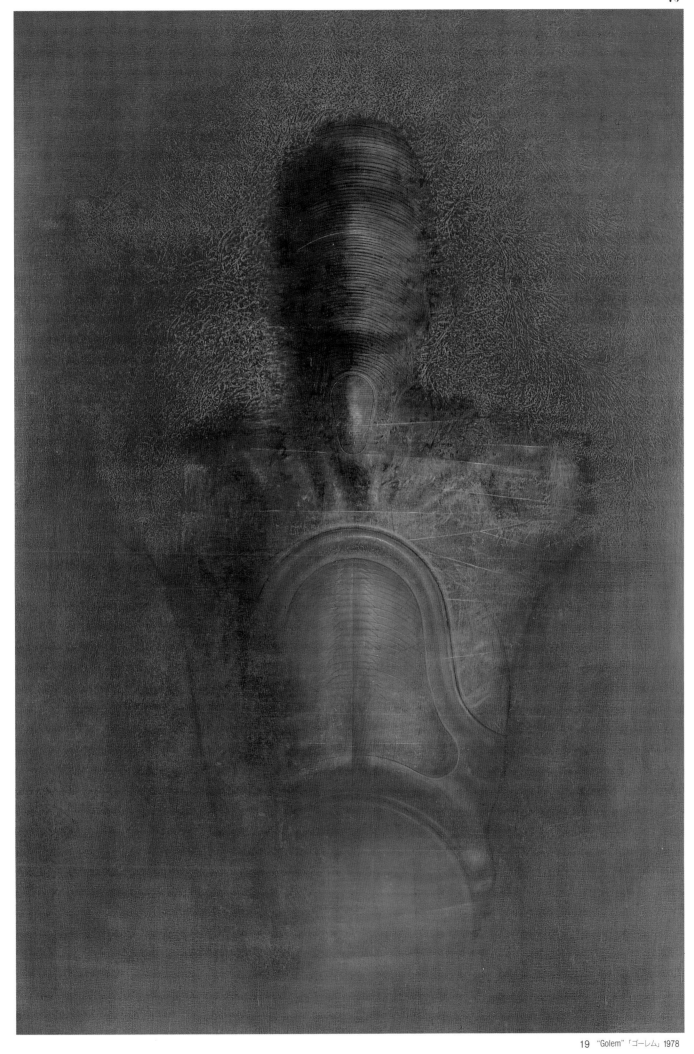

19 "Golem" 「ゴーレム」 1978

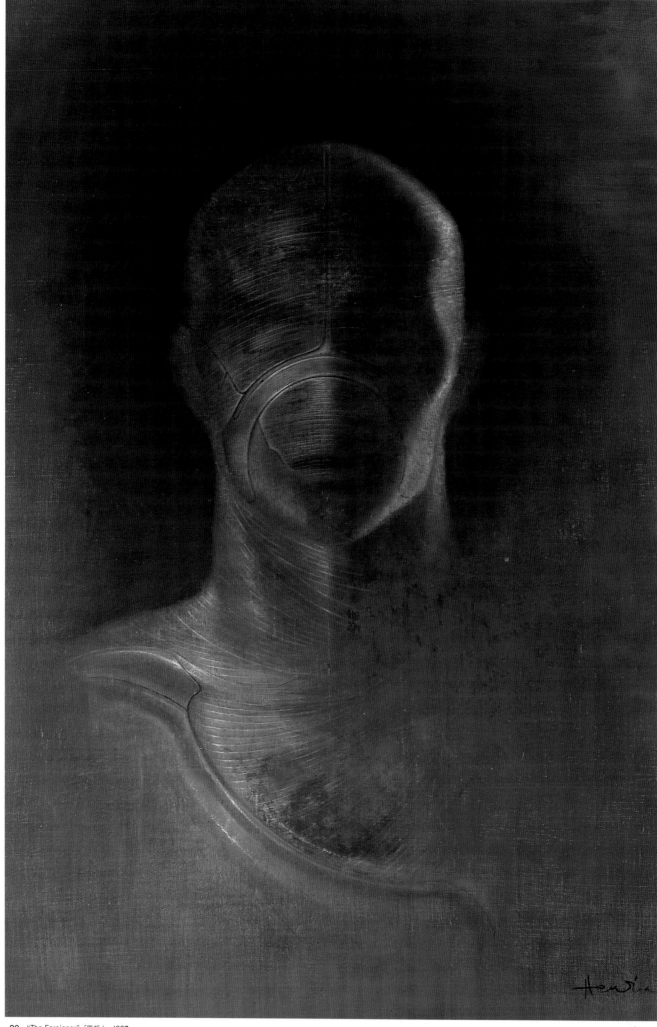

20 "The Foreigner" 「異邦人」 1987

GRAPUS グラピュス

Alain Weill アラン・ヴェイユ

After the generation of Savignac and André François, the leading influence in France's graphic world in more recent years has been Grapus. This group, which uses a purely invented name, was founded in 1970 by three former members of the "atelier populaire n°3" which arose during the 1968 student riots: Pierre Bernard, Gérard Paris-Clavel and François Miehe (who resigned in 1979). Jean-Paul Bacholet and Alex Jordan, from Germany, joined in 1975.

The foremost characteristic of Grapus is that its members engage in collective creation. They produce their images after discussing them together through the whole creative process. This is especially meaningful as Grapus works in the field of political, social and cultural communication.

Being basically communists, Grapus's members have worked for the Communist Party, the C.G.T. (a labor union with a communist bent), the fights against the Vietnam War and for Palestinian rights, and for every global event connected with the defense of human rights.

At the same time, Grapus has created posters and whole visual images for cultural associations and public theatres. It is only recently that the group has dealt with major institutional assignments such as communication design for la Villette and the Louvre Museum.

Bernard and Paris-Clavel both spent one year in Poland studying with Henryk Tomaszewski. This experience had a profound influence on them and induced them to undertake something totally different from what was then being done in France. The style they developed is violent and aggressive, yet also humorous and playful—a mixture of provocation and tenderness. They employ a mix of graphics and photography which they then "pollute," introducing interferences into the image with the text. All this, of course, is cleverly organized, and the obvious mess is in fact a way to draw the attention of, and play with, the public.

Working for clients who could not afford to buy advertising space, Grapus has found a way for its works to be noticed even if they are posted in inconspicuous locations. Their visual world succeeds in attracting the eye.

With this warm and popular approach, Grapus is interested not only in posters but also in numerous ephemera: leaflets, stickers and buttons that it likes to spread around. This approach to global communication allows the members of the group to be sure that, when working for a client, any document issued by the client—even a simple letterhead—will be very strictly and carefully designed.

This paradoxical mixture of gross provocation and sophisticated graphic design has molded Grapus's style. It is a system that works brilliantly because behind it lies a strong ideological background, a belief in man and the fight for a better world.

Year after year Grapus has welcomed many trainees into its fold. It has also taken part in most international events around the world. As a consequence, Grapus has had a key influence on the evolution of France's graphic school through the past 20 years.

サヴィニャック、アンドレ・フランソワの次世代として、近年フランスのグラフィック界に最大の影響を及ぼしているのがグラピュスである。グラピュスという新しく造られた名を持つこのグループは、1970年にピエール・ベルナール、ジェラール・パリ＝クラヴェル、フランソワ・ミエ（1979年に脱退）によって結成されたが、もともと彼らは、1968年学生運動の最中に誕生した「アトリエ・ポピュレール・ヌメロ・トロワ」のメンバーであった。1975年にはジャン＝ポール・バショレとドイツ出身のアレックス・ジョルダンがグループに参加した。

グラピュス最大の特徴は、メンバーが共同で制作を進めていく点である。全過程を通じ、全員が話し合って制作をする。これは政治的、社会的そして文化的コミュニケーションの分野で活躍するグラピュスの作品にとって、特に重要なことなのである。

大体において共産主義者であるグラピュスのメンバーは、共産党やCGT（共産主義労働組合）、ベトナム反戦運動、パレスチナ解放運動など、世界的な人権擁護運動に向けて活動をしてきた。

また同時に、文化団体や公立劇場などのポスターやヴィジュアル・イメージを制作してきた。ラ・ヴィレットやルーブル美術館のような大きな機関の仕事をするようになったのは、ごく最近のことである。

ベルナールとパリ＝クラヴェルの2人は、ポーランドのヘンリク・トマシェフスキーの下で1年学んでいる。この経験は2人には多大な影響を与え、当時のフランスとしては全く異質なものをつくり出させたのである。彼らがつくったスタイルは、過激で攻撃的である一方、ユーモラスで遊び心がいっぱい。挑発と優しさの混ざりあいなのである。彼らは、グラフィックと写真の両方を使った絵に文字を入れ、それを今度は妨害するかのごとく「汚して」いる。もちろんこれは巧妙に施されているのだが、この乱雑さが大衆を惹きつける方法であり、また大衆との戯れなのである。

グラピュスは広告スペースを買う余裕のないクライアントと仕事をするなかで、作品が目立たぬ場所で貼られても注目されるような方法を見出した。彼らのビジュアルの世界は人目を引くことでいつも成功するのである。

この心暖まる、大衆的なアプローチを、ポスターだけでなく、リーフレット、ステッカー、ボタンなどありとあらゆるものに応用しようとした。このグローバルなコミュニケーションによったことで、メンバーたちは、クライアントが発信するどんな文書でも（単なるレターヘッドであっても）厳しく丁寧にデザインするようになったのである。

この過激な挑発と洗練されたグラフィックデザインという全く逆のものとの共存が、グラピュスのスタイルをかたちづくっている。それは、強いイデオロギー、人間への信頼、そしてより良い世界を目指す戦いといったものがその背景にはあるからこそ、活きてくるのである。

グラピュスは年々多くの研修生を迎えるようになり、また、国際的なイベントにも関わるようになってきた。その結果、この20年を通じて、グラピュスはフランス・グラフィック界の革命に、その鍵となるような影響を及ぼしてきたのである。

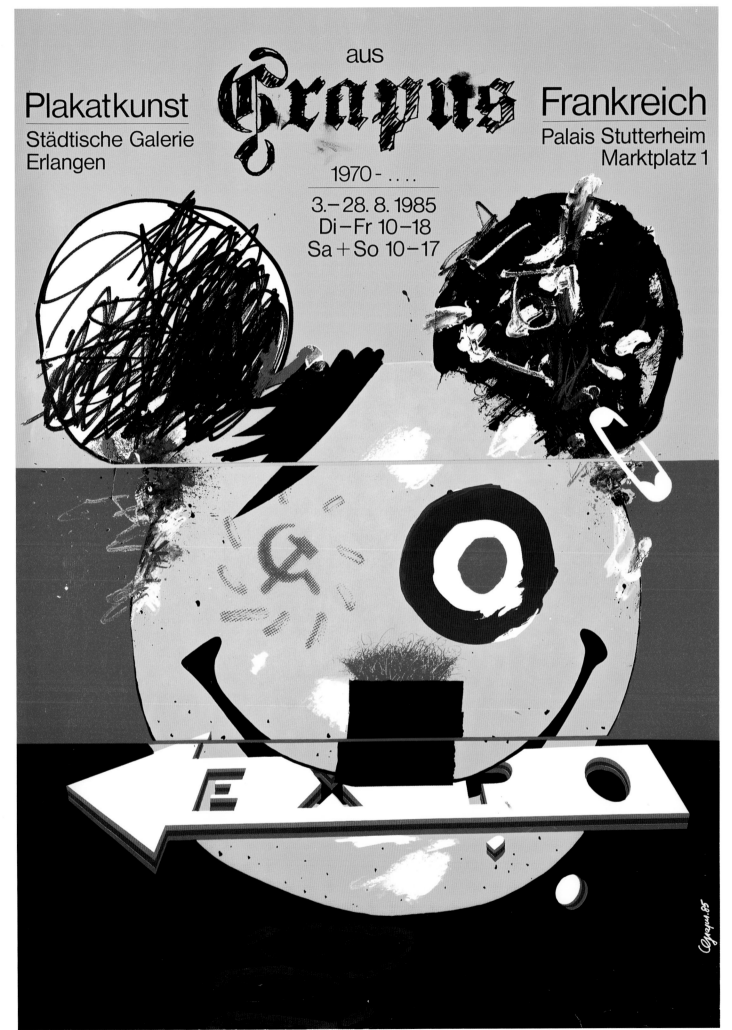

2 Poster for children's show 子供のためのショーのポスター 1981

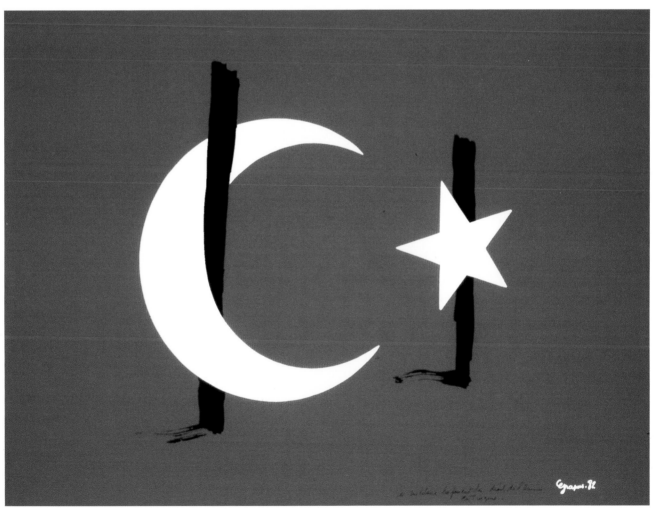

PCF 20 décembre 1980 / 60ème anniversaire du Parti Communiste Français
comité de ville du Blanc-Mesnil

3 Poster in commemoration of 60th anniversary of French Communist Party フランス共産党60周年記念ポスター 1980

4 Poster promoting festival celebrating friendship between France and Turkey トルコーフランス友好文化祭ポスター 1982

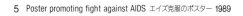

5 Poster promoting fight against AIDS エイズ克服のポスター 1989

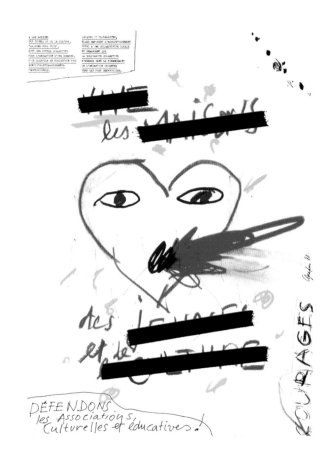

7 Poster to save a cultural organization 文化団体救済ポスター 1983

6 Anti-apartheid poster 反アパルトヘイトポスター 1988

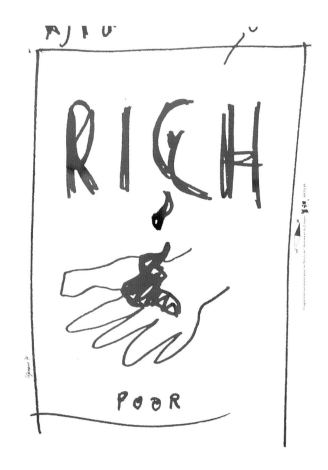

8 Human rights poster 人権ポスター 1989

9 Poster for Grapus exhibition グラピュス展ポスター 1988

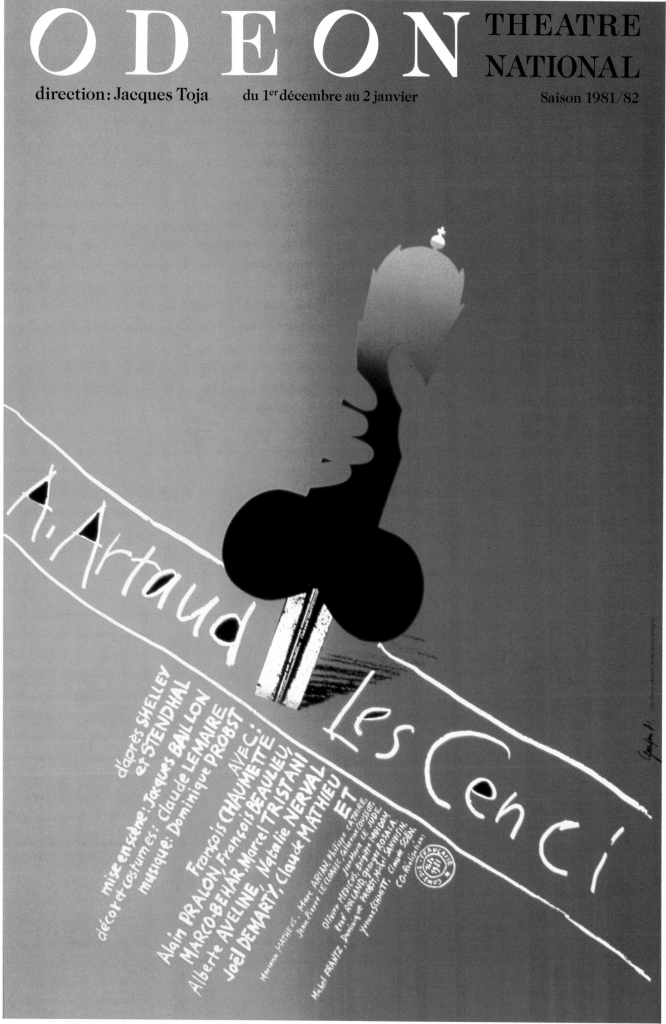

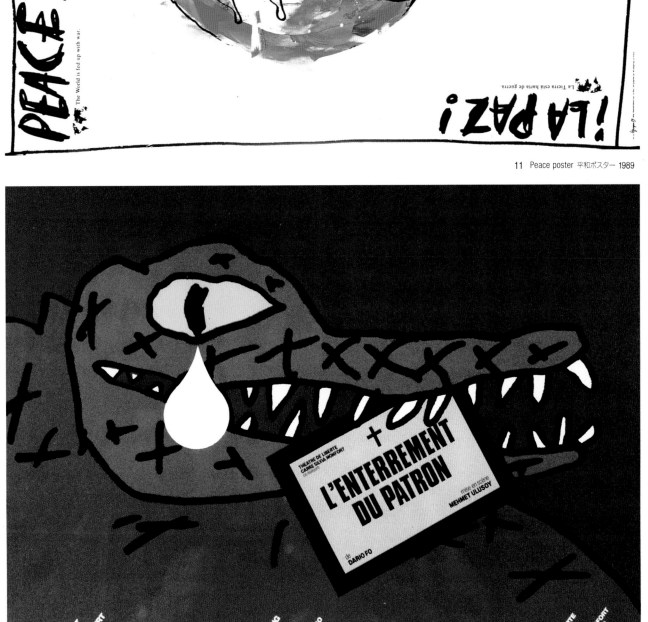

11 Peace poster 平和ポスター 1989

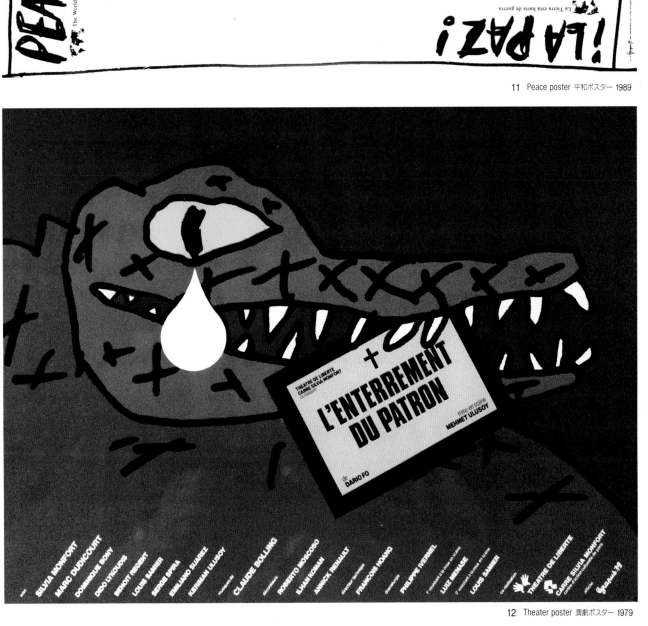

12 Theater poster 演劇ポスター 1979

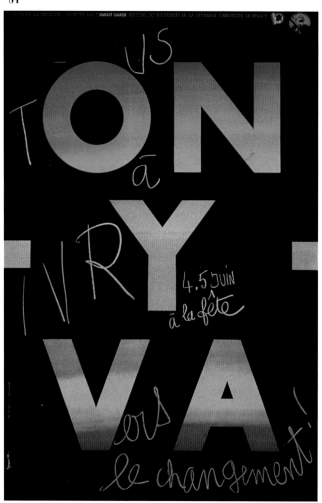

13 Poster promoting Communism 共産主義のポスター 1977

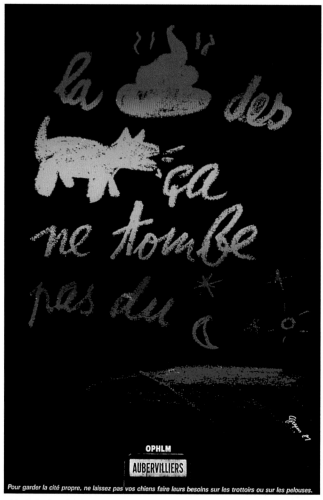

14 Poster for urban beautification 町の美化ポスター 1981

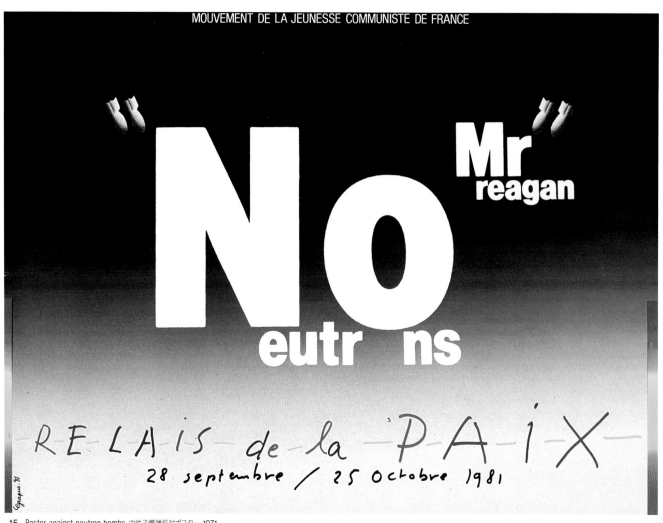

15 Poster against neutron bombs 中性子爆弾反対ポスター 1971

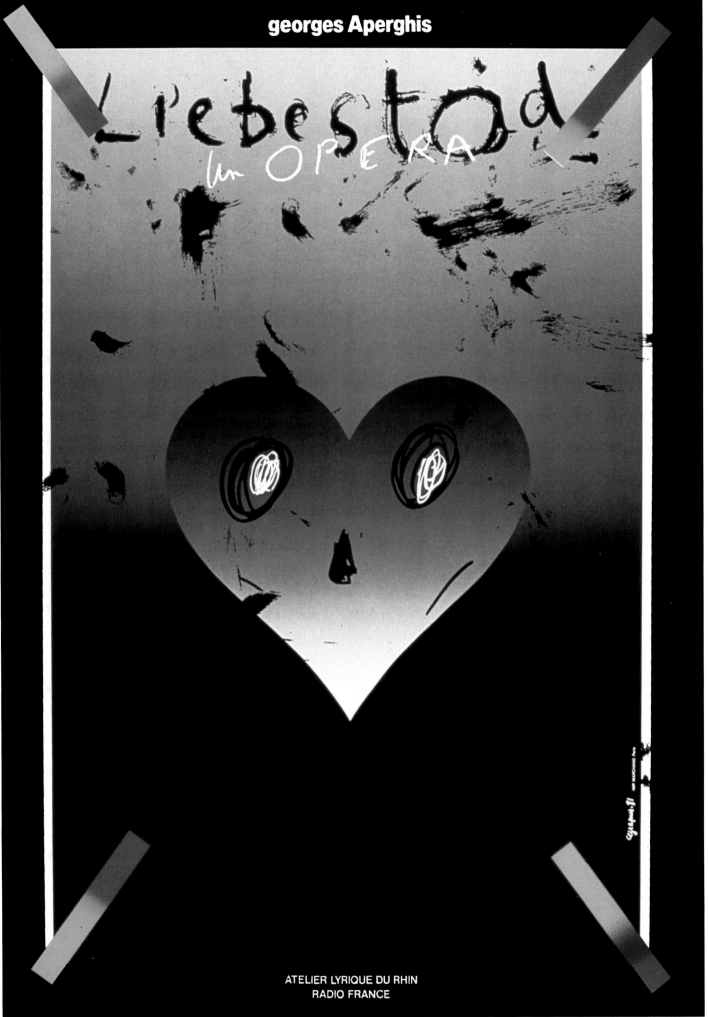

georges Aperghis

Liebestod
un OPERA

ATELIER LYRIQUE DU RHIN
RADIO FRANCE

16 Opera poster オペラポスター 1981

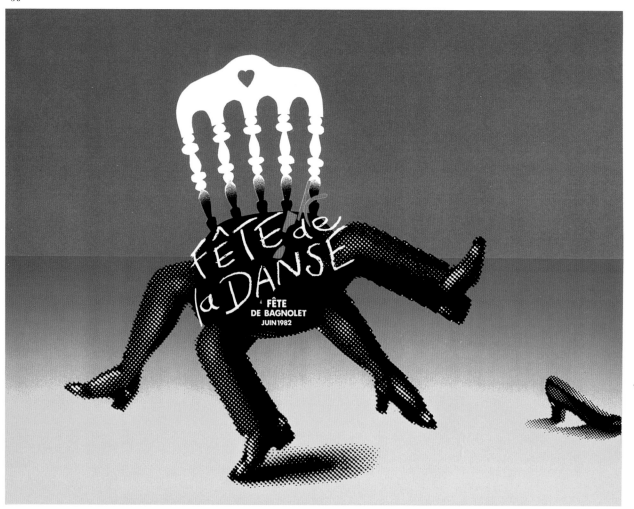

17 Poster for dance festival ダンス祭ポスター 1982

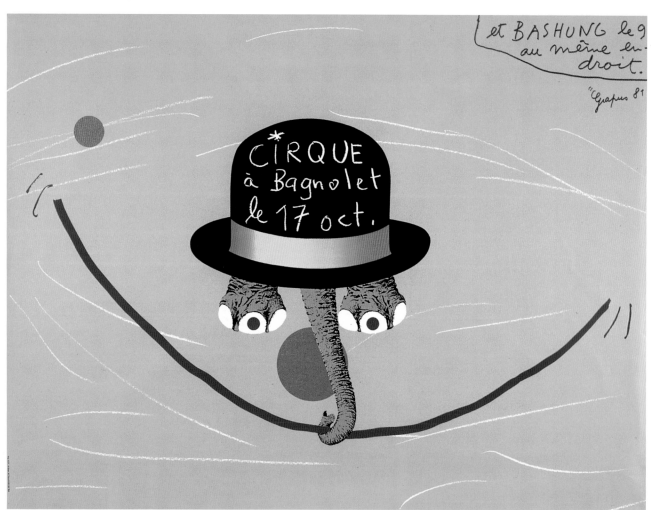

18 Promotional poster イベントポスター 1981

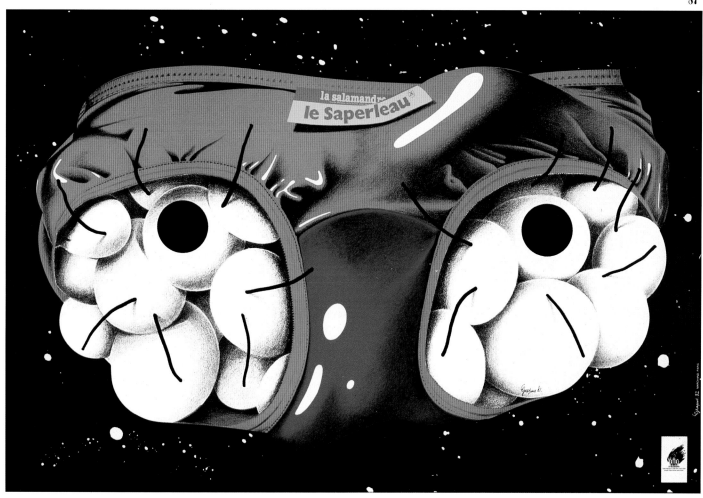

19 Theater poster 演劇ポスター 1981

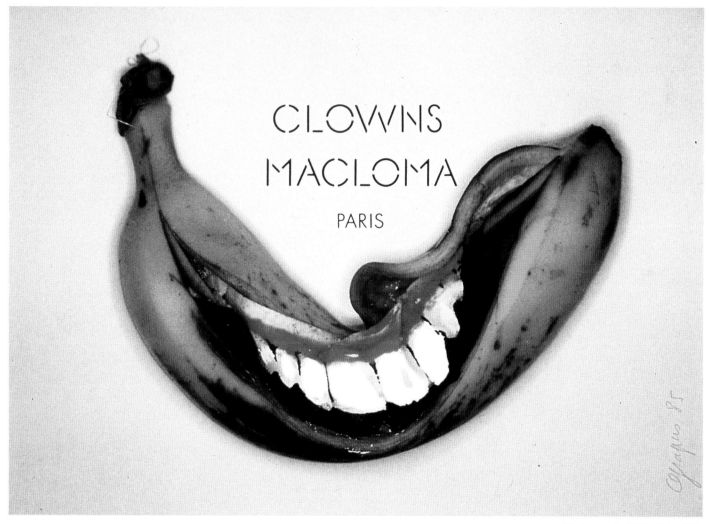

20 Clown poster 道化師のポスター 1985

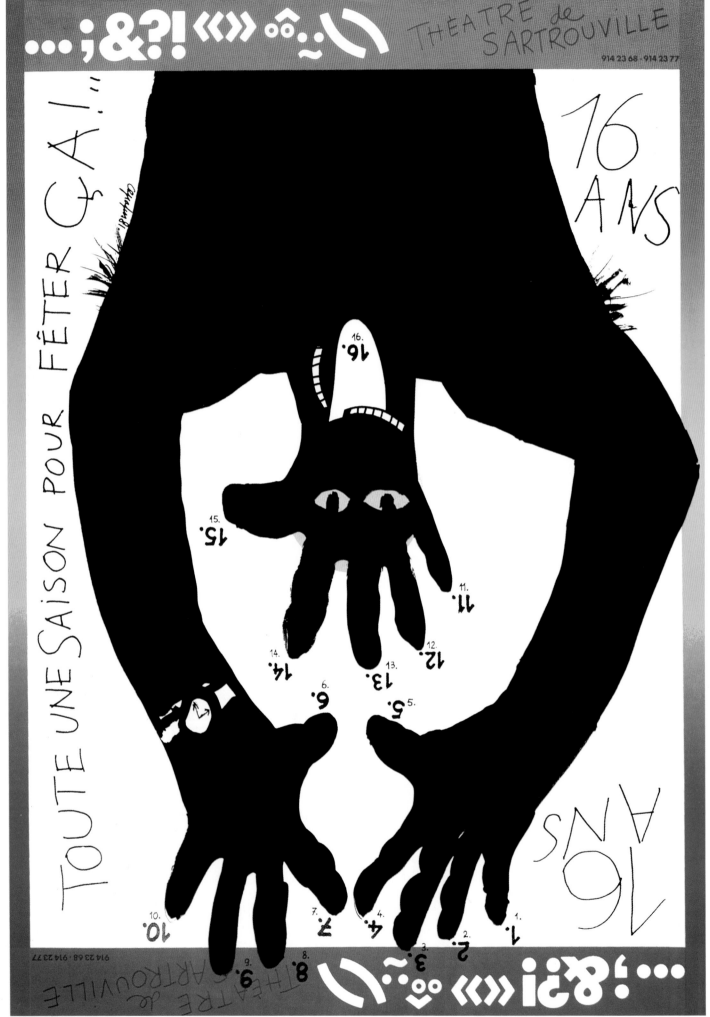

21 Poster commemorating 16th anniversary of a theater 劇場16周年記念ポスター 1981

22　Poster for one-man show　個展ポスター　1981

23　Theater poster　演劇ポスター　1986

24　Theater poster　演劇ポスター　1980

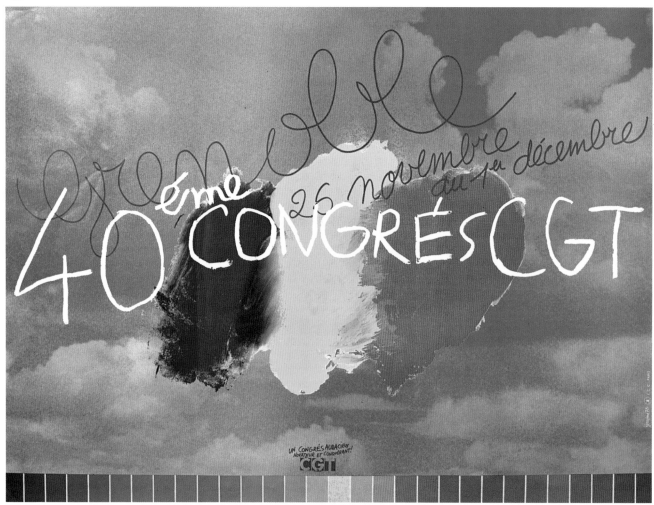

25 Poster for labor confederation congress 労働総同盟総会のポスター 1976

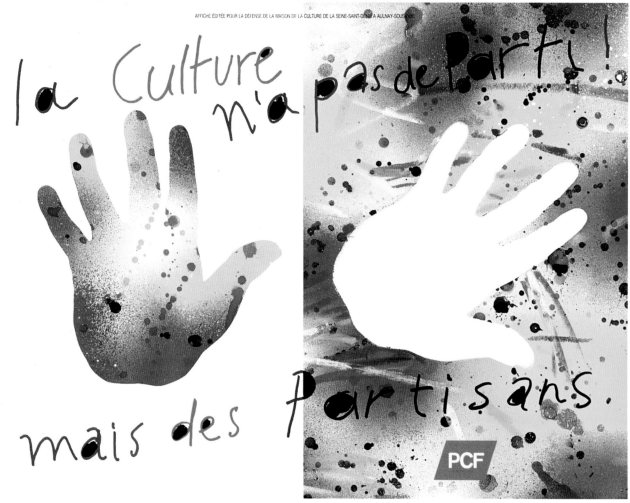

26 Poster in support of cultural center 文化センター支援のポスター 1984

27　Poster promoting technological exhibition　科学技術展ポスター　1982

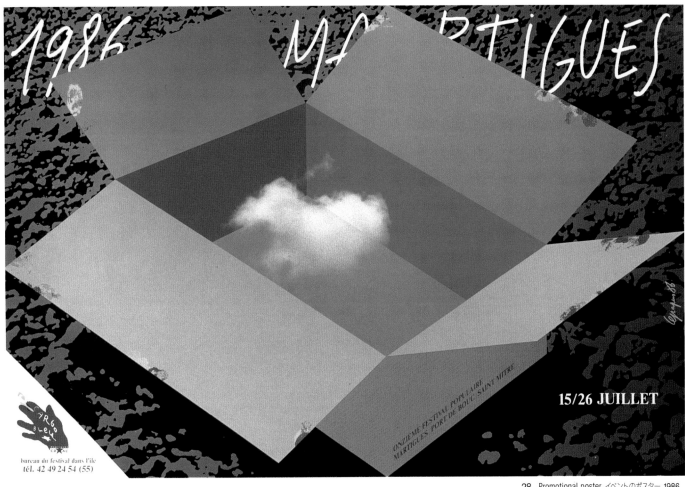

28　Promotional poster　イベントのポスター　1986

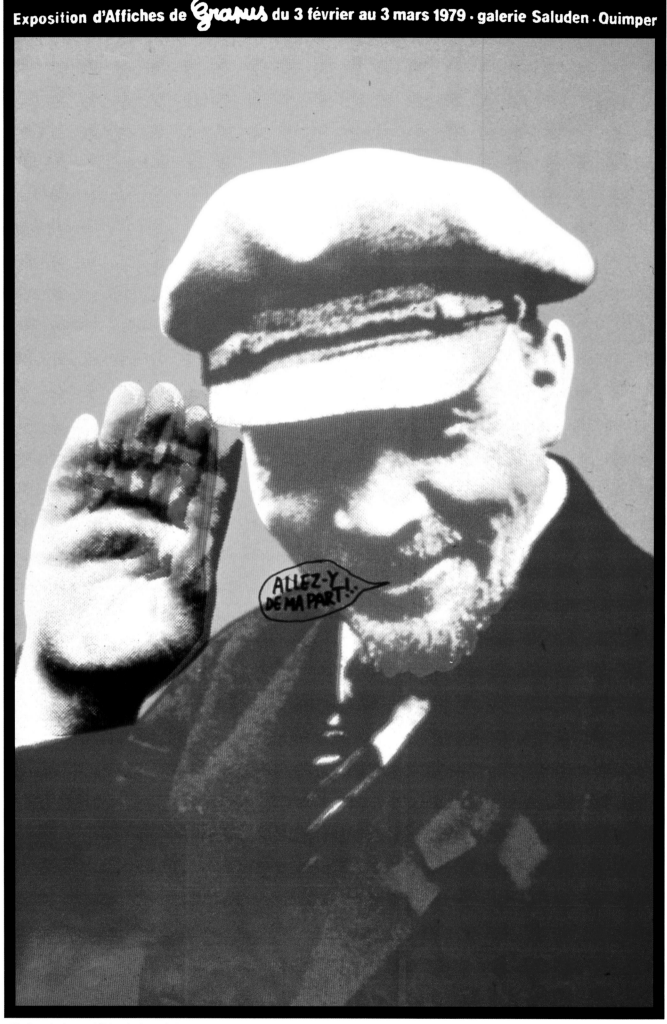

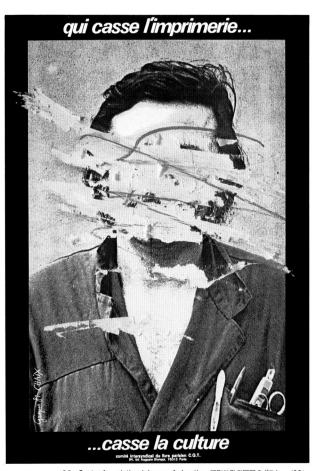

30 Theater poster 劇場ポスター 1988

32 Poster for printing labor confederation 印刷労働者同盟のポスター 1981

31 Theater poster 演劇ポスター 1981

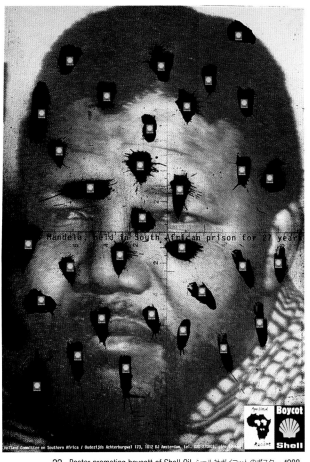

33 Poster promoting boycott of Shell Oil シェル社ボイコットのポスター 1988

34 Poster for exhibition on bourgeois-class families　ブルジョワ家族展のポスター　1984

35 Poster for citizens' action campaign　市民活動のポスター　1989

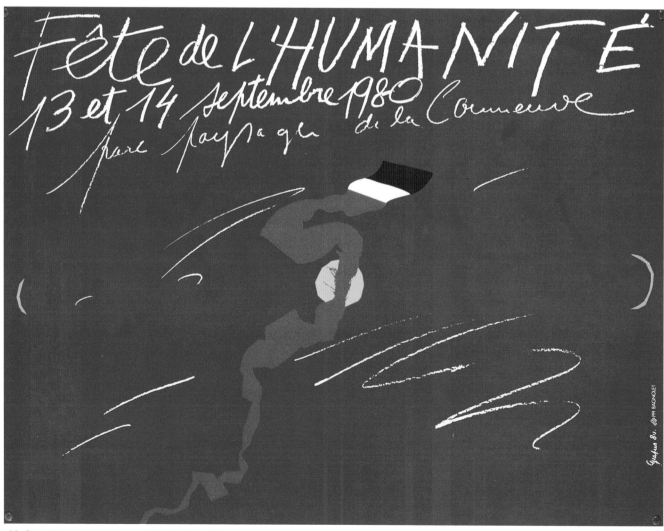

36 Poster for humanity festival　ヒューマニティ祭のポスター　1980

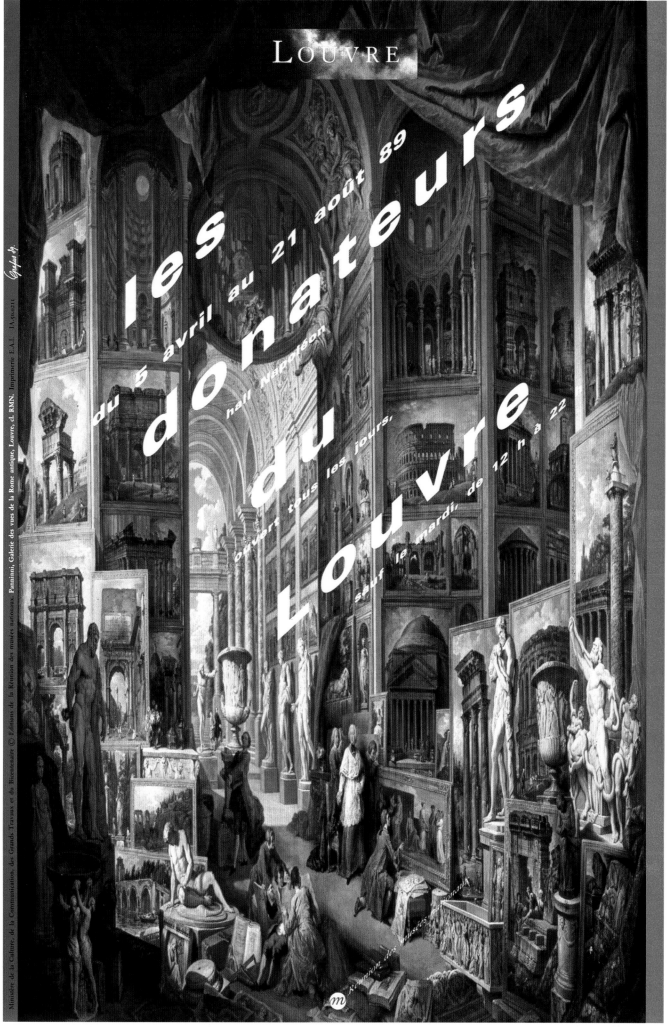

LOUVRE

les donateurs du Louvre

du 5 avril au 21 août 89

hall Napoléon

ouvert tous les jours,

sauf le mardi, de 12 h à 22

38 Poster for Grapus exhibition グラピュス展ポスター 1988

IIeme

Festival d'Automne
Mont Fermeil

1981

39 Festival poster 自治祭のポスター 1981

ITALO LUPI イタロ・ルピ

Tetsuro Itoh　伊藤哲郎

I had the pleasure of meeting Italo Lupi at a dinner party given by Mario Bellini, who introduced Lupi as his "most important friend." Prior to the occasion I was already familiar with Lupi by name; yet I was taken aback to discover this world-renowned graphic designer to be a man with a serious, erudite air, like that of a philosopher or college professor. Then I recalled that Lupi had a university background in architectural science, and everything fell into place. Lupi may in fact be the only Italian graphic designer who started as an architect.

Of late Lupi has won much acclaim for his work designing the cover of *Domus*, the world-class architectural magazine. In a creative coup, for his first assignment Lupi introduced small holes in the cover that offered random glimpses of the colorful facade of Milan's Lambrate Station, a project of Ignazio Gardella. What Lupi achieved thereby was a three-dimensional world in a two-dimensional medium—an idea conceivable only by someone with a strong background in architecture.

Of course, Lupi's involvement with *Domus* has not been limited to cover design. He has also brought fresh, dynamic changes in overall layout as well, applying his genius in editorial design to both typography and pictorials. In the process he has transformed the magazine into a work of supreme aesthetic beauty.

Lupi was invited by Bellini to serve as *Domus*'s art director upon the latter's appointment as chief editor of the magazine—an event monitored closely around the world. Bellini says teaming up with Lupi was essential in order to give the magazine new life and energy. His confidence in Lupi, he adds, stemmed from Lupi's deep understanding of architecture and his innovativeness. And as already noted, Lupi responded to Bellini's high expectations masterfully.

Lupi's works are elaborately wrought and precisely contrived, yet boldly rich in irony—a style that has been called "Anglo-Saxon." Perhaps this description is not off the mark, for Lupi does appear quite fond of Britain, as evidenced by the fact that he maintains a second home in London. At any rate Lupi is a true gentleman, a worldly man who enjoys traveling and the company of others. That is to say, he is a man who shows interest in virtually all aspects of life, and the broad knowledge he derives from this openness inevitably takes form in his artistic endeavors.

When I asked Lupi what area interested him most at present, his immediate response was "posters." He said he is trying his hand at posters because he sees them as the ultimate medium for conveying messages of persuasive force. For a man of such outstanding editorial design skills, and a man who has scored brilliant successes based on his artistic sensitivity and high level of perfection, to now take up the challenges of poster art, indicates that Lupi's creative world is still expanding. And without doubt, his newest artistic forays will open new realms in Italian design.

I look forward, with excitement and confidence, to the three (or maybe even four!) dimensional world that Italo Lupi will assuredly bring to poster art in the not distant future.

マリオ・ベリーニの晩餐会で「僕のもっとも大切な友人だ」といって紹介されたのがイタロ・ルピだった。私は以前から彼の名を知ってはいたが、グラフィックデザイナーとして世界的な名声を得ている彼が、シリアスで教養溢れる哲学者か大学教授の雰囲気を持っていたのには驚いた。だが、彼がミラノ工科大学の建築科出身であることを思い出して、ひそかに納得した。それにしても建築家からグラフィックデザイナーに転向した例は、イタリアでは彼が唯一ではなかろうか。

ルピは最近、世界的な建築誌『DOMUS』の表紙を手がけて注目された。彼はなんと表紙に数個の小さな穴をあけた。その穴からは、イニャツィオ・ガルデッラのプロジェクトであるランブラー駅のファサードの鮮やかな色どりがチラリとみえるようにアレンジされていた。つまり彼は、この数個の穴で思いがけない三次元の空間を造りあげたのだ。二次元の印刷物に三次元の世界を醸成する、まさに研鑽を積んだ建築家の頭脳からの発想である。さらにルピは表紙だけでなく雑誌全体のレイアウトにも、ダイナミックでしかも新鮮なグラフィック感覚を導入した。活字と図版の構成に天才的な手腕を発揮した彼がエディトリアルデザインの高度な美学を世に示したものといえよう。

マリオ・ベリーニが世界の注目を浴びつつ『DOMUS』の編集長に就任したと同時にイタロ・ルピがアートディレクターとして招請された。「誌面に活力を与え、『DOMUS』を蘇生させるために、ぜひともルピと組まねばならないと思った。彼は建築を理解し、しかも新しい視点での発想のできるデザイナーだからである」とベリーニはいっている。ルピはベリーニの期待に十二分に応えている。たしかにルピのデザインは綿密に正確に計算されながら、大胆なアイロニーに富んでいる。だからある人が、ルピはアングロサクソン的だと評していたが、成程彼はロンドンに別宅を持っているほど英国好きだし、奥さんも英語の教師である。だからそのようなメンタリティを秘めているのかもしれない。彼は旅行と社交が大好きという紳士である。つまり、あらゆる事象に興味を持っている人間なのだ。当然の結果として広い教養が作品に凝縮されて現われる。ルピの造形的構成はたしかに冷徹に計算されていると思う。しかし私から見ればその造形的構成から生まれてくる雰囲気は明るくて、明快で、しゃれていて、いかにもイタリアそのものという感じがする。

「いま一番興味を持っていることは」という私の質問に、言下に「ポスターだよ」とルピは答えた。たかだか1枚の紙の中に、どれほど多くのメッセージがこめられるか。彼は今、ポスターを何よりも強力な主張と伝達と説得の舞台として選択し、グラフィックの無限な可能性に挑戦しようと試みているのだ。エディトリアルデザインに優れ、感性と完成度で勝利を獲得した彼がポスターに挑戦することは、ルピの創造の場がより一層拡がっていることを暗示している。しかも、その挑戦こそがイタリアデザインの新しい世界を切り拓く扉になるに違いない。イタロ・ルピは、きっと1枚のポスターの上に三次元、いや四次元の世界をさえ現出させてくれるだろう。ますます面白く、深みを増すルピに、私の心は今、期待でいっぱいである。

Amministrazione
Provinciale
di Como

pittura
scultura
architettura
negli
anni Trenta

Como:
palazzo Volpi
San Francesco

27 maggio
3 settembre
1989

9.30 - 12
15.30 - 19
Lunedì chiuso

Collaborazione:
Comune di Como
Regione Lombardia

Contributo:
Cariplo
INA Assitalia

l'Europa dei razionalisti

1　Poster for exhibition on European rationalists 「合理主義者のヨーロッパ展」ポスター 1989

l'Europa dei razionalisti

pittura
scultura
architettura
negli
anni Trenta'

Como:
palazzo Volpi
San Francesco

20 maggio
27 agosto
1989

Amministrazione
Provinciale
di
Como

Con il contributo
di:
INA
Cariplo

l'Europa dei razionalisti

Amministrazione
Provinciale
di Como

pittura
scultura
architettura
negli
anni Trenta

Como:
palazzo Volpi
San Francesco

27 maggio
3 settembre
1989

9.30 – 12
15.30 – 19
Lunedì chiuso

Collaborazione:
Comune di Como
Regione Lombardia

Contributo:
Cariplo
INA Assitalia

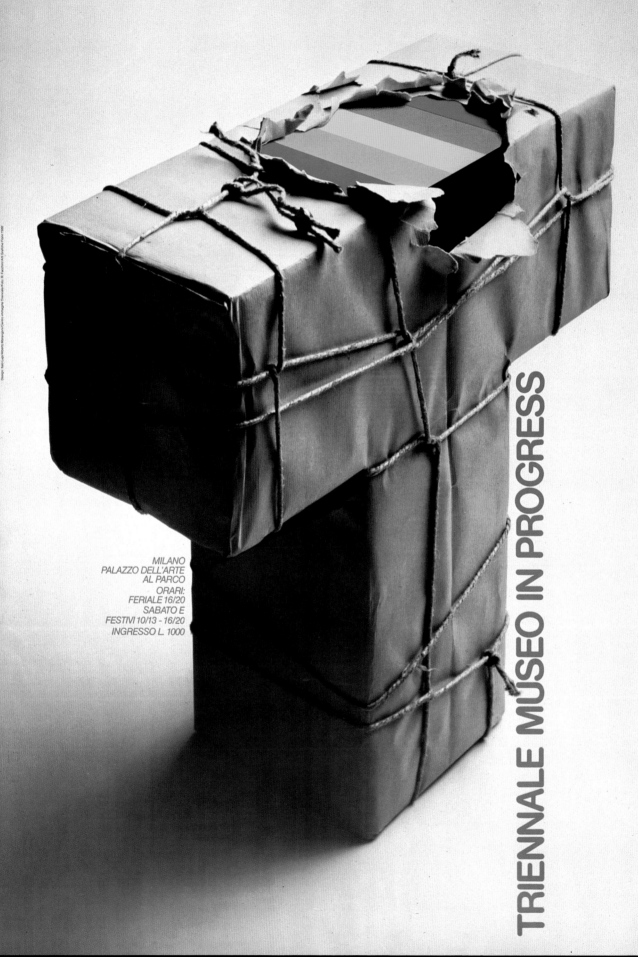

TRIENNALE MUSEO IN PROGRESS

MILANO
PALAZZO DELL'ARTE
AL PARCO
ORARI:
FERIALE 16/20
SABATO E
FESTIVI 10/13 - 16/20
INGRESSO L. 1000

6

8

Prototype of symbol for Milan Triennale ミラノトリエンナーレシンボルマーク試作 **1983**

M O D A
I T A L I A

Pier 88, 48th St. and the Hudson River
New York City
April 5 to 17, 1988. daily 10 am to 6 pm

10

M O D A
I T A L I A

12

Co-chairmen:
Paolo Viti,
Director of cultural
Relations, Olivetti.
Bill Lacy,
Architect,
Bill Lacy Design.

Registration,
Information:
Fee $475
(US dollars).
Additional family
member $250.
Full time
student $125
(photocopy
of current
ID required
with registration).

39TH
INTERNATIONAL
DESIGN
CONFERENCE

Late registration
fee $75,
if postmarked
after June 8th.
Registration
is limited
Make check
payable to IDCA
and mail to:
IDCA
PO box 664
Aspen, CO 81612
List all applicants
by name
For further
information:
IDCA
PO box 664
Aspen, CO 81612
(303) 925.2257

A S P E N

TUESDAY, JUNE 13
TO SUNDAY 1989

THE

39TH INTERNATIONAL DESIGN CONFERENCE IN ASPEN, 13-18 JUNE 1989

THE ITALIAN
MANIFESTO

CREATIVITA'

TECNOLOGIA

IMPRESA

NEL SISTEMA

ITALIANO

DELLA MODA

CREATIVITY AND

TECHNOLOGY

IN THE ITALIAN

FASHION SYSTEM

EDITORIALE DOMUS

domus

NUMERO 677 — NOVEMBRE 1986

MONTHLY REVIEW OF ARCHITECTURE INTERIORS DESIGN ART

ISOZAKI:
MUSEO A LOS ANGELES

CANALI:
MUNICIPIO A SASSUOLO

MONESTIROLI:
CASA PER ANZIANI

LIBRI:
4 PAGINE DI RECENSIONI

DANESE:
30 ANNI DI RICERCA

MUNARI
INTERVISTA MUNARI

RASSEGNA:
LAMPADE DEL 1986

◼ ● C ▲
MUSEUM OF CONTEMPORARY ART

15

domus

NUMERO 703 — MARZO 1989

MONTHLY REVIEW OF ARCHITECTURE INTERIORS DESIGN ART

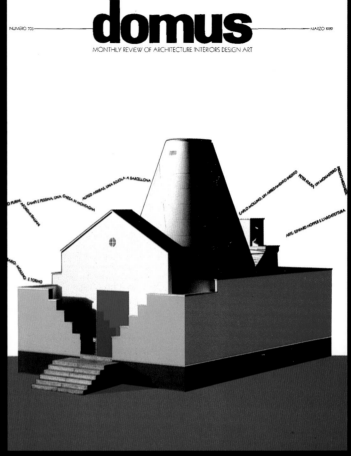

17

domus

NUMERO 717 — GIUGNO 1990

MONTHLY REVIEW OF ARCHITECTURE INTERIORS DESIGN ART

IGNAZIO GARDELLA, FACOLTÀ DI ARCHITETTURA

GRUPPO MECANOO, DUE EDIFICI A ROTTERDAM

LINA BO BARDI: CENTRO SOCIALE «FABRICA POMPEIA» SAN PAOLO

INTERVISTA A VITTORIO GREGOTTI

16

domus

NUMERO 670 — MARZO 1986

MONTHLY REVIEW OF ARCHITECTURE INTERIORS DESIGN ART

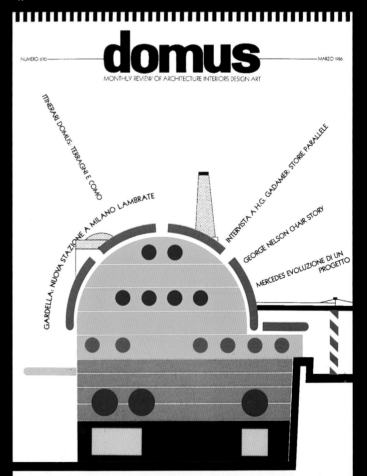

ITINERARI DOMUS: TERRAGNI E COMO

GARDELLA: NUOVA STAZIONE A MILANO LAMBRATE

INTERVISTA A H.G. GADAMER: STORIE PARALLELE

GEORGE NELSON CHAIR STORY

MERCEDES EVOLUZIONE DI UN PROGETTO

18

NUMERO 710

domus

NOVEMBRE 1989

MONTHLY REVIEW OF ARCHITECTURE INTERIORS DESIGN ART

GIULIO ROMANO
RESTAURO DI PALAZZO TE.
ITINERARIO. INTERVISTA A MANFREDO TAFURI

ALESSANDRO ANSELMI, MUNICIPIO DI NANTES-REZE

ATTUALITÀ: ESPERIENZE GIAPPONESI

DUE INTERNI MANIERISTI: A TOKYO E A PARMA

PETER ZUMTHOR, CAPPELLA NELLA SURSELVA

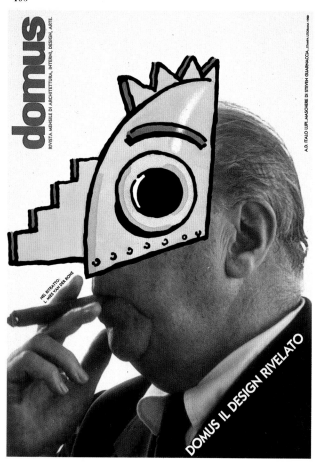

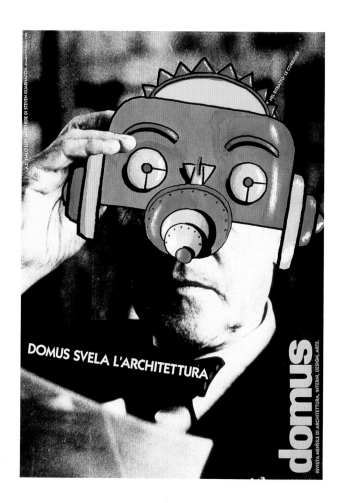

20-23 Posters promoting *Domus* 建築雑誌「DOMUS」のポスター 1988

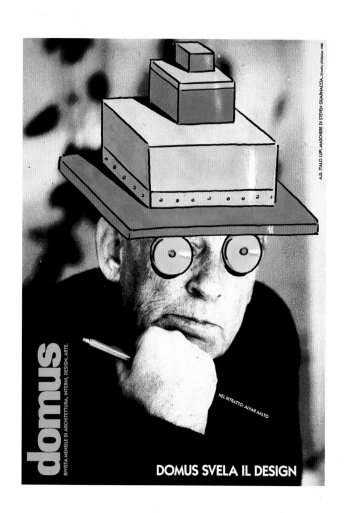

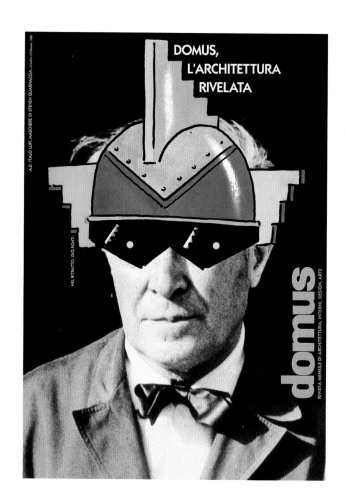

n. 182 marzo 1980 lire 2.500 (abroad $ 5.50)

ABITARE

vivere nella casa, nella città, nel territorio ★ home, town and environmental li

**ARCHITETTURA CON CITAZIONI
NUOVE LAMPADE
COSTRUIRE SUL COSTRUITO
LA CITTA' INFORMA
CONSERVARE, COME E PERCHE'
LE SCUOLE D'ARTE**

QUOTATIONS IN ARCHITECTURE ● NEW LAMPS ● BUILDING ON WHAT'S BUILT ● THE CITY ADVISES ● CONSERVATION, HOW AND WHY
WITH ENGLISH TEXT ● RÉSUMÉ EN FRANCAIS ● ZUSAMMENFASSUNG IN DEUTSCH ● RESUMEN EN ESPAÑOL

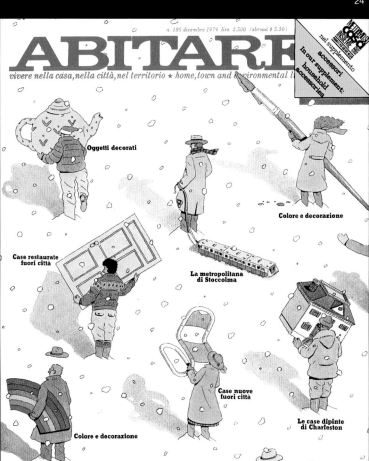

n. 180 dicembre 1979 lire 2.500 (abroad $ 5.50)

ABITARE

vivere nella casa, nella città, nel territorio ★ home, town and environmental l

Oggetti decorati

Colore e decorazione

Case restaurate
fuori città

La metropolitana
di Stoccolma

Case nuove
fuori città

Le case dipinte
di Charleston

Colore e decorazione

Colour and decoration ● Charleston's painted houses ● Decorated ware ● New houses outs[...]ovated houses outside town
● Stockholm's underground railway

With English text ● Résumé en francais ● Zusammenfassung in deut[...] Resumen en español

24-25 Covers of *Abitare* magazine on interior design インテリア雑誌『ABITARE』の表紙 1979-80

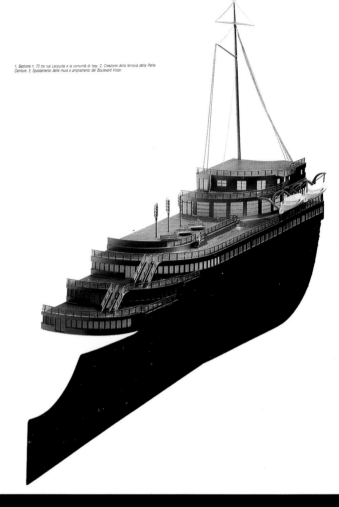

Non fosse per la purezza delle sue linee, ecco verosimilmente una costruzione che si noterebbe appena: un edificio banale, costruito su un terreno lungo un centinaio di metri ma largo soltanto sei, che nessuno avrebbe mai pensato potesse ospitare un albergo, 46 monolocali, 6 studi di artisti, del commercio e dei negozi per la Città. Cosa che Patout stesso non avrebbe potuto fare se la leggerezza del cemento collegata all'utilizzo di lunghi ballatoi agganciati sulla facciata posteriore non gli avessero permesso di aggiungere, dietro un vasto muro-schermo, una serie di appartamenti che vanno dal monolocale al duplex e la cui suddivisione si legge nel disegno dei coronamenti che sfilano verso la prua della nave, invertendosi poi brutalmente su un cielo di studi di artisti allineati come dei giocattoli di fronte a Issy e Vanves.

■ Were it not for the purity of its lines, here is probably a construction that would hardly attract notice: a commonplace building erected on a plot some hundred metres long, but only six wide, which no one would ever have thought could have found room for a hotel, 46 single-room flats, 6 artists' studios, business space and shops for the City. Which Patout in person could not have done had not the lightness of the concrete linked to the use of long railed balconies hooked onto the rear facade enabled him to add, behind a broad wall-screen, a batch of apartments ranging from singles to duplexes and whose subdivision can be read in the drawing of the coping that run towards the ship's bow, but brutally turning onto a sky of artist's studios lined up like toys in front of Issy and Vanves.

Pierre Patout, edificio del 1927, Boulevard Victor, veduta assonometrica.

George Nelson «Pretzel-Chair» ICF

La singolare storia di una sedia raccontata dal suo autore George Nelson, dai galleristi di Fifty-50 di New York e da Vico Magistretti. ● The remarkable story of a chair told by George Nelson, the New York Fifty-50 gallery owners and Vico Magistretti.

Racconta George Nelson: «Questa sedia? l'ho disegnata nel '55. È carina. Ci han messo trent'anni a metterla in produzione e non è fuori moda. Sì, ci dovrebbero essere delle cose che durano più di cinque anni... Cose come quelle di Prouvé, di Eileen Gray, che ritornano...

Perché l'ho pensata così, la sedia? Non so... Allora, molte sedie erano o a scocca in plastica tipo Eames o a elementi a bastone. La mia idea era di fare qualcosa di molto resistente e molto leggero – come la sedia di Ponti, che ammiro moltissimo – qualcosa da poter sollevare con due dita. Per avere forza e leggerezza insieme, ho pensato al compensato. E col compensato ho visto che le forme diventano curve, totalmente curve. Così è venuto fuori il «Pretzel», la «Pretzel-Chair».

Herman Miller ha visto però che una sedia così non la poteva produrre, e si è cercato chi lo potesse. Ma il prezzo era troppo alto. Tre volte il prezzo normale. Non se ne parlò più per trent'anni.

Mi rimaneva il prototipo, che avevamo fatto in studio, a mano. Lo conservai per ricordo. Maddalena De Padova, quando venne a New York, lo vide e pensò che si poteva trovare chi lo producesse. Suggerì che mi mettessi in collaborazione con Vico Magistretti – c'eravamo già incontrati, Vico ed io, con simpatia reciproca – e così chiamammo la sedia «The Georgistretti Chair»... Senonché Vico, per entusiasmo, per temperamento, finì per farne qualcosa di totalmente diverso dalla «Pretzel-Chair». Non c'era ragione di continuare, allora... pensai che avrebbero prodotto la sedia di Vico, non la mia... Senonché, tutt'a un tratto, ecco Sangiorgio della ICF che arriva, che dice che la vuol fare e che la fa. Mi dicono che è molto cara, e che de non ne vendono molte, ma io sono felice, in verità, che la sedia esista. È molto ben fatta, è ottima, e tutto va bene. È stato bello lavorare con Vico e siamo sempre amici». *New York, 13 gennaio 1986*

■ **George Nelson:** «Yes, it was designed in 1955. A nice chair. They waited thirty years to take it into production, and it hasn't gone out of fashion. There should be things that last more than five years, things by people like Prouvé, like Eileen Gray. They revive their furniture.

Why did we make the chair this way? Most of the chairs had plastic shells following Eames, or straight sticks. I wanted my chair to be strong and very light, something you could lift with two fingers... as with Gio Ponti's chair, which I admire very much. To achieve strength and lightness at the same time I decided to make the whole chair out of laminated wood, but then I discovered that when you make a chair out of laminated wood, you don't get straight sticks, but totally curved forms. So it came out a «Pretzel-chair».

When Herman Miller was unable to make it, they found somebody who was able to make it, but then the price was too high: three times what you could pay for a chair. So it died. For thirty years.

I kept a hand-made prototype, made in my office, to remind me of my baby. Then Maddalena De Padova came to New York,' she saw the chair, she said

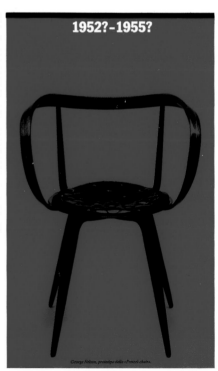

1952?-1955?

George Nelson, prototipo della «Pretzel-chair».

A L B U M

IN USA: QUANDO LO STYLING ERA BUONO

La mostra organizzata dal Brooklyn Museum, New York. «The Machine Age in America 1918-1941», è una importante esposizione della cultura materiale e visiva americana nel periodo fra le due guerre. L'ampia, e in certi casi, disparata raccolta di manufatti presenta degli approcci nuovi e interessanti sia in termini di storiografia che di interpretazione critica. Attraverso l'esposizione di una larga gamma di beni di consumo come mobili, stoviglie, elettrodomestici, tessuti, abbigliamento, sotto forma di disegni e plastici architettonici, fotografie, stampe, pitture, disegni e sculture, vengono presentati una serie di temi. Alcuni dei quali costituiscono poi le varie sezioni della mostra. La critica ventuale, la geometria decorativa, Lo streamlining, La commercializzazione dell'età della macchina, la composizione universali. L'emergenza dell'arte di una nuova epoca. Le tematiche prese in esame, che rappresentano i contributi più significativi dell'epoca tra gli anni venti e trenta alla cultura universale, vanno della nuova tipologia degli edifici (grattacieli) e dai problemi tecnici e formali alla fluidità di concezione del 1916, all'espansione universale, alle forme continue e fluide che caratterizzano la progettazione dei veicoli e la stessa.

I RAPPORTI TRA LE CORBUSIER E L'INDUSTRIA

PORTRAIT
D'UN HUME PELU AMERICAIN
DANS L'ÉTAT DE NUSTTE

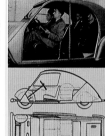

L'esposizione, che ha inaugurato a Zurigo il suo itinerario europeo, è esplicitamente intesa a fornire argomentazioni attorno a un nodo cruciale dell'attività di Le Corbusier. Il periodo de L'Esprit Nouveau, gli anni del sodalizio con il pittore purista Ozenfant alla direzione della stessa rivista. Sono gli anni della grande svolta per l'architettura, quando attraverso le pagine della rivista Le Corbusier dà corpo e voce alla molteplicità delle manifestazioni di cultura, arte e tecnica. Punto di collegamento fra le istanze delle avanguardie (in pittura, letteratura...), nel periodo prebellico e la nascita compiuta del costruttivismo «apparso il l'ordre» negli anni Venti, L'Esprit Nouveau coglie certamente alcune linee di continuità tra tali differenti esperienze e debitore a un verso di Guillaume Apollinaire della propria intestazione e si ricollega a pagli impulsi d'ammirazione prebellica per i moderni come trionfali costituiti dalle «macchine» (per esempio i fatti dell'aeroplano di Blériot). Su queste premesse si costruisce anche la mostra, concepita come a momento di sistematizzazione del materiale critico per un nuovo ulteriore approfondimento: la struttura espositiva – nell'osservazione generale di Stanislaus von Moos – è suddivisa in momenti astratti e razionante alla molteplicità di Le Corbusier con le proprie suggestioni, con gli oggetti, i quadri, i manifesti, i documenti, i modelli di architettura e la ricostruzione parziale dell'interno del Padiglione Esprit Nouveau (1925, all'esposizione internazionale delle Arti Decorative a Parigi). Lo scavo sui materiali d'archivio attorno a questi temi e a questi anni non può dirsi esaurirsi conclusivo, come presentava Von Moos nel catalogo: l'esposizione si segnala quindi come a momento di sistematizzazione del materiale critico per un nuovo ulteriore approfondimento: la struttura espositiva – nell'osservazione generale di Stanislaus von Moos – è suddivisa in momenti astratti e razionante alla molteplicità di Le Corbusier con le proprie suggestioni, con gli oggetti, i quadri, i manifesti, i documenti.

1925

ARTS DÉCO

AUTRES ICONES
LES MUSÉES

zioni con la corporazione degli ingegneri industriali. «Non ci si comprende», sarà la desolata conclusione di Le Corbusier) ci colgono per mezzo delle sequenze costante fra alloggi oggetti industriali citati, le dichiarazioni programmatiche dei «tempi nuovi» e i richiami allo spirito dell'epoca - anche in senso macchinista. Blériot, la Tour Eiffel e gli aeroplani - tecnici.

L'esposizione non esaurisce in questa sezione il percorso critico: si prosegue con la presentazione dei fattori attuali (nelle opere pittoriche, di Ozenfant e dello stesso Le Corbusier, di Fernand Léger, di Picasso) e con l'autorappresentazione in scala 1:1 dell'interno del restauro Padiglione dell'Esprit Nouveau, un «Museo immaginario» (cioè A. Rüegg) nel saggio in catalogo, e un percorso d'architettura lungo un'intera sequenza di immagini 1935-38) - conclude l'itinerario in piena conseguenza con la catena di pigmentazioni proposte. FRANCESCO PAGLIARI

VINCONO I CALLIGRAPHI

Il Mauro Panzeri è vincitore del concorso per il marchio della «Festa Nazionale de l'Unità». La proclamazione è stata accompagnata dalla lettura della relazione della Giuria (redatta da chi qui scrive), presidente della Giuria, e che ha tentato di descrivere con una certa particolarità le difficile serie di decisioni di esclusione che la Giuria con un lavoro dibattibile ha dovuto via via prendere. La relazione è stata servirsi in tutto questo ma indubbiamente può essere anche letta come l'evocazione successiva de l'abbandono motivato di «pionieri di testo» estremamente diverse. Dalla testa intrisa di creatività diretta di Maurizio Tucchet alla propettantissima qualificazione ambientale dello studio Perù-Gualzetti. Dalla festa giovanile che voglie neo-futuriste di Cristiana Erbetta alla festa nostalgica e al un tempo ironicamente indolazzata dello studio Tapiro. Da una festa imponente di sapore internazionale: il progetto Graphiti, ad una avvedutà atmosfera populiare sofisticata: il progetto Tornasole. Oppure il clima neutrati dell'ironia sui Saori Emilienni Carrulo, in contrapposizione a un approccio neutro, intenzionalmente-manipolatorio: Turchi. O infine l'ipotesi di «sintonia» cromatica e formale di Elena Green, contrapposta alla ironità e sapenza ambiguità di Vignali.

In parte, forse, questa diversificazione delle tesi possibili, questa molteplice divergenza, il deviato e una condizione di partenza, una crocestrada delle modalità di deciso del concorso. Si è trattato di un concorso privo di un brief preliminare che non fosse puramente tecnico. Come avviene presso «la migliori famiglie» anche del management: si è trattato di progetto di essere soprattutto riflessione che produsse la domanda a cui deve rispondere. E ancor più il esere processo di produzione di una «realtà» dentro la quale scegliere. La novità metodologica consiste nell'affidare a una Giuria, cioè nel tentare di suggerimente, il compito del riconoscimento quello dell'adesione di un emblema e sempre il delicato meccanismo della scelta di un volto per un corpo organizzativo. Il proprio, e di un unico apparato di elaborazione di opzioni possibili hanno lavorato i partecipanti. Il per questo è stato tanto difficile scegliere in quanto il problema non era tanto quello di selezionare secondo un criterio quantitativo di «realtà» ma secondo una graduatore qualitativa di «dimostratrice».

Probabilmente il progetto vincente, con la sua pronunciata poetica e con i suoi «irrianti» dei calligraphimi di Apollinaire, ma anche a certe liberi gestualità di Matisse, e in generale agli attuali esiti della poesia visuale è stato il lavoro che con maggiore nettezza ha saputo rendere visibile il sottile equilibrio di ingredienti, di finalità implicite ed esplicite, di vincoli tecnici e strategici, di contesti ideologici ed anche emozionali, che informa una «Festa de l'Unità».

Mauro Panzeri is the winner of the competition for the symbol for the Italian Communist Party's annual popular festival, the «Festa Nazionale de l'Unità».
The announcement was accompanied by the reading of the Jury's report (edited by the

Milano, 28 agosto - 14 settembre.

Festa nazionale dell'Unità

present writer), an attempt to describe in some detail the difficult series of exclusions made in the course of a long and lively debate. Another way of seeing the same report might be as a listing (with justifications for rejection) of a range of extremely varied «Fiesta de l'Unità concepts» - The «Festa» was seen variously as an event permeated by creativity (Maurizio Turchet), a reflection of the environment (the very carefully-designed symbol by the Perù-Gualzetti studio), a youthful festivity with neo-futurist inclinations (Cristiana Erbetta), an experience combining nostalgia and ironic detachment (Tapiro studio), an important event with an international flavour (Graphiti), an event both popular and intelligently sophisticated (Tornasole), an approach springing from the intellectual «irony» about «Holy Cows» (Camuffo); just the «Festa de l'Unità» (Turchi's) deliberately neutral and non-interpretative approach); a chromatic and formal «symphony» (Elena Green); or an event both light-hearted and intriguing (Vignali).

The competition was intended perhaps more than anything else to be a means of producing this very «variety» of responses, from among which a choice could be made. The new element was the decision to appoint a Jury, in an attempt to make the choice more objective. The adoption of a symbol always involves a delicate mechanism of selecting a face for a corporate organization. In this case the participants in the competition worked like a single device for producing possible alternatives. Hence the difficulty of selecting a winner, since the task did not depend on any quantitative criterion of «merit» but on a qualitative judgement of «approach». The winning design, with its poetic style and educated references to Apollinaire's calligrammes, to free gestuality à la Matisse and to present-day visual poetry, probably conveys most clearly the subtle equilibrium of a «Festa de l'Unità»: its implicit and explicit aims, its technical and political limitations, and its who-le background both ideological and sentimental.

IL CONGRESSO AGI IN OLANDA

Con linguaggio telegrafico (piovoli quindici punto cinque/biciletta punto uno uno uno, parte da rocchetta impennata del porto di Amsterdam, un battello che alle diciannove punto trenta ore, sbarca i membri dell'Alliance Graphique Internationale con rappresentanti Massimo Vignelli in testa nell'atelier della bella e spergiudicata Marie Röling (AGI), a Weesp. Mazpretes, lanc-da musicale, supper indonesiano, naturalmente molto colore locale (post punk, dark, etc.)

Si dà inizio alla testa di apertura del congresso AGI annuale che dal quindici punto cinque, al diciannove punto cinque, per tre giorni e diciannove punto cinque ore, non avrà troppo centrato come lingua ufficiale.

La nuova presidenza oppone alle precedenti gestioni lerdipola, il Vignelli-partner: l'Alliance Graphique Internationale deve essocilamente ritrovare la sua identità attraverso lo scambio culturale, discutere i più recenti temi della comunicazione e aprire a nuovi talenti.

Al Kröller-Müller (il van de Velde) immerso in

A Weesp, la regista del Congresso AGI di centro, deus-de participanti inviati da Presidents dell'AGI. Maria de Sammet.
A Nesco, locomotiva da 25 Guilder disegnata da Becker

un vasto capannone lombardo, Deborah Susman presenta (con le lumière) il progetto grafico ed allestimenti) delle Olimpiadi di Los Angeles, e poco dopo un film su Herbert Bayer, dal Bauhaus di Dessau, fino ad Aspen Colorado, impressione un film.

Poi, di seguito, Piet Zwart, capostipite ed originale della grafica costruttiva olandese, una spettacolare presentazione degli straordinari lavori di Ootto Oxenaar per le poste e la zecca di Stato (l'Italia non cfr stato), una mostra serie di film camagiorizzati, fino a tarda notte (per ora le bottei madueque di Léger il inequivocabile). E ancora, polisettimana tra oriente e occidente. Miss Tanaka.

Momento magico: quando il jazz-comette la sua autobiografia e la sala rovige il più) lunga e instabile applauso a quell'uomo straordinario che ha rivisitato il suo passato con la meticolosa precisione e la generale dolcezza che apre.

Una mostra spontanea di membri AGI, nuovi libri, nuovi progetti, breakfast, coffee break,

lunch, drinks (jawn account!) e transfer by bus. Poi, finalmente, l'assemblea generale (membri-only) acclama i nuovi componenti dell'Associazione, e discute i più recenti temi della comunicazione e dell'espunzione verso un nuovo talentuoso. Assemblate nella gioia di giuramenti della maggioranza e divisione nella divisione del secondo gruppo, sobrietà per il nuovo presidente che a un nuovo lingua ufficiale.

To Kröller-Müller (of van de Velde), immersed in a vaguely Lombard park. Deborah Susman presents - son et lumière - the project (graphics and exhibition) display of the Olympic Games in Los Angeles and, a little later, a film regarding Herbert Bayer, from the Bauhaus at Dessau, to Aspen Colorado. It impresses everyone to a certain extent. And then, following on, Piet Zwart, Dutch founder and pride of constructive graphics, a spectacular presentation of the extraordinary works of Ootto Oxenaar for the Postal Service and Mint

(Italy didn't wake up), a terrible series of computerized films until late at night (and until now «a ballet indonesiano» by Léger is inappreciable). Magic moment when Les Lionni presents his autobiography and the audience gives its longest and most insistent applause to the extraordinary man who has gone over his past, with the meticulous precision and general charm of his works. A spontaneous exhibition of AGI posters, new books, new projects, breakfast, coffee break, lunch, drinks (own account!) and transfer by bus. And, finally, the general assembly – members only – acclaims the new members although not without the vivacious protest of the adventures of the Vignelli-Think-i-unitaerone» from Zurich and Lilm (graphics). The Americans were in part absent – head in the clouds and other fears, unjustified. The Vignelli-Think does swell the spirit although it does also destroy the body.

Gioielli per Cleto Munari

di Marco Romanelli

Gli antropologi, partendo dal presupposto che non esistono popolazioni che non a decorano essersi ni a essi il sono popolo «ssali», ritengono possibile che la decorazione sia la forma più primitiva di abbigliamento. In essa si esprime, oltre a componenti estetiche, l'esigenza di manifestare aggressività o difesa. Portare un oggetto a contatto con il corpo significa, in certo modo, estendere la corrispondenza della propria esistenza alla superficie dell'oggetto stesso. Risulta che pensare la tensione ergopoidi addottivi oggetti per fini decorativi: tale attitudine è da attribuirsi a un sentimento di «esaltazione del proprio corpo», sarai altresì assimilabile all'attaccamento dell'essere umano qualora a certon con i lunghe collane o con una scatola che percuota ritmicamente la gamba[?]. Così nei gioielli di Munari si ravvisabile una serie di significati più o meno consapevoli: un valore magico, un desiderio di protezione che si accompagna a una volontà di distinzione ne. Se tali connotati e hanno sofferma mancato a fine di discernere, nella collezione, approcci diversi al tema progettuale. Approcci fondamentalmente riportabili a due grandi categorie: la prima, casuale nel gioiello contemporaneo, stero-riferita e so-sializzata, tesa a privilegiare un aspetto di «dilettismo» e quindi a porre il gioiello quale simbolo di potere e di status. La seconda, al contrario, caratterizzata da ornamenti

germano. E nel primo caso più facile è sul piano della poetica personali, altrimenti riprecedila maniersitica citazione di un linguaggio, puro è proprio. Il privilegiare l'aspetto decorativo in chiave ad esempio architettonico (formale per Portoghesi, personale per Isozaki), piuttosto che l'aspetto magico, in chiave ecctica (Bellini), alchemica (Eisenman), testimonia in assoluto la reazione personalissima del progettarsi nei confronti di un oggetto che conserva un enorme potere espressivo. Espressione delle motivazioni più intime dell'individuo in confronto ai problemi primari, espressione che si fonda su presuppone necessariamente un'interiorazione, ma serve a riportare, evocare all'esterno emozioni e sentimenti. In alcuni di questi gioielli, seguatamente quelli aperti al potere tra intimo ed esterno, nell'attraversare il cavaglio o il configura più come inconoscibile, ma diviene un simbolo – «oltre il Deo gravo» – trasmesso nel tempo l'interno non è configurato più come inconoscibile, ma divertente un esser costante della tradizione considerata perista tecnica sobria nell'altrimenti delle pietre. Aspetti. Queste tale abbiamo non ai pone inoltre forse viamente mediare, esso nelle pre-«intermediar», quasi barbaro negli accennamenti direti grazie ai quali la parti preziose del gioiello son si pone ben tramite in prima istanza, ma solo successivamente, come sintesi dell'esperienza percettiva della diversa luminosità e materialità dei materiali. A conformare, se in scoperte archeologiche rori riestaurano, una sostanziale fissità formale, materica e percettivo tecnologica dell'oggetto-gioiello, ora si all'inscindibile insegnamento trasmesso nelle tracce di padre il figlio, di maestro in allievo. Si può prendere così un esemplare primo spiritivo della collezione Munari: la creatività del lavoro artigianale, anello-elemento della configurazione, poste una l'idea

Marco Bellini, con Marco Romanelli decora
per l'orecchia in oro giallo e bianco (foto a
sinistra e selezia sopra e sotto), e decorat per la
mano in oro giallo (foto sotto).

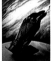

principalmente autoriferiti e narcistici o che, quantomeno, mediino le due istanze. Analogamente credo abbiamo operato una sintesi e volendo diversi colore che hanno deciso di accettare un universo tipologico esistente per dar luogo, in esso, delle più o meno rissate variazioni formali o colore che si pone profitei di architetto tipologie in modo d'uso inuovi e rinnovati. In questo senso negli interventi di Hollein, Portoghesi, De Lucchi, Isozaki, Tra i secondi quelli di Eisenman, Bellini, Mendini, Ti-

In alto: Stanley Tigerman, anello doppio in
oro e ametesina a destra, sempre di
Tigerman, braccialie in oro; qui sopra:
Stanley Tigerman, necklace made from gold-plated
wood; coral, black onyx); left: Hans
Hollein, gold earring with turquoise.

successivamente, come sintesi dell'esperienza percettiva della diversa luminosità e materialità dei materiali.

Disegni preliminari dei alcuni componenti da testa del sistema: portaceste, portaombrelli, cestino pattumiera
■ Concept drawings for a series of pieces to be put on the floor: ash-tray, umbrella-stand, wastepaper basket.

Fotografia e sezioni esecutive dei vari oggetti da tavolo.
■ Photograph and working sections of the desk top.

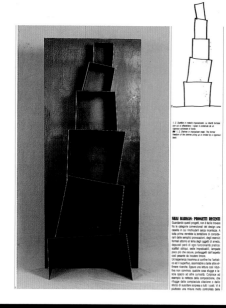

1, 2. Scaffale in metallo impiastricciato. La libertà formale con cui si differenzia i pezzi è contenuta da un rigoroso schematura di livello.
■ 1, 2. Shelves in impiastriciated metal. The formal freedom of the shelves piling up is limited by a rigorous base.

SHAI BARNAA: PROGETTI RECENTI
Guardando questi progetti, non è facile trovare fra le categorie convenzionali del design una casella in cui inscriverli senza incertezza. A tutta prima venebile la tentazione a considerarli della semplici provocazioni, degli esercizi formali attorno a tema degli oggetti di arredo...

Renzo Piano **Libreria Teso, Fontana Arte**

Un oggetto essenziale che, sfruttando al massimo i coefficienti di compressione del cristallo, visualizza l'utopia di un'architettura di vetro. La ricerca avanzata sulle potenzialità tecnologiche e sull'uso dei materiali, caratteristica dell'operare di Renzo Piano, trova qui un completo equilibrio con i risultati formali raggiunti. ■ *An essential object which by exploiting the compression coefficients of glass to the maximum, visualizes the utopia of a glass architecture. The advanced research on the technological potential and use of materials, characteristic of Renzo Piano's work, finds here a complete balance with the formal results achieved.*

Progetto: Renzo Piano · Building Workshop
con la collaborazione di Ottavio Di Blasi

Servizio fotografico Luciano Soave

La libreria Teso discende dal tavolo disegnato da Renzo Piano, sempre per Fontana Arte, nel 1986. Il teorema in sezione che ora allora inventò in una breventura riscente sulle fascia interna dei cristalli semplificati che formavano la gamba, il qua portava all'inverno (vedi dettaglio nella foto in alto). La libreria è composta dunque da elementi verticali in cristallo molato spessi 15 mm e da un piani continui sempre in cristallo molato da 15 mm. Un sistema di fissaggio invisibile tenuto dai cristalli, fissato ad ogni piano orizzontale, consente di bloccare morsetti e mensole. La libreria misura cm 240x55, alta cm 200. Il peso netto è kg 210.

■ *The Teso bookcase descends from the table designed by Renzo Piano, for Fontana Arte, in 1986. The steel tie-rod in that model which was fitted into a milling on the inner side of the cristalled glass forming the legs, has here been moved inside (see detail in photo, top). The bookcase is thus composed of vertical elements in polished glass 15 mm thick and of continuous shelves again in polished glass 15 mm thick. A system of vertical chromed stainless steel tie-rods, fastened to every horizontal shelf, allows uprights and shelves to be clamped. The bookcase measures 240x55 cm, height 200 cm. The net weight is 210 kg.*

di Ottavio Di Blasi Si è normalmente portati ad associare all'idea di trasparenza quella di assorbimento, di inconsistenza. Nonostante l'aspetto fragile ed immateriale il vetro è capace di resistere a compressioni di più di 100 kg/cmq, una prestazione davvero incredibile se si pensa che il cemento resiste a solo 10-20 kg/cmq.

Trasparenza, leggerezza visiva, inalterabilità nel tempo, planarità, resistenza agli agenti chimici: hanno queste caratteristiche materiche a fare nascere la sfida progettuale. Riuscire ad usare il vetro non solo a proprio materiale da costruzione e soprattutto usarlo da solo, senza l'intrusione di altri materiali opachi, creando strutture portanti radicalmente trasparenti. Se il vetro ha questa capacità di resistere alla compressione, occorre allora riuscire ad usarlo nel modo che gli è più congeniale: in compressione. La stessa tecnica viene adottata per le travi ed i ponti in cemento precompresso, usando barre o cavi d'acciaio si precollocita la struttura molecolare del materiale che, in questo modo, risulta più resistente e refrattario alle fessurazioni. Così è nato, nel 1986, una serie di tavoli che recano all'interno delle gambe barre in acciaio che, una volta messe in tensione, realizzano coi piani una struttura molto rigida. Il gioco è riuscito: a dispetto della iniziale sensazione di diffidenza ed a contendo di attrazione, la piccola struttura a portale del tavolo è il la sfidare: i tentativi di alta prova dappresso a farlo oscillare, poi a sedervisi sopra. Il fascino di questo oggetto deriva proprio dal paradosso del verificare la solidità di un materiale che siamo abituati a considerare fragile ed inconsistente.

Compiuto questo primo passo scatta il desiderio di proseguire la ricerca con un tema ancora più impegnativo, un sistema di librerie esclusivamente in cristallo, senza controventi, aggraffabile in modo da poter formare delle vere e proprie pareti. Nel progetto della libreria si è cercato di semplificare le lavorazioni già sperimentate sui tavoli: le barre non state portate all'interno delle lastre di vetro eliminandoli gli incollaggi e puntando ad utilizzare al massimo il materiale nella sua forma più comune. Le barre, La libreria è infatti costruita da grandi superfici (240x55x15) intercalate tra loro con lastre più piccole in posizione verticale. Tra le une e le altre si agiscono due coppie di barre d'acciaio che le comprimono, formando un pacchetto unico. La polesina e riposti aggiornati consente aggrugsamenti lineari. Si possono di conseguenza creare pareti integralmente in cristallo, accessibili nei due lati grazie all'assenza di controventatura. Si tratta in fondo solo di un gioco che ha a che fare poi uno l'artigianato che non con l'industrial design, più con la voglia di sperimentare tecniche costruttive diverse che non son la logica del prodotto.

E poi chissà, in futuro, si potrà forse riprovare con dimensioni ancora maggiori: delle vere e proprie architetture trasparenti.

■ One is normally inclined to associate the idea of transparency with that of incorporeity and inconsistency. Despite its fragile and immaterial appearance, glass is capable of resisting compressions of over 100 kg/cm sqm, a truly incredible performance considering that concrete resists only 10-20 kg/cm sqm.

The material advantages of transparency, visual lightness, unalterability, flatness and resistance to chemical agents are in themselves enough to pose a challenge to design: to succeed in using glass as an actual construction material and, above all, to use it by itself, without the intrusion of other opaque materials, for the creation of paradoxically transparent bearing structures. If glass has this capacity to resist compression, then it must be used in the way most congenial to it: by compressing it. The same technique is adopted for beams and bridges in prestressed concrete. Using steel bars or cables, the molecular structure of the material is pres-

its main entryway, while at the same time representing the perspectival axis on which the entire architectural figure is based - this axis in fact extends for the entire depth of the block, partially interrupted only by the double order of the entry portico. In this way, the broad free space between the *Monumenten* numbers 10, 12, and 14 and the *Monumenten* number 24 is entirely occupied by the articulated volume of the library, though in reality only the two longitudinal bodies with others windows reach the edge of the road. And from the road, through the three intervals, it is possible to see all of the constituent elements of the new building complex (the structure of the library itself through the service entrance, all three of the building structures through the chief entry and, through the narrow opening of the *Bauwich*, the garden and, in the background, the linking structure).

2. The other problem to which we referred, concerning the relationship between the building and its immediate surroundings, has been treated in terms, so to speak, of analysis; that is, case by case, side by side.

a) We have already said, in reference to the facade facing the *Oude-Boteringestraat*: this is the principal facade, a perspectival axis bounded by the three structures of the building. Here the public building directly overlooks the road without contradicting its original measurements and architectural character.

b) The facade facing the *Poststraat-Zuid* shows the lateral bulk of the principal structure of the library (here one floor lower in order to reflect the runoff line of the smaller street); a few design details allow one to detect the L-shape in the point of contact between the three *Monumenten*, and on the other side, the connection with the transversal structure of the linking body.

c) The facade facing the *Poststraat-West*, occupied along its entire length by the linking structure, is clearly a rear facade. It is a closed facade, and it reiterates, in a canonic fashion, all of the compositional elements of the matter buildings of the old town (the small windows, the cargo door, the winches, and so on, of the old *Pakhuizen* of the city).

d) Lastly, the solution applied to the facade on the *Brouwerstraat/Academieplein* is chiefly a result; the result of a reciprocal displacement over the area of the block of the functional structures. Nevertheless, this solution - which also entirely isolates the *Monument* number 24 (accentuating its already considerable degree of monumentality) and the formation of a garden, open to the public space - in the end proves to be appropriate and in line with the architectural characteristics of this space, rich in various episodes.

I conclude this brief description with a final observation that concerns the first, most general problem. It is true that the principal problem faced in this project was that of inserting a large public building into a close-knit, regular fabric of constructions. It is further true that the problem was resolved in the project chiefly in the sense of mediating the conflicting scales, rather than in any sharp counterposition between the two different sizes; though not to the point of concealing the problem itself.

In reality, the objective of the project itself was always to allow the tension to appear, to reveal the disparity in expressive terms, between these two compositional elements. That is, the problem should have remained open, even after receiving an answer. And in this sense, the design should have revealed, along with the answer, its evident difficulties - that is, the conflict, which is the initial point of departure, along with the particular form that this conflict takes on in an effort to apply

(continued on page XXX)

Fronte sulla Oude Boteringestraat / Elevation on Oude Boteringestraat.

Fronte sulla Broerstraat / Elevation on Broerstraat.

Fronte sulla Poststraat-west / Elevation on Poststraat-west.

Fronte sulla Poststraat-zuid / Elevation on Poststraat-zuid.

Sezione sulla via interna / Section through internal area.

Assonometria generale dell'isolato / Axonometric of the block.

36　Christmas card for lighting manufacturer　照明器具メーカーのクリスマスカード 1990

S P E B G N R　V U　W U S

38 Paper bag for record shop レコード店のペーパーバッグ 1981

rivista
IBM

TECNICA & CULTURA
SCIENZA & SOCIETÀ
INFORMATICA & TELEMATICA

44 Cover of PR magazine for IBM Italia IBMイタリアのPR誌表紙 1990

45 Cover of annual report for IBM Italia IBMイタリア年間報告書の表紙 1988

46 Poster for general meeting of IBM Italia IBMイタリアの総会ポスター 1988

IL LUOGO DEL LAVORO

A.D. ITALO LUPI · DISEGNO: GIOVANNI MULAZZANI ——— Tipografia L. Mariani snc 1986

PUNTO VENDITA VIA FOLLI 43

GranCiclismo

49 Billboard for bicycle manufacturer 自転車メーカーのサインボード 1985

LE CITTÀ IMMAGINATE

Electa

XVII Triennale

UN VIAGGIO IN ITALIA
NOVE PROGETTI PER NOVE CITTÀ

cinelli

Biciclette

ISCHIA

A.D.: LUPI / PH. FACCHINI /G.F.

NEI MARI DEL SUD C'E' UN'ISOLA

Comune d'Ischia, settore Turismo. 80077 Ischia Porto. Tel. 081/991013-991166

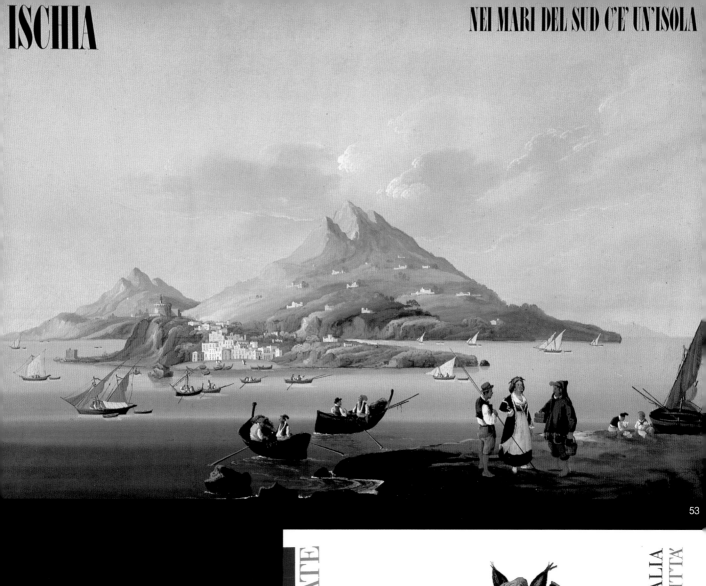

XVII Triennale

LE CITTA' IMMAGINATE

UN VIAGGIO IN ITALIA
NOVE PROGETTI PER NOVE CITTA'

Electa

BONACINA MEDA/ITALIA

55 Calendar for furniture manufacturer 家具メーカーのカレンダー 1974

VIENNA

56 Poster for general meeting of IBM Italia IBMイタリアの総会ポスター 1988

BONACINA MEDA/ITALIA T.(0362)70401/71312

57 Calendar for furniture manufacturer 家具メーカーのカレンダー 1971

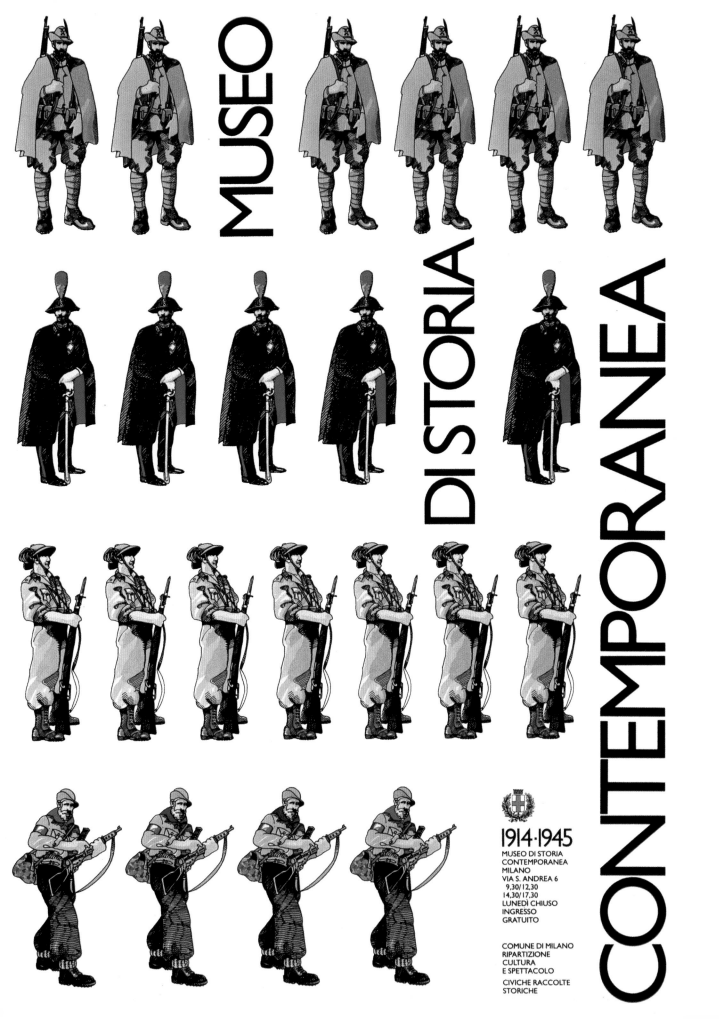

MUSEO
DI STORIA
CONTEMPORANEA

1914·1945
MUSEO DI STORIA
CONTEMPORANEA
MILANO
VIA S. ANDREA 6
9,30/12,30
14,30/17,30
LUNEDÌ CHIUSO
INGRESSO
GRATUITO

COMUNE DI MILANO
RIPARTIZIONE
CULTURA
E SPETTACOLO

CIVICHE RACCOLTE
STORICHE

Listino Prezzi

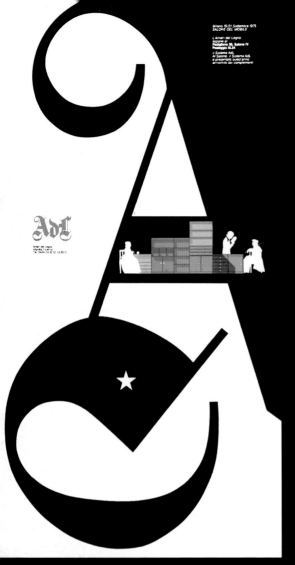

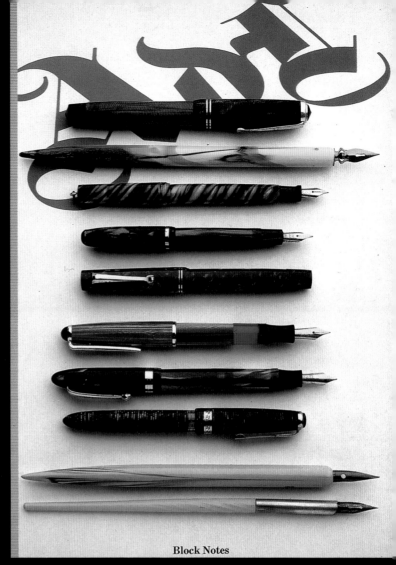

Block Notes

60 Poster for furniture manufacturer 家具メーカーのポスター 1975

61 Catalog for furniture manufacturer 家具メーカーのカタログ 1979

WALDEMAR SWIERZY ヴァルデマル・シュヴィエジ

Noboru Matsuura 松浦 昇

Waldemar Swierzy is truly a "superstar" among Poland's poster artists. As a member of the "Polish Poster School" he has created more than 1,000 posters to date.

Swierzy initially studied graphic design under Józef Mroszczak as a student at the Cracow Academy of Fine Art in Katowice, from which he graduated in 1952. At the time of his graduation, Polish poster art was in a crisis situation, the result of a proclamation in 1949 to adhere to socialist realism in art. Mroszczak, seeking to thwart this official challenge to artistic freedom, left his post in Katowice in 1952 and took up a position as poster editor at a graphic arts publishing house in Warsaw. Simultaneously he assumed a teaching position at the Warsaw Academy of Fine Arts, where he was a colleague of Henryk Tomaszewski (also new to this faculty). Mroszczak then invited his protege Swierzy to join him at the publishing house to serve in charge of poster production.

Swierzy accepted Mroszczak's invitation and moved to Warsaw. There he soon made the acquaintance of young graphic artists like Wiktor Górka and Roman Cieslewicz. They and their group were engaged in a dogged battle against socialist realism, aiming instead to establish new design forms in poster art based on individual design philosophies.

Swierzy's posters are characterized by a unique, multifaceted approach. For each subject, Swierzy first searches out the particular design style that best matches his theme; then he manipulates his forms and conventions freely. Through his career he has produced posters of every conceivable genre. Yet in each of them, one discovers artistic richness and diversity that are truly astonishing.

Consider his circus posters, for example. On one hand his bearded female nude of 1981 appears grotesque on the surface; yet on a deeper level it reveals the artist's keen sense of humor. By contrast, his circus poster of 1977 seems humorous at first, but on closer inspection is actually quite grotesque. And although other artists have also produced outstanding circus posters over the years, what sets Swierzy's works in this genre apart is the artist's continuously changing viewpoint: he looks at each subject from a different distance. Furthermore, by creating a world apart from reality—that is, by infusing his acute sense of humor, satire or the grotesque into colors and shapes—Swierzy succeeds in creating a world that conveys his philosophical and spiritual values.

With only rare exceptions—such as when he was temporarily influenced by pop art after 1952—Swierzy uses human subjects. This orientation became even stronger after he turned to actual portraits in the 1970s, a vein in which he continues to work today. Representative of his posters of this kind are those on Jimi Hendrix (1974), Stanisław Teisseyre (1975) and his mentor Józef Mroszczak (1976). These and his other portraits all demonstrate Swierzy's exceptional powers of expression, observation and, of course, creativity. In fact, it is his creativity—in the face of numerous imposing restrictions—that, perhaps more than anything else, deserves recognition. For through their visual language, Swierzy's portraits succeed brilliantly in making statements both personal and public.

ポーランドポスター学校のメンバーのひとりであり、今までに1000点以上のポスターを制作しているヴァルデマル・シュヴィエジは、ポーランドポスター界のスーパースターといえる。彼はクラクフ美術アカデミーのカトヴィツェ分校で、ユゼフ・ムロシュチャク教授からグラフィックデザインを学び、1952年に卒業した。ポーランドでは1949年に社会主義リアリズムが宣告され、彼が卒業した頃、ポーランドポスターは危機的状態に陥っていた。ムロシュチャク教授は、この危機的状況を打破するために、同年、ワルシャワにある美術グラフィック出版社のポスター編集責任者として転任し、また、ヘンリク・トマシェフスキーと一緒に、ワルシャワ美術アカデミーで精力的に教鞭を執った。そして、シュヴィエジをカトヴィツェから美術グラフィック出版社のポスター管理者として招いた。

シュヴィエジは、ワルシャワで若いグラフィックアーティストのグループと接触し、ヴィクトル・ゴルカやクラクフからやってきたロマン・シェスレヴィッチらと知り合った。若い彼らは、社会主義リアリズムの教義から脱し、個人の造形思考を優先させ、絶え間ない競争の中でその時期のポスターにおける様々な新しい造形形式の成立を促した。シュヴィエジのポスターは、テーマに対して個性的で多様的なアプローチが特徴であり、それぞれのテーマに合った独特な造形的処方を見つけ、自由に形式と因襲を操作する。彼は、今までにあらゆる分野のポスターを制作している。その中から、サーカスポスターをとり出してみても、作品の豊かさと多様性には驚かされる。顔は髭がのび放題で女性ヌードというショッキングな1981年のサーカスポスターは、一見グロテスクであるが、優れたユーモア感覚が隠れている。反対に1977年のサーカスポスターは、ユーモラスに表現されているが、よく見るとグロテスクである。他にも優れたサーカスポスターはあるが、彼の視点は常に一定せず、相異なる距離からテーマを眺めている。そして、現実の世界とは異なったもうひとつの世界、つまり、彼の優れたユーモア感覚やひとの意表をつくグロテスク、風刺感覚などを色彩と形体の中に込めることによって、思想的、精神的価値を伝達できる世界を創造しているように見える。

彼は、1952年からポップ・アートの影響を受けた時期やごく例外を除いて、ほとんど人間をモチーフに扱っている。1970年代からより鮮明になって人間をクローズ・アップした肖像へ移り、今日まで続いている。その代表作に『ジミー・ヘンドリックス』(1974年)、『スタニスワフ・テイセイレ』(1975年)、そして恩師のポスター展のポスター『ユゼフ・ムロシュチャク 1910－1975』(1976年)などがあるが、彼の卓越した表現技術と洞察力は勿論のこと、創造力が遺憾無く生かされている。創造力とは、彼のようにさまざまな制約を克服する能力においてこそ認められるべきものである。シュヴィエジは肖像を描くことによって、常に一種の舞台顔を演じ、駆使する視覚言語は個性的であると同時に、公共的であるという二重性を見事に体現している。

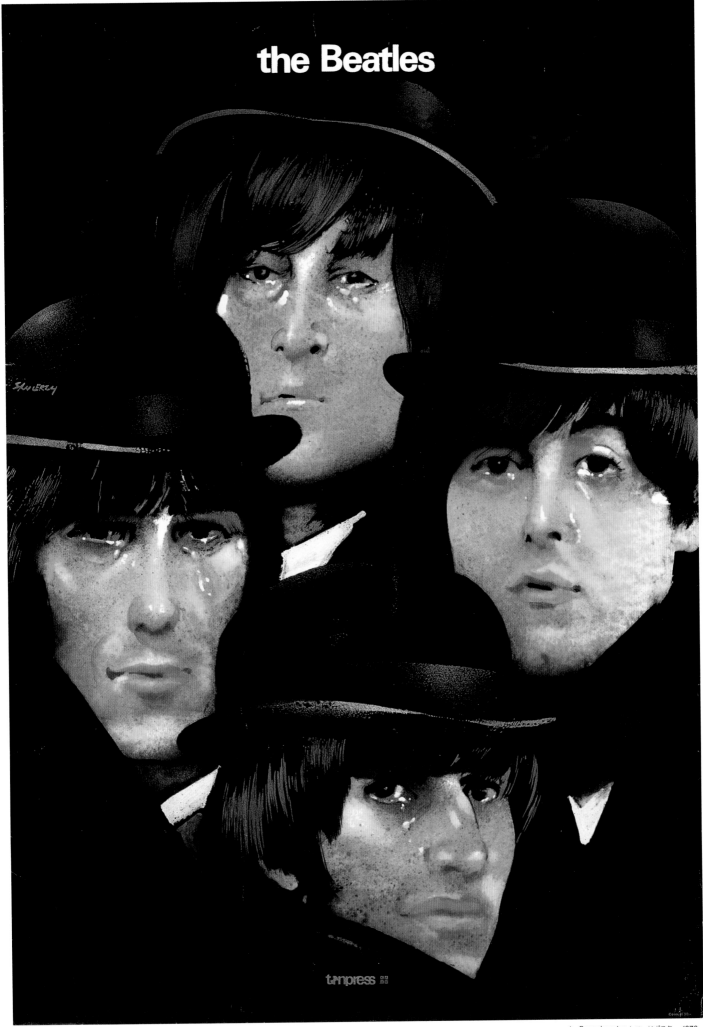

1　Record poster　レコードポスター　1978

2　Illustration for movie poster　映画ポスターのイラスト 1974

3-4　Illustrations for movie posters　映画ポスターのイラスト 1988

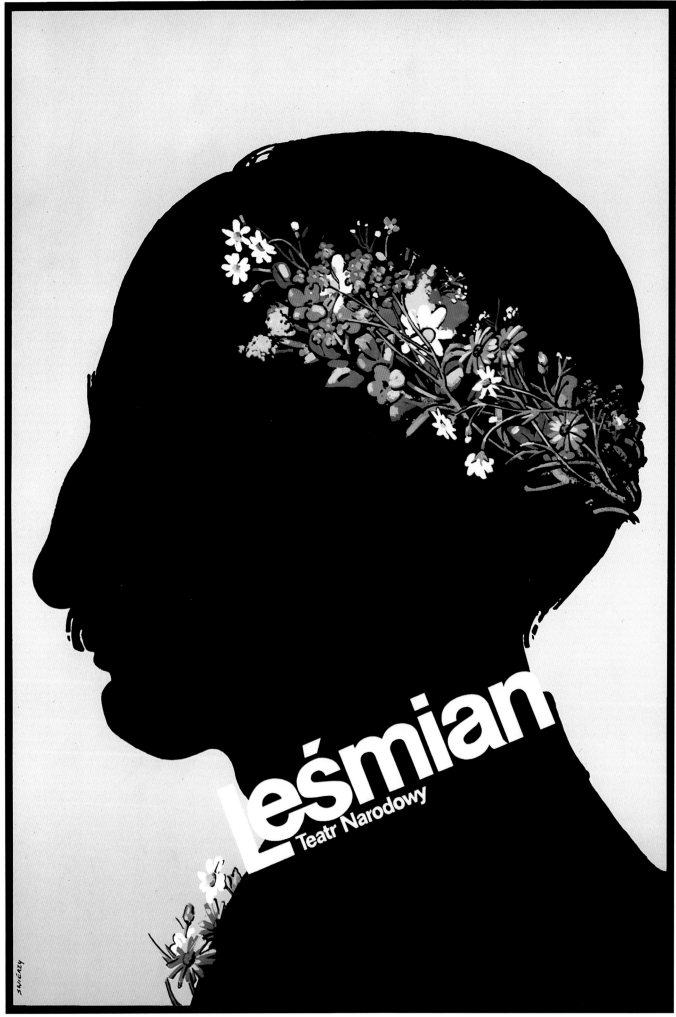

Leśmian
Teatr Narodowy

5　Exhibition poster　展覧会ポスター　1982

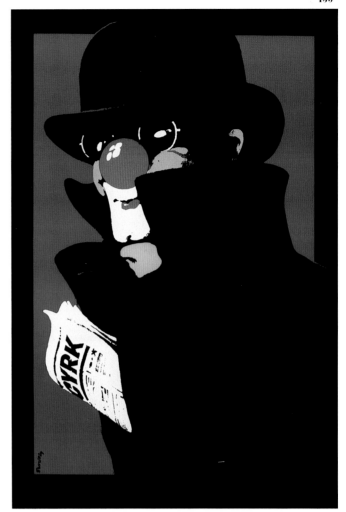

7 Circus poster サーカスのポスター 1974

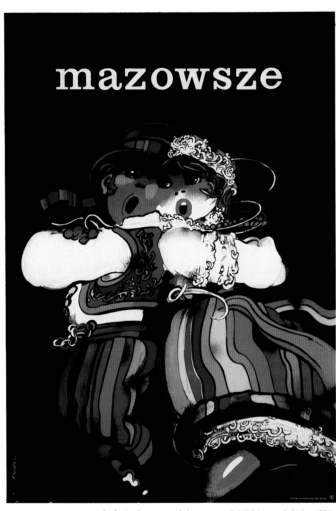

6 Poster for song-and-dance revue 歌と踊りのショーのポスター 1974

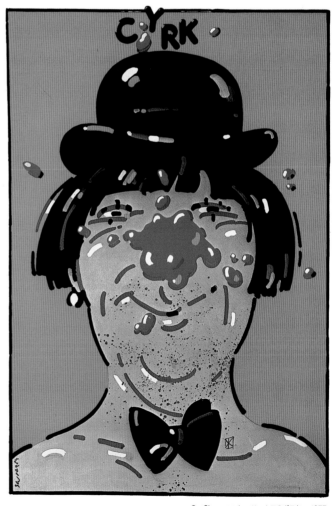

8 Circus poster サーカスのポスター 1977

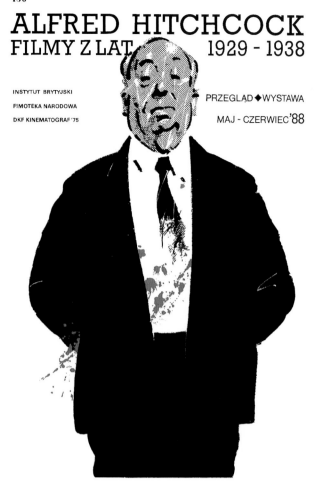

ALFRED HITCHCOCK
FILMY Z LAT 1929 - 1938

INSTYTUT BRYTYJSKI

FIMOTEKA NARODOWA

DKF KINEMATOGRAF '75

PRZEGLĄD ◆ WYSTAWA

MAJ - CZERWIEC '88

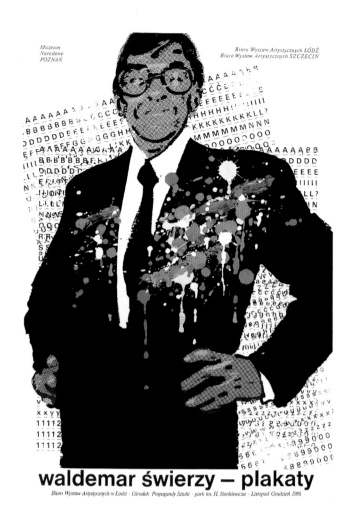

Muzeum Narodowe POZNAŃ

Biuro Wystaw Artystycznych ŁÓDŹ
Biuro Wystaw Artystycznych SZCZECIN

waldemar świerzy – plakaty

Biuro Wystaw Artystycznych w Łodzi · Ośrodek Propagandy Sztuki · park im. H. Sienkiewicza · Listopad Grudzień 1986

9 Poster for Hitchcock film show ヒッチコック映画ショーのポスター 1988

10 Exhibition poster 展覧会ポスター 1986

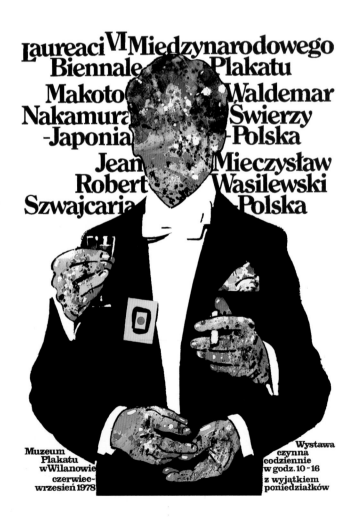

Laureaci VI Miedzynarodowego Biennale Plakatu
Makoto Waldemar
Nakamura Świerzy
-Japonia -Polska
Jean Mieczysław
Robert Wasilewski
Szwajcaria -Polska

Muzeum Plakatu w Wilanowie czerwiec- wrzesień 1978

Wystawa czynna codziennie w godz. 10 - 16 z wyjątkiem poniedziałków

11 Exhibition poster 展覧会ポスター 1978

Polska
Orkiestra
Kameralna

Polish
Chamber
Orchestra

12　Poster for chamber orchestra　室内交響楽団のポスター　1982

Związek Polskich Artystów Plastyków Okręg Warszawski

Franco Balan
plakat

warszawa czerwiec 1980
Galeria **DAP** *Ul. Mazowiecka 11ᵃ*

13 Exhibition poster 展覧会ポスター 1979

Piotr Potworowski

Muzeum Narodowe **Październik 1976**
w Poznaniu **- Styczeń 1977**

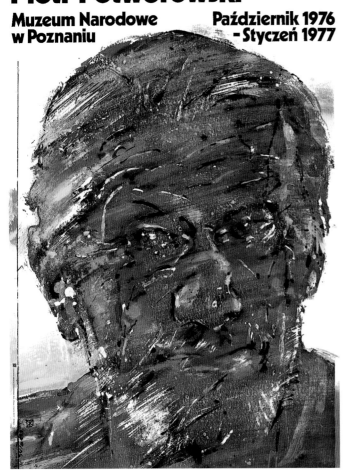

14 Exhibition poster 展覧会ポスター 1976

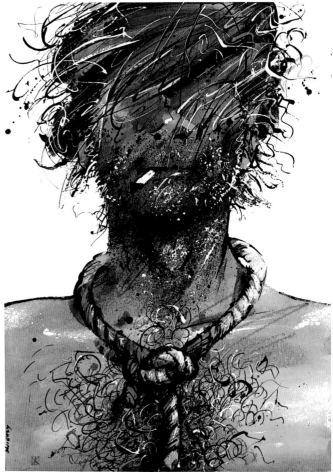

Teatr Dramatyczny **obciach** *Janusz Głowacki*

15 Theater poster 演劇ポスター 1979

Teatr
Kochanowskiego
Opole

William
Shakespeare

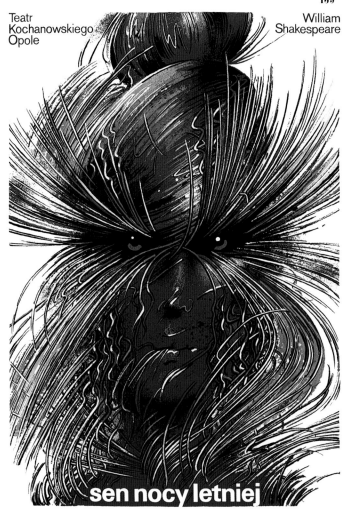

sen nocy letniej

17 Theater poster 演劇ポスター 1982

Laureaci

Nagród Państwowych i Ministra Kultury i Sztuki
w dziedzinie plastyki w 35 leciu PRL

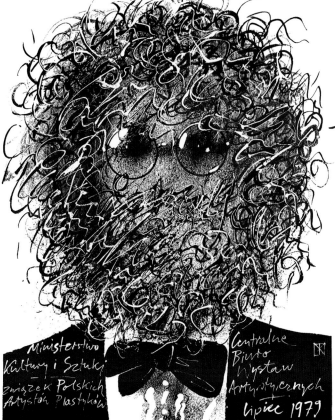

Warszawa, Zachęta, Pl. Małachowskiego 3
wystawa otwarta codziennie od 11°° do 19°° oprócz poniedziałków

16 Exhibition poster 展覧会ポスター 1979

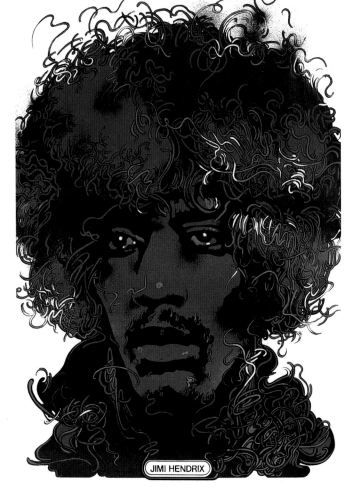

JIMI HENDRIX

18 Jimi Hendrix poster ジミ・ヘンドリックスのポスター 1974

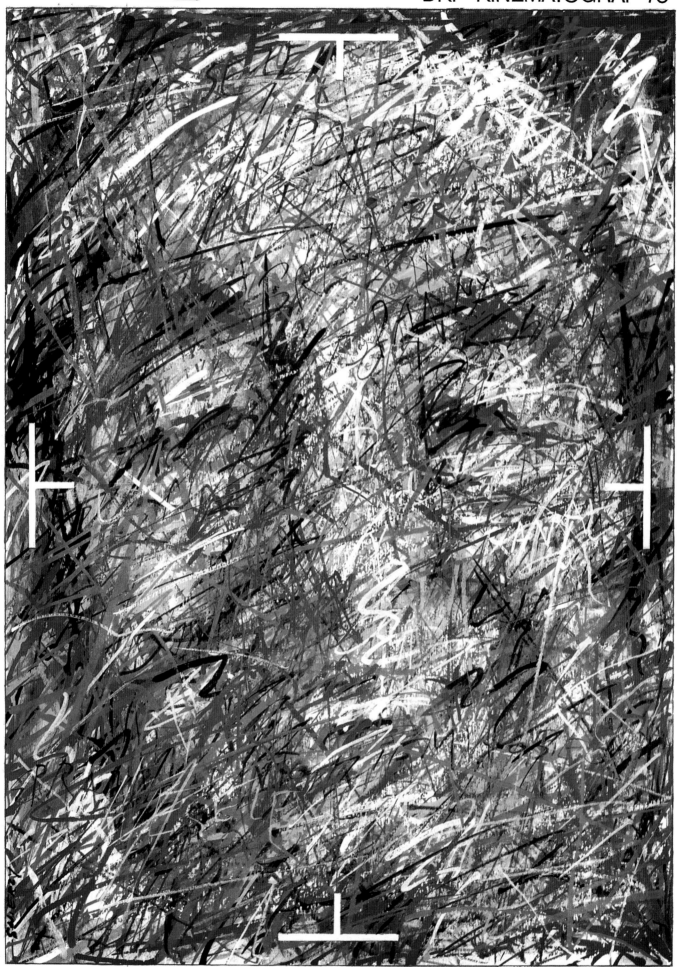

30 FILMÓW **ANDRZEJ WAJDA** WYSTAWA-PRZEGLĄD FILMÓW

19 Poster for Andrej Wajda film show アンジェイ・ワイダ映画ショーのポスター 1986

Polska Orkiestra Kameralna

Yehudi Menuhin

Centrum Sztuki Studio

Poland at XIII Biennale in São Paulo 1975

Tadeusz Brzozowski

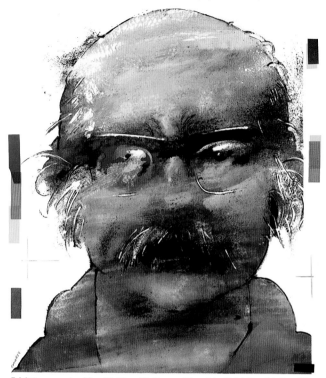

Exhibition organized by Ministry of Culture and Art of the Polish People's Republic

SPONSORS: AGFA-GEVAERT • Energy by Helena Rubinstein • LOT V • NINA RICCI • INTERPRESS-FILM

20 Concert poster コンサートポスター 1984

22 Exhibition poster 展覧会ポスター 1974

Galeria Teatru Nowego Warszawa

RÓŻEWICZ

plakaty z kolekcji Krzysztofa Dydo

MUZEUM NARODOWE w POZNANIU

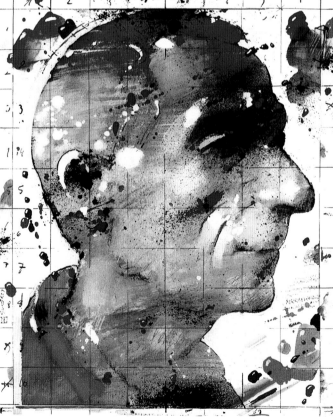

STANISŁAW TEISSEYRE - MALARSTWO

GRUDZIEŃ 1975 - LUTY 1976

21 Exhibition poster 展覧会ポスター 1984

23 Exhibition poster 展覧会ポスター 1975

Wielcy Ludzie Jazzu / Jazz Greats

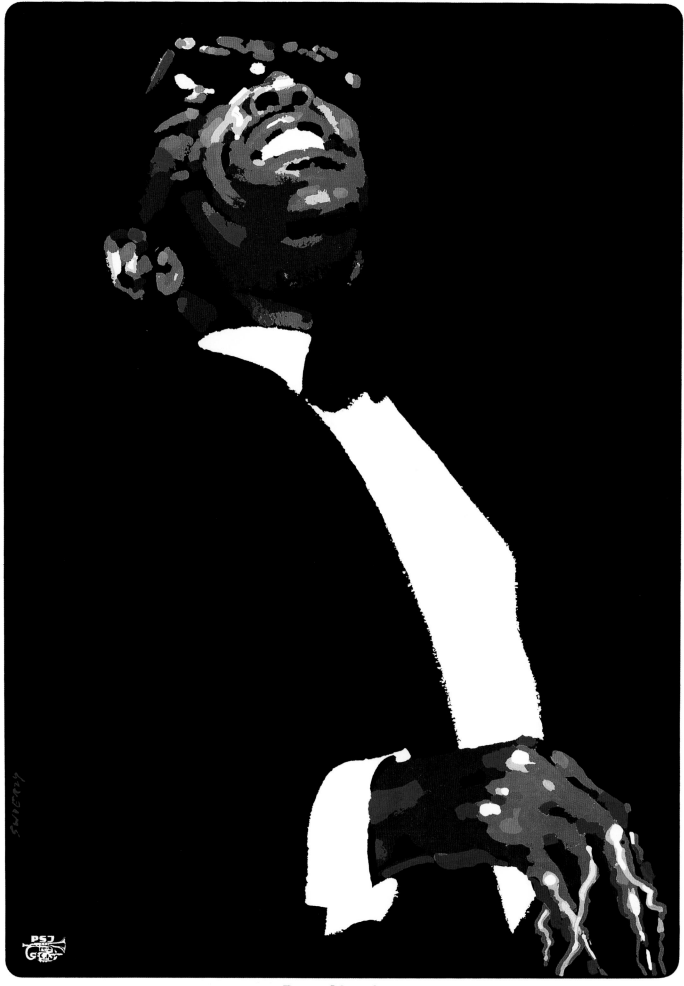

Ray Charles

24-25 "Jazz Greats" series 「ジャズ・グレーツ」シリーズ 1988

Wielcy Ludzie Jazzu / Jazz Greats

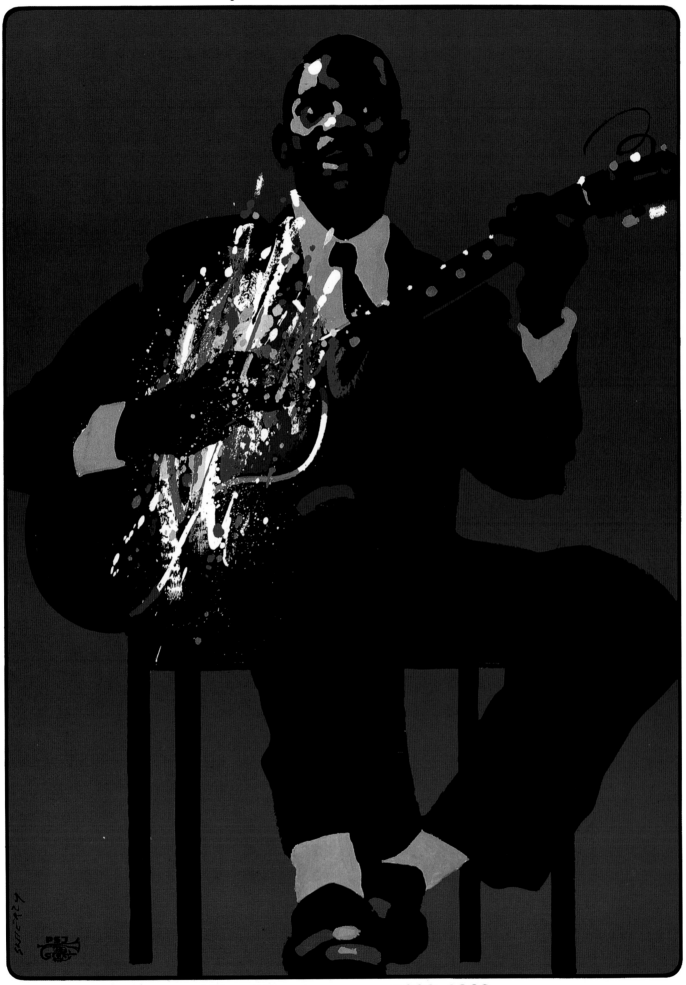

Wes Montgomery 1923–1968

Wielcy Ludzie Jazzu / Jazz Greats

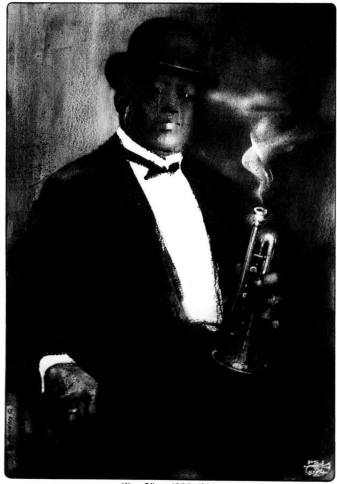

King Oliver 1885-1938

26 "Jazz Greats" series「ジャズ・グレーツ」シリーズ 1974

Wielcy Ludzie Jazzu　Jazz Greats

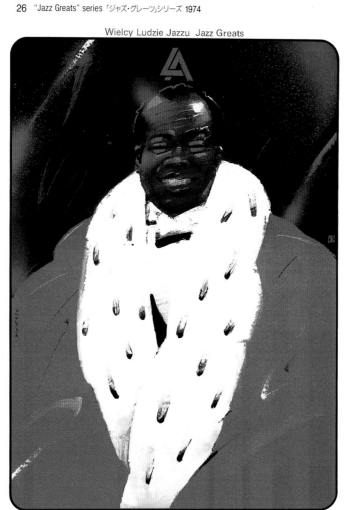

Louis Armstrong 1900-1971

27 "Jazz Greats" series「ジャズ・グレーツ」シリーズ 1980

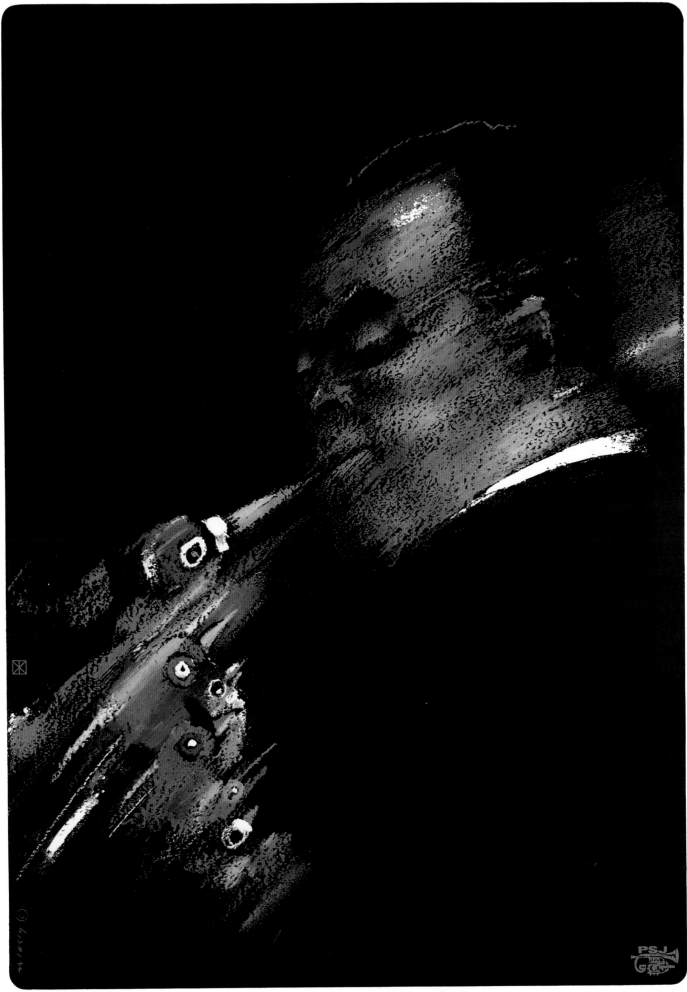

Charlie Parker 1920-1955

28 "Jazz Greats" series 「ジャズ・グレーツ」シリーズ 1975

30th INTERNATIONAL JAZZ FESTIVAL

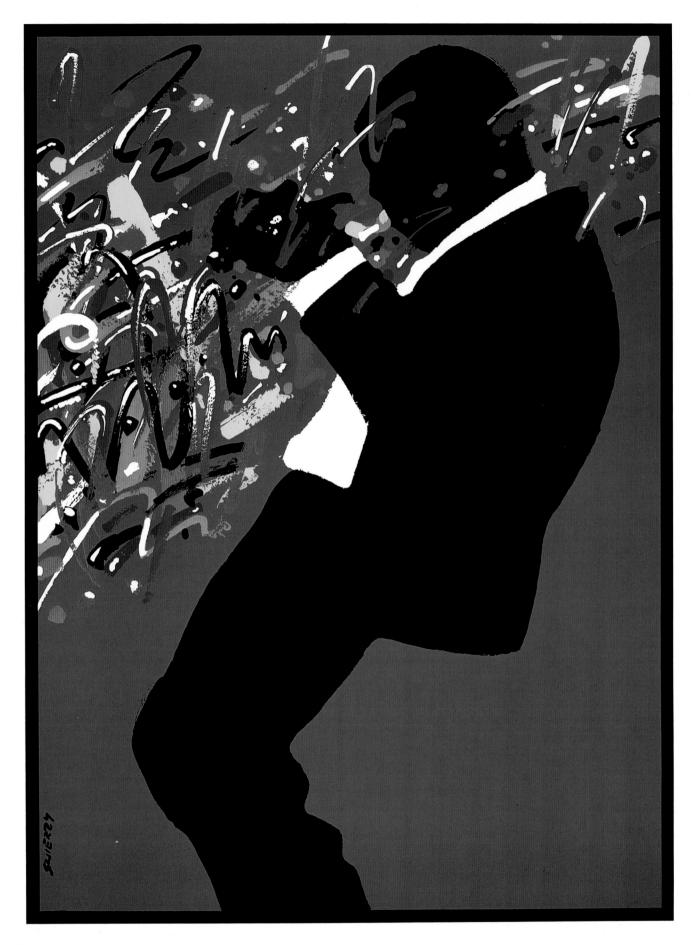

JAZZ JAMBOREE | WARSAW POLAND | OCTOBER 1988

29 Poster for jazz festival ジャズフェスティバルのポスター 1988

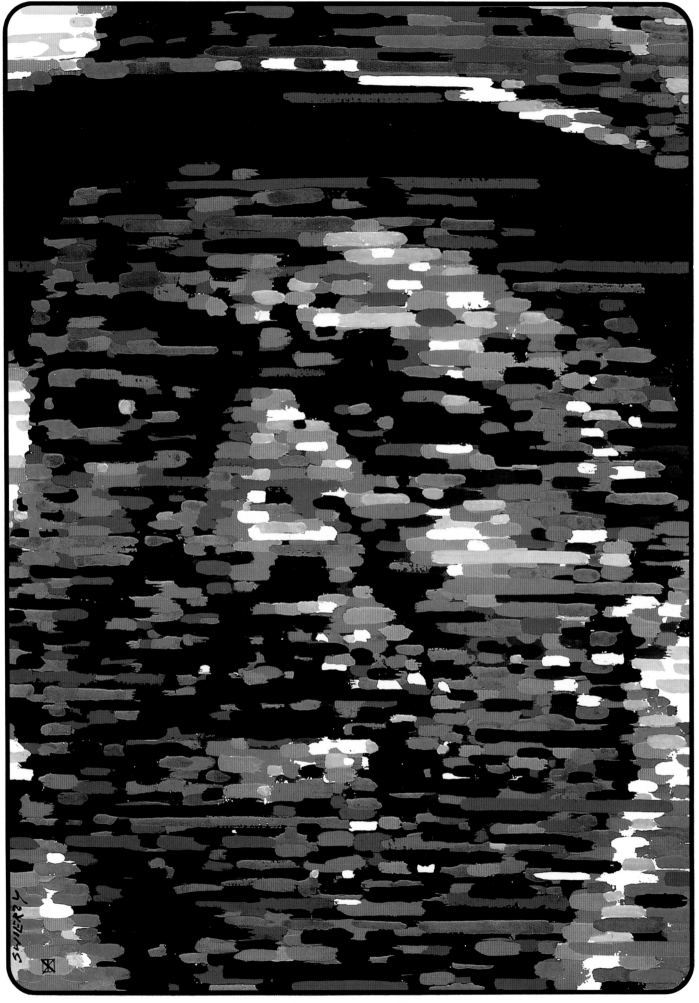

Count Basie

30 "Jazz Greats" series 「ジャズ・グレーツ」シリーズ 1985

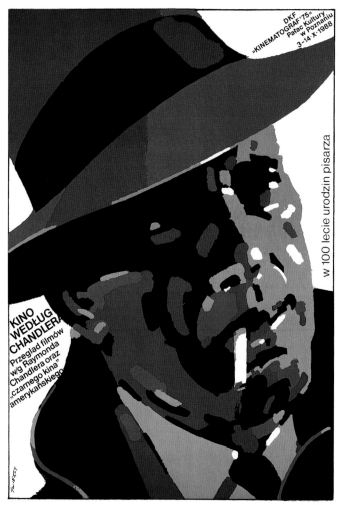

31 Poster for Chandler film show チャンドラー映画ショーのポスター 1988

ROBERT DE NIRO

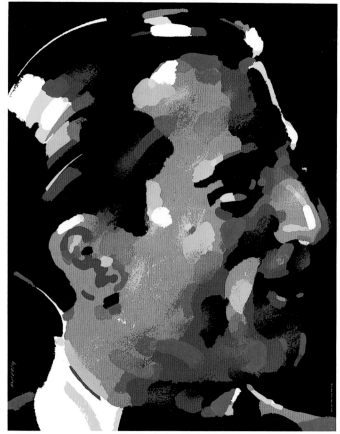

FILM FESTIVAL·POLAND·IX·1989

32 Poster for Robert De Niro film show ロバート・デ・ニーロ映画ショーのポスター 1989

ADAM STYKA

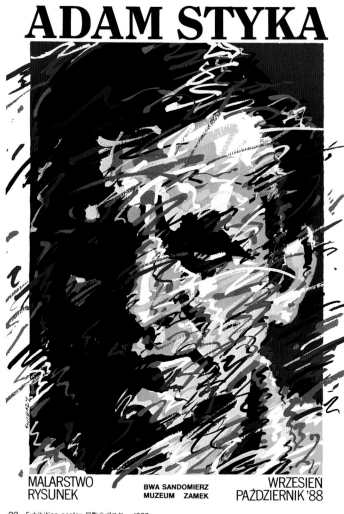

33 Exhibition poster 展覧会ポスター 1988

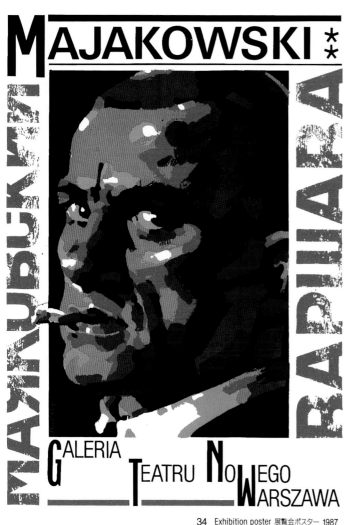

MAJAKOWSKI **

GALERIA TEATRU NOWEGO WARSZAWA

34 Exhibition poster 展覧会ポスター 1987

Muzeum **Plakatu** ma 20 lat

35 Exhibition poster 展覧会ポスター 1988

WITKACY GALERIA TEATRU NOWEGO w WARSZAWIE 1885-1985

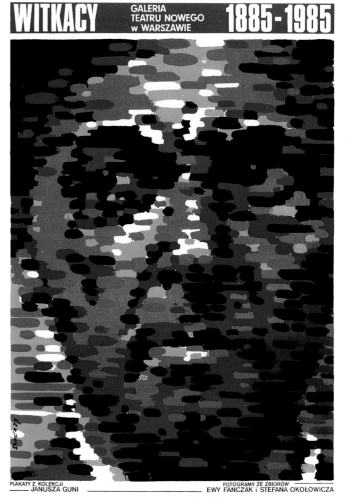

PLAKATY Z KOLEKCJI JANUSZA GUNI FOTOGRAMY ZE ZBIORÓW EWY FANCZAK i STEFANA OKOŁOWICZA

36 Exhibition poster 展覧会ポスター 1985

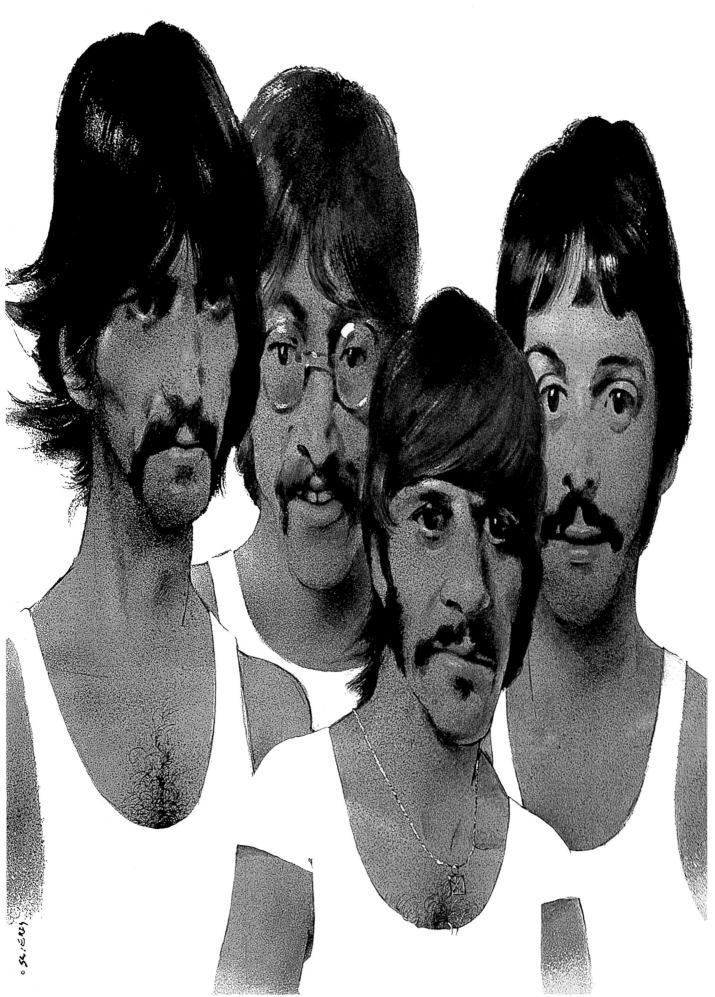

37　Beatles poster　ビートルズのポスター　1977

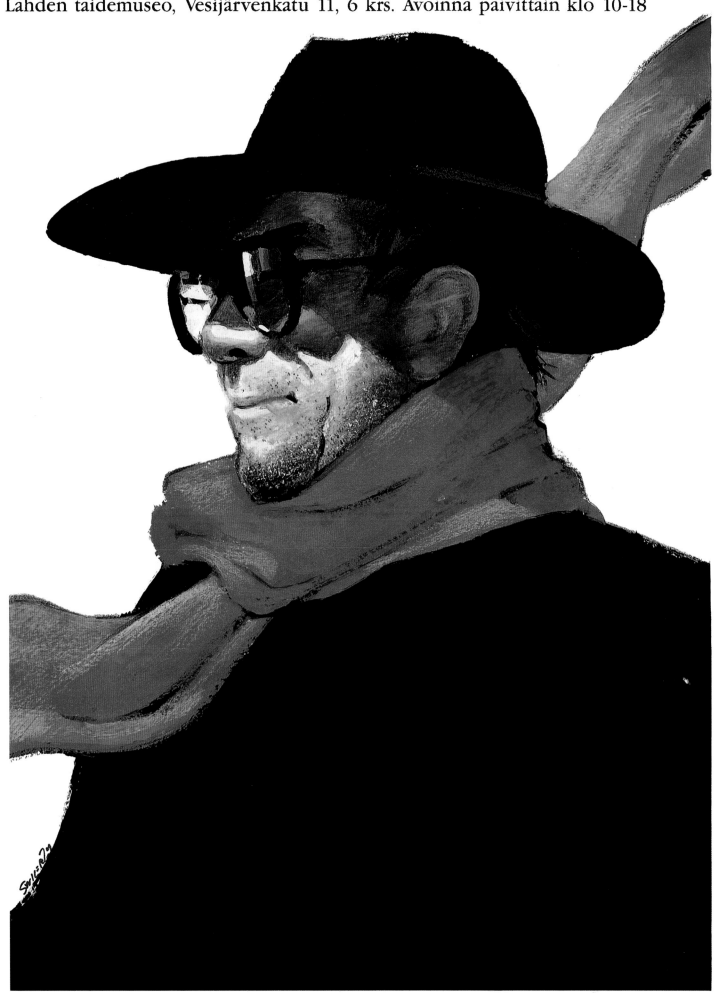

Waldemar Świerzy. Julisteita. 26.11.1989-21.1.1990

Lahden taidemuseo, Vesijärvenkatu 11, 6 krs. Avoinna päivittäin klo 10-18

Editor's Viewpoint 編集者の視点

BEST 100 JAPANESE POSTERS, 1945-89 戦後日本のポスター100

Yusaku Kamekura 亀倉雄策

As a cultural adjunct to its business activities, the Toppan Printing Co., Ltd. recently sponsored a project to select the "best 100" Japanese posters of the post-war era. The chosen works are being reproduced as an integral set and donated free of charge to art museums around the world.

To coincide with the premiere showing of the 100 posters in Los Angeles early last autumn, a comprehensive catalog was published under the brilliant editing of Ikko Tanaka. Unfortunately, this magnificent publication is not available commercially and thus has little opportunity to meet the public eye.

As a remedial measure I have decided to introduce the complete set of 100 posters in *CREATION* in digest form. In the Preface to Volume 7 I touched briefly on the project, but here I would like to add the following excerpts from remarks which I wrote for the catalog itself.

"This compendium of the 'best 100' Japanese posters of the post-war era has been compiled to record those works which set the artistic milestones of this 45-year period. In one volume it affords the reader a comprehensive overview of the historical highlights of post-war Japanese poster art.

"Five persons took part in the selection process: Shigeo Fukuda, Ikko Tanaka, Makoto Nakamura, Kazumasa Nagai and myself. Without intending so, the five members of the selection panel are all graphic designers whose professional orientation is more artistic than commercial. As might thus be expected, the 100 posters chosen for inclusion in this volume are recognized foremost for their artistic contributions....

"To determine which works should be incorporated into this publication, each member of the selection committee was assigned to select the 100 posters which he would personally wish to include. (Based on my own experience, I might add that this proved to be a formidable task.) Then the five members assembled... to discuss their collective findings. Interestingly (or perhaps as might be expected), of the 500 posters which were suggested in this manner, 70 percent were nominated by all five participants. Discussions thereby focused on the remaining 30 percent.

"We are well aware that not everyone will agree with our final selections or, for that matter, with our basic criteria of assessment. Admittedly, if we had emphasized commercial contribution rather than artistic significance (which are the only two feasible means of poster categorization), then our choices would have been entirely different. We therefore ask for the reader's understanding of our decision to concentrate on posters of artistic rather than commercial importance for the present purposes.

"The selection process turned out to be a somewhat emotional experience for me. It brought back vivid memories of how determined we Japanese designers of the early post-war period had been, despite the vitense destitution of our homeland, to master— and, if possible, surpass— the design skills of the advanced nations of the West.... And though looking back I now realize how unpolished and unrefined our posters of those days actually were, nevertheless I recall how infused they were with a burning inner energy—the energy of our youthful aspirations."

凸版印刷株式会社が文化事業の一環として戦後日本のポスターを100点選んで復元し、世界中の美術館に寄贈するという企画が実行に移されている。昨年の初秋にロサンゼルスで、この100点のポスター展が開催された折、田中一光の見事な編集構成で豪華版のカタログが上梓された。しかし残念ながら非売品のため、一般の人の目に触れる機会は、ほとんどない。そこで本誌はダイジェストという形で全図版を収録して読者にお目にかけることにした。本誌7号の私の前書きで、この100点のポスターについて触れているが、次にロサンゼルス展のカタログの序文として私が書いたものの抜粋を再録したい。あわせて読んでいただければありがたい。

この「日本のポスター100」は、戦後45年を振り返って、その時代の変遷の過程に、道標の役割を果した記録として選択したものである。だから、戦後日本のポスター史が一望のもとに見渡せるはずである。この100点の選者は5人。福田繁雄、田中一光、中村誠、永井一正、亀倉雄策である。

この5人の選者は、はからずもグラフィック・デザイナーの中でも芸術志向型であるだけに、選ばれた100点は日本のポスターの芸術性を正面から問う態度になってしまった。それは、1枚のポスターが持つ生命力はもちろん、さらに時代の進展の節目というか、曲がり角というか、そうした歴史的な地点に立って重要な役割を果したポスターの表現内容を問う結果にもなってしまったのだ。

私たち5人は、各人それぞれ100点のポスターを選び、カラーコピーをつくって持ち寄って討議を重ねた。私事で恐縮だが、自分の考えで100点を選ぶことは、資料を探すことからして想像をこえる大変なことだった。そうして、各自の選んだ100点、合計500点を一堂に持ち寄った。面白いといえば面白いし、当然といえば当然なのだが、その500点のうち70%は、5人とも同じポスターを選んでいた。残りの30%が討論の対象になったわけだ。

多少の曲折はあったものの、とにかく選ばれた100点については、立場、あるいは視点が違えば当然異論が出ることは承知している。例えば、もし選者が芸術性よりも商業性を重視したら、この100点は全く違った方向に展開したはずである。ポスターという性質から考えると、芸術性か商業性かの2点しか選択の道がないのだから、今回、芸術性の道を選んだのも見識の問題とご了承いただきたい。この100点を選びながら、私は胸を去来する熱いものを感じないわけにはゆかなかった。あの戦後の疲弊した日本の地でデザイナーたちは先進欧米のデザインから吸収しようと真剣だった。さらに、追いつきたいと、どんなにあせったことか。また紙質や印刷技術の悪い状況を克服することに知恵をしぼったものだ。こうした情熱が、デザイナーを結集させ、集団をつくって社会的な地位の向上を目指した。その手段がポスター展だった。今見ると、そのころのポスターは粗削りで洗練さに欠けるといっても、そこにはほとばしるものがあった。そのほとばしるものとはなんだったのか。私は、そのほとばしりは、デザインの青春時代をかけぬける爽やかなロマンだったと思う。

BEST 100

JAPANESE

POSTERS,

1945-89

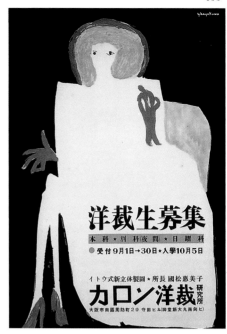

1949 Yoshio Hayakawa

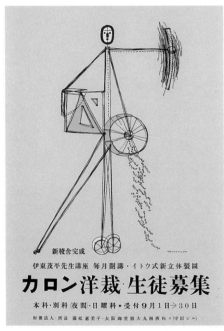

1951 Yoshio Hayakawa

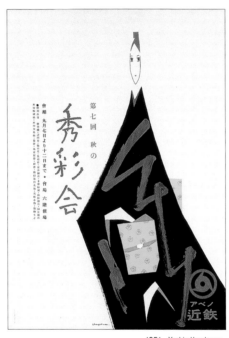

1951 Yoshio Hayakawa

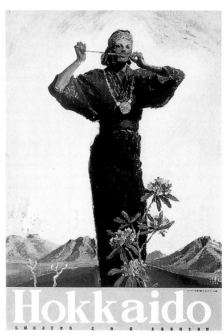

1952 Kenichi Kuriyagawa

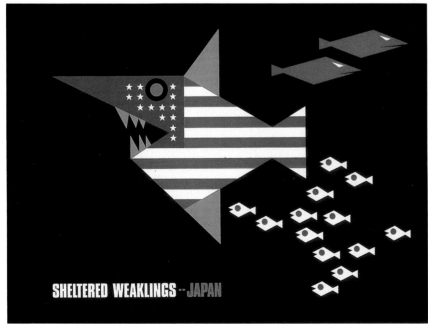

1953 Takashi Kono

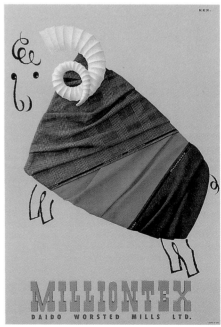

1954 Kenji Itoh

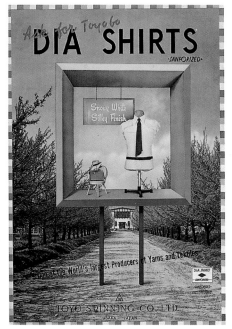

1954 Motoi Shigenari

1955 Ryuichi Yamashiro

1955 Takashi Kono

1956 Yusaku Kamekura

1957 Yusaku Kamekura

1957 Tadashi Ohashi

1957 Yusaku Kamekura

1958 Ikko Tanaka

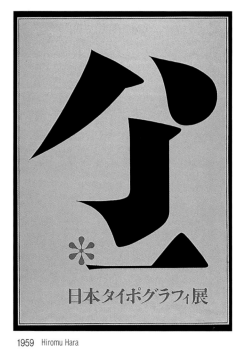

1959 Hiromu Hara

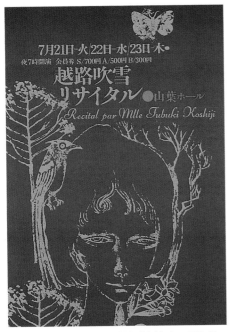

1959 Kohei Sugiura／Akira Uno

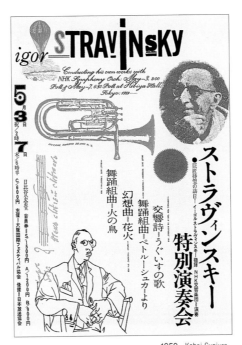

1959 Kohei Sugiura

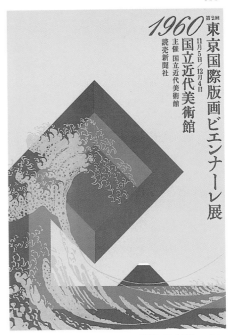

1960 Ryuichi Yamashiro

1961 Ikko Tanaka

1961 Gan Hosoya／Saburo Kitai

1964 Kiyoshi Awazu

1961 Yusaku kamekura／Osamu Hayasaki

1962 Yusaku Kamekura

1963 Yusaku Kamekura／Osamu Hayasaki

1965 Tadanori Yokoo

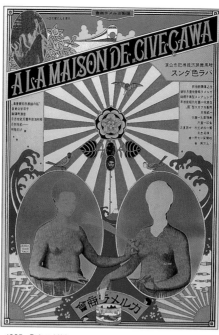

1965 Tadanori Yokoo

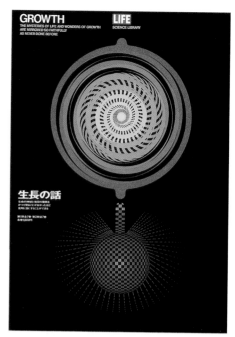

1966 Kazumasa Nagai

1966 Tsunehisa Kimura

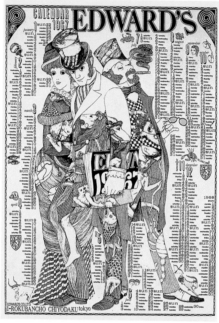

1966 Yoshitaro Isaka

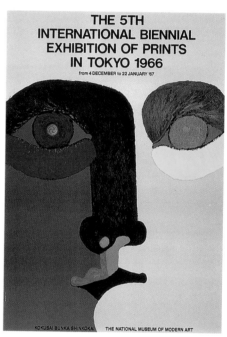

1966 Yoshio Hayakawa

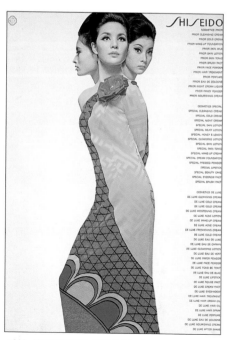

1966 Makoto Nakamura／Noriaki Yokosuka

1966 Mitsuo Katsui

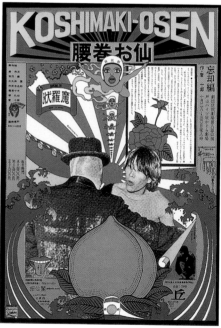

1966 Tadanori Yokoo

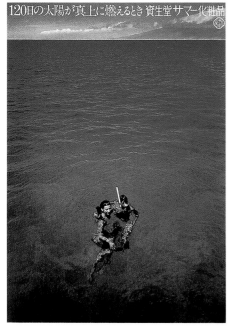

1967 Eiko Ishioka／Noriaki Yokosuka

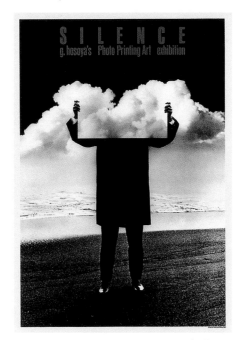

1967 Gan Hosoya

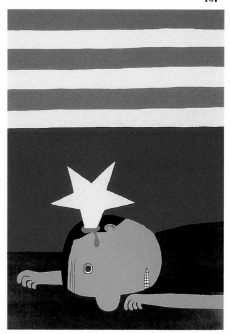

1968 Makoto Wada

1968 Tadanori Yokoo

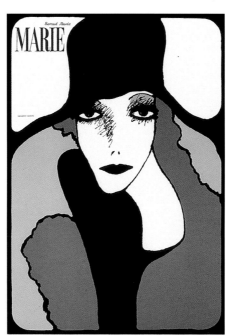

1968 Tadahito Nadamoto

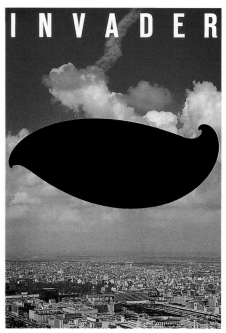

1969 Gan Hosoya

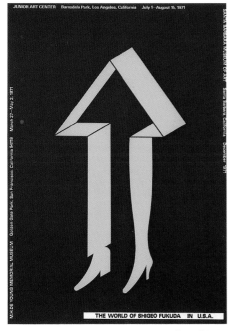

1971 Shigeo Fukuda

1971 Keisuke Nagatomo／Seitaro Kuroda

1971 Masuteru Aoba

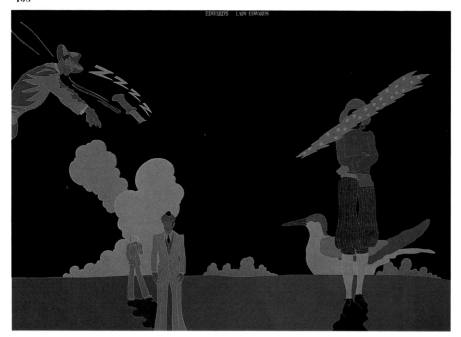

1971 Keisuke Nagatomo／Seitaro Kuroda

1971 Shin Matsunaga／Yojiro Adachi

1972 Kohei Sugiura

1972 Eiko Ishioka／Harumi Yamaguchi

1973 Tadanori Yokoo

1973 Iwao Miyanaga／Kazumi Kurigami

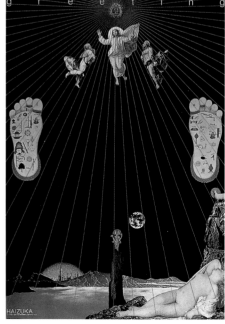

1973 Tadanori Yokoo

指先と目元の新感覚。⑤資生堂ネイルアート・資生堂フラッシュアイズ

1973　Makoto Nakamura／Noriaki Yokosuka

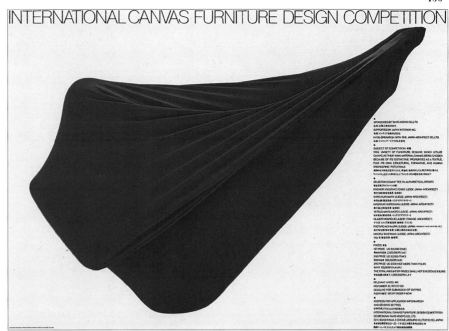

INTERNATIONAL CANVAS FURNITURE DESIGN COMPETITION

1973　Eiko Ishioka／Noriaki Yokosuka

abcdef gq rstuvwxyz

1974　Kazumasa Nagai

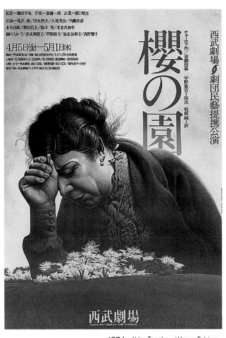

櫻の園

西武劇場

1974　Ikko Tanaka／Haruo Takino

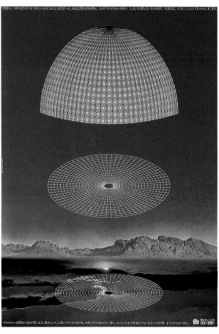

1974　Kazumasa Nagai

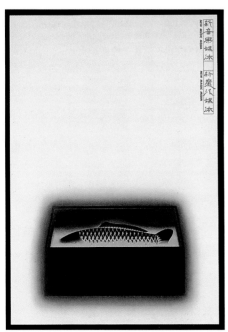

1974　Koichi Sato

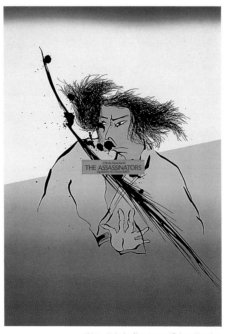

THE ASSASSINATORS

1974　Keisuke Nagatomo／Seitaro Kuroda

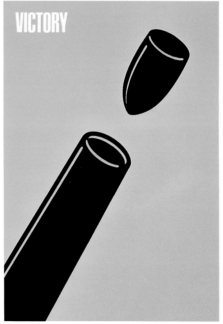

VICTORY

1976　Shigeo Fukuda

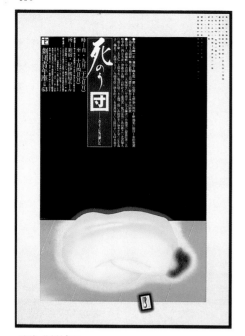

1976 Koichi Sato

1976 Takahisa Kamijo

1976 Teruhiko Yumura

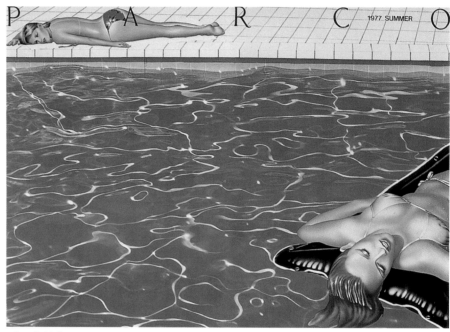

1977 Yoshio Hasegawa／Harumi Yamaguchi

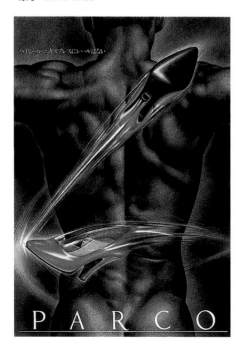

1977 Eiko Ishioka

1978 Makoto Nakamura／Noriaki Yokosuka

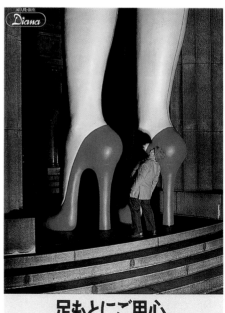

1978 Katsumi Asaba／Eiichiro Sakata

1979 Mitsuo Katsui／Ikko Narahara

1979 Eiko Ishioka／Kazumi Kurigami

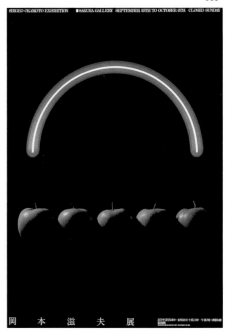

1979 Shigeo Okamoto

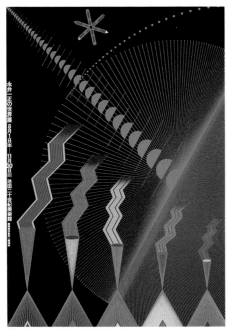

1980 Kazumasa Nagai

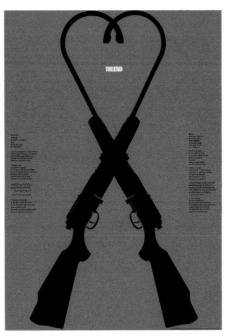

1980 Masuteru Aoba

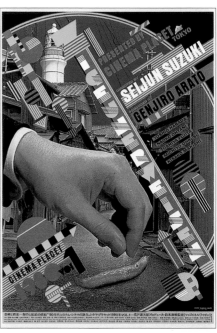

1980 Tsunehisa Kimura

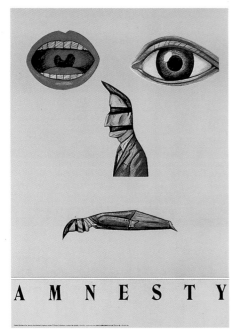

1980 Yosuke Kawamura

1981 Yusaku Kamekura

1981 Shigeo Fukuda

1981　Ikko Tanaka

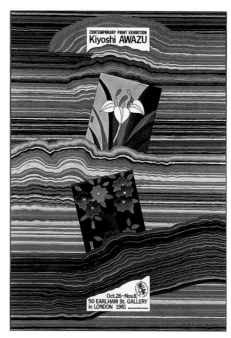

1981　Kiyoshi Awazu

1982　Shigeo Fukuda

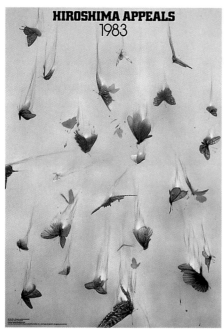

1983　Yusaku Kamekura／Akira Yokoyama

1983　Makoto Saito／Katsuhiko Hibino

1983　Takenobu Igarashi

1984　Kohei Sugiura／Fujio Watanabe

1984　Yukimasa Okumura

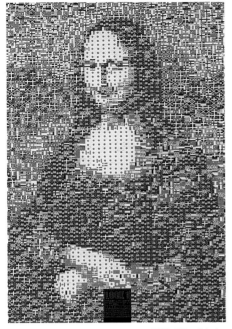

1984　Shigeo Fukuda

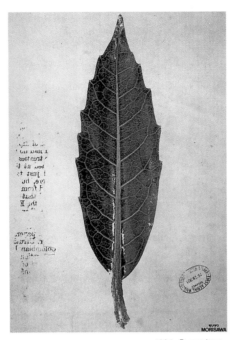

1984　Tsuguya Inoue

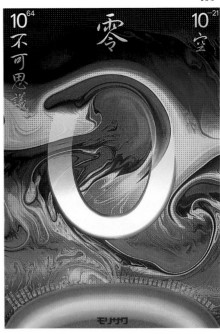

1985　Mitsuo Katsui

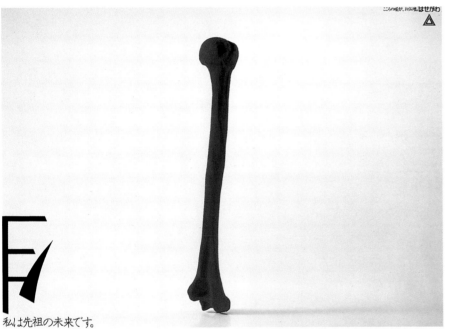

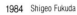

1985　Makoto Saito／Kazumi Kurigami

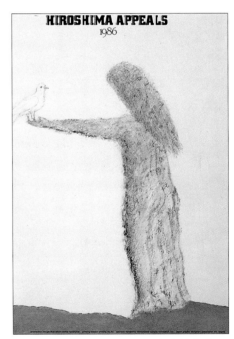

1986　Yoshio Hayakawa

1986　Shin Matsunaga

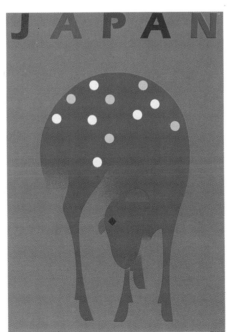

1987　Ikko Tanaka

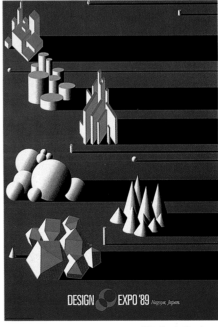

1987　Yusaku Kamekura

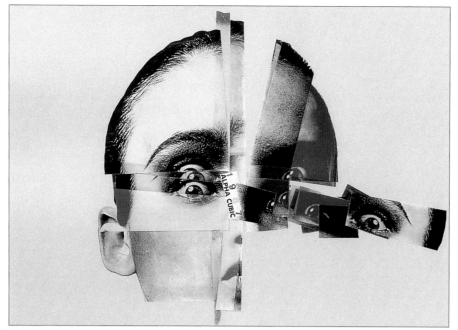

1987 Makoto Saito／Eiichiro Sakata

1987 Masatoshi Toda

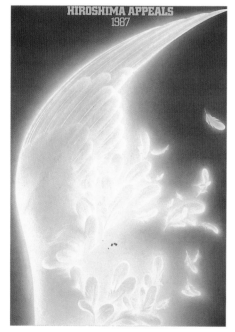

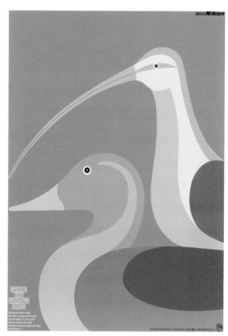

1987 Kazumasa Nagai／Tamie Okuyama

1987 Ryohei Kojima

1988 Ikko Tanaka

1988 Masayoshi Nakajo

1988 Masayoshi Nakajo

1988 Masayoshi Nakajo

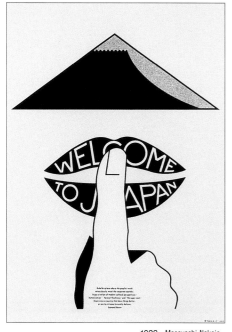

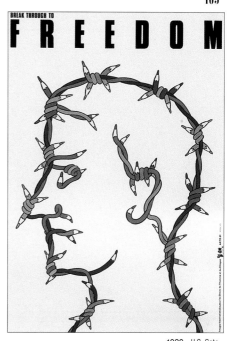

1988　Masayoshi Nakajo

1988　Kazumasa Nagai

1989　U.G. Sato

1989　Masatoshi Toda／Sachiko Kuru

1989　Koichi Sato

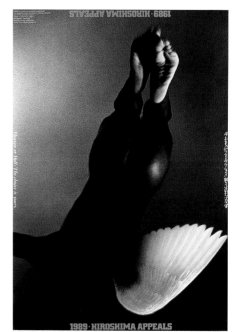

1989　Katsumi Asaba／Kazumi Kurigami

1989　Katsumi Asaba／Kazumi Kurigami

1989　Mitsuo Katsui

ARTISTS' PROFILES
作家略歴

SHIGEO FUKUDA
福田繁雄

JAPAN
1932 Born in Tokyo.
1956 Graduated from Tokyo National University of Fine Arts and Music with a degree in design.
1970 Mainichi Industrial Design Award.
1972 Gold Medal at Warsaw International Poster Biennale.
1975 Highest Award in international poster competition commemorating 30th anniversary of Poland's victory in war.
Highest Award in design competition of commemorative coin for Montreal Olympics.
1976 Minister of Education's Newcomers Award.
1977 Cartoon Art Award from *Bungei Shunju*.
1980 Kodansha Cultural Award in Publishing.
Silver Prize at Brno Biennale of Graphic Design.
1983 Silver Prize at Lahti International Poster Biennale.
1985 Excellence Award at International Poster Biennale in Nimes.
First Prize at International Peace Poster Biennale in Moscow.
1986 Mainichi Arts Award.
1987 Yamana Prize at Japan Advertising Awards.
Hall of Fame Award from New York ADC.
1988 Prize in international arts competition commemorating 200th anniversary of French Revolution.
1989 Silver Medal at International Invitational Poster Biennale in Colorado.

1932 東京都生まれ
1956 東京芸術大学美術学部図案科卒業
1970 毎日産業デザイン賞
1972 ワルシャワ国際ポスタービエンナーレ金賞
1975 ポーランド戦勝30周年国際ポスター・コンペ最高賞
モントリオール・オリンピック大会記念銀貨デザイン・コンペ最高賞
1976 芸術選奨文部大臣新人賞
1977 文芸春秋漫画賞
1980 講談社出版文化賞
ブルーノ国際グラフィック・ビエンナーレ銀賞
1983 ラハチ国際ポスター・ビエンナーレ銀賞
1985 ニーム国際ポスター・ビエンナーレ優秀賞
モスクワ平和ポスター国際ビエンナーレ第1位
1986 毎日芸術賞
1987 日本宣伝賞山名賞
ニューヨークADC名声の殿堂(Hall of Fame)賞
1988 フランス革命200周年記念国際芸術コンペ(アンバンテ88)入賞
1989 コロラド国際招待ポスター・ビエンナーレ銀賞

AGI(国際グラフィック連盟)日本会員
RDI(英国王立芸術協会)会員

YOKO YAMAMOTO
山本容子

JAPAN
1952 Born in Urawa, Saitama Prefecture.
1976 Participated in 6th International Print Biennale in Cracow, Poland.
1977 Participated in "Art Now '77" at Hyogo Museum of Modern Art and 2nd Contemporary Print Contest Exhibition in Osaka.
1978 Graduated from Kyoto City University of Arts, majoring in Western painting. Participated in '78 Japanese Contemporary Print Grand Prize Exhibition.
1980 Participated in Japanese Print Exhibition at Tochigi Prefectural Art Museum.
1981 Participated in Japan Art Festival (Tokyo, Osaka, London).
1982 Participated in "November Steps" exhibition of contemporary artists, in Yokohama.
1983 Participated in 4th International Print Biennale in Korea.
1984 Participated in "Prints of Today" exhibition in Saitama and Graphic Art and Design Exhibition in Toyama.,
1985 Participated in Contemporary Self-portrait Exhibition in Saitama and Japanese Print Exhibition in Tochigi.

Awards
1975 Purple Medal, Kyoto Municipal Art Museum.
1976 1st Art Core Prize.
1977 Sales Award at 1st Kyoto Prefectural Exhibition of Western Prints. Newcomers Award at 2nd Kyoto Prefectural General Exhibition of Western Prints. 2nd Contemporary Print Contest Prize.
1978 Sales Award at 2nd Kyoto Prefectural Exhibition of Western Prints. Seibu Prize at 2nd Japanese Contemporary Print Grand Prize Exhibition.
1980 Kyoto Arts Newcomers Prize. Arts Prize at Avon Annual Women's Awards.
1983 Award for Excellence at 4th International Print Biennale in Korea.

1952 浦和市生まれ
1976 第6回クラコウ国際版画ビエンナーレ展(ポーランド国立美術館)
1977 アートナウ'77(兵庫県立近代美術館)
第2回現代版画コンクール展(大阪府民ギャラリー)
1978 京都市立芸術大学西洋画専攻科修了
'78日本現代版画大賞展(西武百貨店・渋谷店)
1980 日本の版画展(栃木県立美術館)
1981 ジャパン・アートフェスティバル(上野の森美術館・東京、大阪府立現代美術センター・大阪、CamdenArtsCenter・ロンドン)
1982 今日の作家展〈November Steps〉(横浜市民ギャラリー)
1983 第4回韓国国際版画ビエンナーレ展(国立現代美術館・ソウル)
1984 版画の今日展(埼玉県立近代美術館)
グラフィックアート・アンド・デザイン展(富山県立近代美術館)
1985 現代のセルフポートレイト展(埼玉県立近代美術館)
日本の版画(栃木県立美術館)

受賞歴
1975 京都市美術展紫賞
1976 第1回アート・コア賞
1977 第1回京都府洋画版画選抜展買上賞
第2回京都府洋画版画総合展新人賞
第2回現代版画コンクール展コンクール賞
1978 第2回京都府洋画版画選抜展買上賞
第2回日本現代版画大賞展西武賞
1980 京都市芸術新人賞
エイボン女性年度賞芸術賞
1983 第4回韓国国際版画ビエンナーレ優秀賞

GRAPUS
グラピュス

FRANCE
1970 Founded by Pierre Bernard, François Miehe and Gérard Paris-Clavel, former members of "atelier populaire n°3," to support social, political and cultural activities through the medium of design. Bernard and Paris-Clavel were also proteges of Henryk Tomaszewski.
1975 The three founders were joined by Jean-Paul Bacholet and Alex Jordan, of Germany.
1979 Miehe leaves the group.
—— To date, Grapus has held exhibitions in over 20 countries throughout Europe, North America and Asia. The group has also received innumerable international awards.
—— As a group Grapus disbanded one year ago. However, its three independent spinoffs are expected to collaborate in future projects.

フランス
グラピュスは1970年ピエール・ベルナール、フランソワ・ミエ、ジェラール・パリ＝クラヴェルによって、社会的、政治的、文化的な活動をデザインの立場から支援するために結成された。この3人は1968年に国立美術大学のアトリエ・ポピュレール・ヌメロ・トロワでの制作に参加しており、またそれ以前にピエールとジェラールは、ワルシャワの美術学校のヘンリク・トマシェフスキーのアトリエで1年学んでいる。
1975年にはジャン＝ポール・バショレが、続いてドイツ出身のアレックス・ジョルダンがグループに参加する。1979年にフランソワ・ミエはグラピュスを去る。
展覧会はヨーロッパ、アメリカ、アジアの20数か国で行ない、国際的なコンテストで獲得した賞は数えられないほどである。
1年前にグループによる活動は休止されたが、独立した3つのグループは今後もおたがいに連係していくであろう。

MICHEL HENRICOT
ミッシェル・アンリコ

FRANCE
1941 Born in Paris.

One-man shows
1958 Galerie de l'Odéon, Paris.
1960 "Le Soleil dans la Tête" gallery, Paris.
1961 Galerie Marignan, Paris.
1963 Galerie Marignan, Paris.
1964 "Hunstkabinett," Hamburg.
1966 Galerie Desbrière, Paris.
1968 Galerie Desbrière, Paris.
1971 "IL FAUNO" gallery, Turin.
1973 Galerie Braumuller, Paris.
1975 Galerie Braumuller, Paris, and Heidelberg Museum.
1979 Galerie Braumuller, Paris.
1983 Galerie Campo, Antwerp.
1985 Galerie G. Laubie, Paris.
1988 Boyd-Sherrel Gallery, Los Angeles.
1990 Galerie Dmochowski, Paris.
—— Mr. Henricot's works are included in the permanent collections of the Musée d'Art Moderne in Paris and Musée de Belfort.
—— He has participated in numerous group exhibitions, including exhibitions at the abovementioned museums in Heidelberg and Belfort.

フランス
1941 パリに生まれる

個展歴
1958 ギャルリー・ド・ロデオン（パリ）
1960 ギャルリー・ル・ソレイユ・ダン・ラ・テット（パリ）
1961 ギャルリー・マリニャン（パリ）
1963 ギャルリー・マリニャン（パリ）
1964 フンストカビネット（ハンブルグ）
1966 ギャルリー・デブリエール（パリ）
1968 ギャルリー・デブリエール（パリ）
1971 イル・ファウノ（トリノ）
1973 ギャルリー・ブロミュレール（パリ）
1975 ギャルリー・ブロミュレール（パリ）
ハイデルベルグ美術館
1979 ギャルリー・ブロミュレール（パリ）
1983 ギャルリー・カンポ（アントワープ）
1985 ギャルリー・ジェ・ロビー（パリ）
1988 ギャラリー・ボイド＝シェレル（ロサンゼルス）
1990 ギャルリー・ドモチョフスキー（パリ）

—— パリ近代美術館、ベルフォール美術館のコレクション
—— 数々のグループ展、ベルフォール美術館、ハイデルベルグ美術館などに出品

ITALO LUPI
イタロ・ルピ

ITALY
1934 Born in Cagliari, Sardinia.
1960 Graduated from Milan Polytechnic Institute with degree in architecture.
1962 Consultant to large chain-store, La Rinascente.
1970 Art direction of the magazine Shop.
1971 Special mention for editorial graphics at Typomundos, Prague.
1974-86 Art direction of the magazine Abitare.
1977 1st Prize from the Art Direction Club of Milan for editorial graphics.
1978-80 Teacher of editorial graphics at the Istituto Superiore, Urbino.
1983-89 Art direction of Milan Triennale.
1984-88 Art direction of IBM Italia.
1986 Art direction of Domus.
1988 Silver Medal at XIII International Biennale of Graphic Design in Brno.
Prize for poster design at Lahti Biennale.
1989 Art director of International Design Conference in Aspen.
1990 Design of the magazine Pubblicità Domani.

イタリア
1934 サルジニアのカリアリに生れる
1960 ミラノ工芸学校卒業、建築学士号を修得
1962 大規模チェーンストア「ラ・リナセント」のコンサルタントとなる
1970 「Shop」誌のアートディレクションを行なう
1971 プラハ「タイポムンドス」展においてエディトリアル部門特別賞を受賞
1974-86 「Abitare」誌のアートディレクションを行なう
1977 ミラノアートディレクションクラブからエディトリアル部門1位を受賞
1978-80 ウルビーノ大学でエディトリアルを教える
1983-89 ミラノトリエンナーレのアートディレクションを行なう
1984-88 IBMイタリアのアートディレクションを行なう
1986 「DOMUS」のアートディレクションを行なう
1988 ブルノ国際グラフィックビエンナーレにおいて銀メダルを受賞
ラハチ国際ビエンナーレにおいてポスター部門入賞
1989 アスペン国際デザイン会議のアートディレクションを行なう
1990 「Pubblicità Domani」誌のデザインを行なう

WALDEMAR SWIERZY
ヴァルデマル・シュヴィエジ

POLAND

Freelance graphic and poster designer. Born in 1931 in Katowice. Graduated from the Cracow Academy of Fine Art in Katowice in 1952, with a degree in graphic art. Since 1965, also serving as professor at the Poznań Higher School of Fine Arts.

Major Awards

1959 Toulouse-Lautrec Grand Prix.
1962 3rd Toulouse-Lautrec Award.
1970 First Prize at "Prix X Biennale di Sao Paulo."
1972 Silver Medal at Warsaw International Poster Biennale.
1975 First Prize in Annual Film Poster Competition of the *Hollywood Reporter* (also 1985).
1976 Gold Medal at Warsaw International Poster Biennale.
1977 First Prize at Lahti International Poster Biennale.
1985 Gold and Bronze Medals in "Jazzpo" International Jazz Poster Exhibition in Bydgoszcz.

ポーランド

フリーのグラフィック・ポスターデザイナー。1931年カトウィーツェに生まれる。1952年カトウィーツェのクラクフ美術アカデミーを卒業。1965年からポズナン美術大学教授を務める。

受賞歴

1959 トゥールーズ＝ロートレック賞グランプリ
1962 第3回トゥールーズ＝ロートレック賞
1970 第10回サンパウロビエンナーレ第1位
1972 ワルシャワ国際ポスタービエンナーレ銀賞
1975 ハリウッドレポーター映画ポスターコンペ第1位
1976 ワルシャワ国際ポスタービエンナーレ金賞
1977 ラハチポスタービエンナーレ第1位
1985 ジャズポ国際ジャズポスター展金賞銅賞

CONTRIBUTORS' PROFILES
評論執筆者紹介

MAMORU YONEKURA
Art critic. Contributing editor of Asahi Shimbun (Newspaper). Lecturer of Women's College of Fine Arts.

YUSUKE NAKAHARA
Art critic. Professor of Kyoto Seika University.

SHUNSUKE KIJIMA
Art critic. Professor of Kyoritsu Women's University.

ALAIN WEILL
Specialist in advertising art and contemporary art trends.

TETSURO ITO
Former executive director in charge of public relations and culture at Olivetti Corporation of Japan. President of Spazio Institute. Member of New York ADC.

NOBORU MATSUURA
Graphic artist and specialist in poster history. Member of JAGDA and Japanese Society for Science of Design. Assistant Professor of Kanazawa University.

YUSAKU KAMEKURA
Graphic designer. Member of AGI. President of JAGDA and Japan Design Committee. Editor of *CREATION*.

米倉 守
美術評論家
朝日新聞客員、女子美術大学講師

中原佑介
美術評論家
京都精華大学教授

木島俊介
美術評論家
共立女子大学教授

アラン・ヴェイユ
広告美術・現代美術研究家

伊藤哲郎
元日本オリベッティ取締役広報・文化担当
株式会社スパチオ研究所代表取締役、ニューヨークADC会員

松浦 昇
グラフィック・アーティスト、ポスター史研究家
JAGDA会員、日本デザイン学会会員、金沢大学助教授

亀倉雄策
グラフィック・デザイナー
AGI会員、JAGDA会長、日本デザインコミッティー理事長、本誌編集長

掲載資料のご提供を感謝致します

アルファ・キュービック・ギャラリー
株式会社竹尾研究所
スパチオ研究所
凸版印刷株式会社